THE BEST OF
ANNUAL REPORT DESIGN

ROCKPORT

THE BEST OF
ANNUAL REPORT DESIGN

GLOUCESTER MASSACHUSETTS

ROCKPORT PUBLISHERS

CHERYL DANGEL CULLEN

Acknowledgments

Thank you to all the designers who participated in this project and provided so many brilliant examples of annual reports that it was extremely difficult to choose the best.

I owe a debt of gratitude to Gary Dickson, Jack Gaido, and Ellen Shook for their enthusiasm in helping spread the word.

Special thanks to my mother, who is always there to listen, my father, who is watching out for me even now, and my husband, who encourages my every effort.

First published in the United States of America by
Rockport Publishers, Inc.
33 Commercial Street
Gloucester, Massachusetts 01930-5089
Telephone: (978) 282-9590
Facsimile: (978) 283-2742

Distributed to the book trade and art trade in the United States by
North Light Books, an imprint of
F & W Publications
1507 Dana Avenue
Cincinnati, Ohio 45207
Telephone: (800) 289-0963

Other distribution by
Rockport Publishers, Inc.
Gloucester, Massachusetts 01930-5089

ISBN 1-56496-633-X

10 9 8 7 6 5 4 3 2 1

DESIGN: Moore Moscowitz
LAYOUT: SYP Design & Production
COVER PHOTOGRAPHY: Kevin Thomas Photography

Quark XPress® is a registered trademark of Quark, Inc.
Adobe® Illustrator®, Adobe® Photoshop®, and Adobe® Pagemaker® are registered trademarks of Adobe Corporation.
FreeHand® is a registered trademark of Macromedia, Inc.

Printed in China.

custom animations enable

people to see

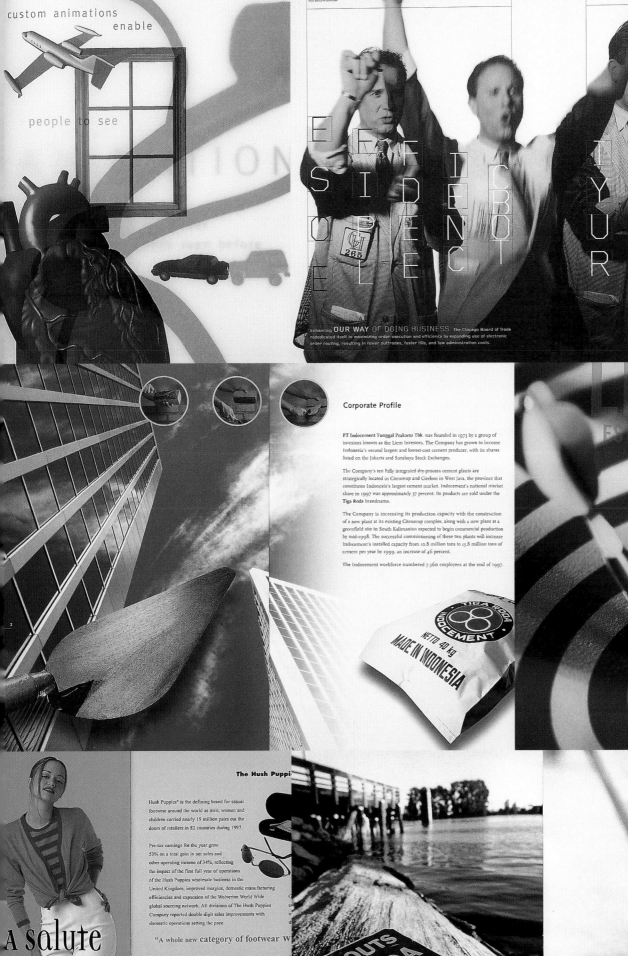

Joel R. Riechers
CHAIRMAN
Floor Agriculture Subcommittee
CI-100 Chairman
Floor Executive Committee

MEMBER
Floor Governs Committee
Floor Brokers (Agricultural) Committee

EFFICIENCY
INSIDE
THE BOX
ELEC

ENDUTRONI
C

NEW
EDITION

Enhancing **OUR WAY** OF DOING BUSINESS. The Chicago Board of Trade rededicated itself to maximizing order execution and efficiency by expanding use of electronic order routing, resulting in fewer outtrades, faster fills, and low administration costs.

Corporate Profile

PT Indocement Tunggal Prakarsa Tbk. was founded in 1973 by a group of investors known as the Liem Investors. The Company has grown to become Indonesia's second largest and lowest-cost cement producer, with its shares listed on the Jakarta and Surabaya Stock Exchanges.

The Company's ten fully integrated dry-process cement plants are strategically located in Citeureup and Cirebon in West Java, the province that constitutes Indonesia's largest cement market. Indocement's national market share in 1997 was approximately 37 percent. Its products are sold under the **Tiga Roda** brandname.

The Company is increasing its production capacity with the construction of a new plant at its existing Citeureup complex, along with a new plant at a greenfield site in South Kalimantan expected to begin commercial production by mid-1998. The successful commissioning of these two plants will increase Indocement's installed capacity from 10.8 million tons to 15.8 million tons of cement per year by 1999, an increase of 46 percent.

The Indocement workforce numbered 7,360 employees at the end of 1997.

TIGA RODA
INDOCEMENT
NETTO 40 kg
MADE IN INDONESIA

LEWIS
ESTLS PRIDEM

The Hush Puppi

Hush Puppies® is the defining brand for casual footwear around the world as men, women and children carried nearly 19 million pairs out the doors of retailers in 82 countries during 1997.

Pre-tax earnings for the year grew 53% on a total gain in net sales and other operating income of 34%, reflecting the impact of the first full year of operations of the Hush Puppies wholesale business in the United Kingdom, improved margins, domestic manufacturing efficiencies and expansion of the Wolverine World Wide global sourcing network. All divisions of The Hush Puppies Company reported double digit sales improvements with domestic operations setting the pace.

"A whole new category of footwear W

The U.S.-based chain of 60 Hush Puppies retail outlets and specialty stores achieved an 8% store-for-store sales increase for the year.

Retailers around the world featured Hush Puppies fashion-right, casual, comfortable shoes for the family as fashion designers and the media continued to build consumer interest in the brand. In the U.S. alone, nearly 18,000 retail stores carry the Hush Puppies brand. The growing trend toward "brown shoes" led several leading athletic footwear retailers to initiate tests of Hush Puppies products in their stores late in the year.

Domestic advertising support was highlighted by the first Hush Puppies television campaign in a decade. Recognizing that 70% of all footwear purchase decisions are made on the retail floor, a major point-of-purchase support effort was

A salute
to our
Retailers

T SCOUTS OF AMERICA

VT ROOPS

Contents

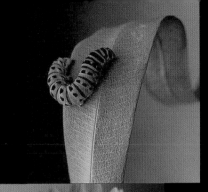

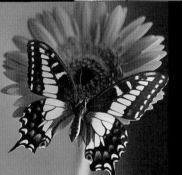

Introduction

Annual reports are a multibillion-dollar industry.

For the industries that have a hand in the production of annual reports, they represent big business. Annual reports have long been the lifeblood of the paper, merchant, and printing industries, not to mention the bread and butter of many design shops, which keep as busy as tax accountants during the first quarter of the fiscal year producing them. Moreover, the very companies who put them out see annual reports as vital to their futures.

Annual reports are viewed by many as the single most important document a company can produce.

No longer is the annual report a financial document, disseminated solely to meet the requirements of the Securities and Exchange Commission. Increasingly, public companies understand their annual report is integral to their overall marketing effort, treating it as not a standalone piece, but as one with the balance of their promotional materials.

Annual reports are the one piece of communication that reaches all audiences, presenting the company's personality, identity, and branding.

Because audience demographics have broadened substantially, annual reports have to be multilingual—talking not only to individual shareholders, but also future investors, employees, potential employees, customers, prospective customers, portfolio managers, security analysts, and the industry at large. In some instances, as you will see here, they literally must be multilingual to communicate to a global audience in one case, in five different languages.

Annual reports are breaking down conventions regarding what is right and proper annual report design.

With so many audiences to speak to, the annual report has loosened up. A conservative, bear-market approach may have worked once, but now the best annual reports are those that approach design aggressively.

The best annual report designs are those where the client and the designer work in tandem, empowering one another to make whatever decisions will leave a lasting impression on the report reader.

The Best of Annual Report Design showcases sixty-five annual reports from more than sixty designers the world over. Collectively, they present a wealth of ideas and problem-solving tips.

These annual reports earned the ranking of "the best" because of their ability to communicate with the recipient and to entice the reader to delve into the pages. Each report is recognized and lauded for its unique thumbprint—whether it is the design's ingenuity, innovation, resourcefulness, simplicity, elegance, or sophistication.

They are the best because they teach us something about ourselves.

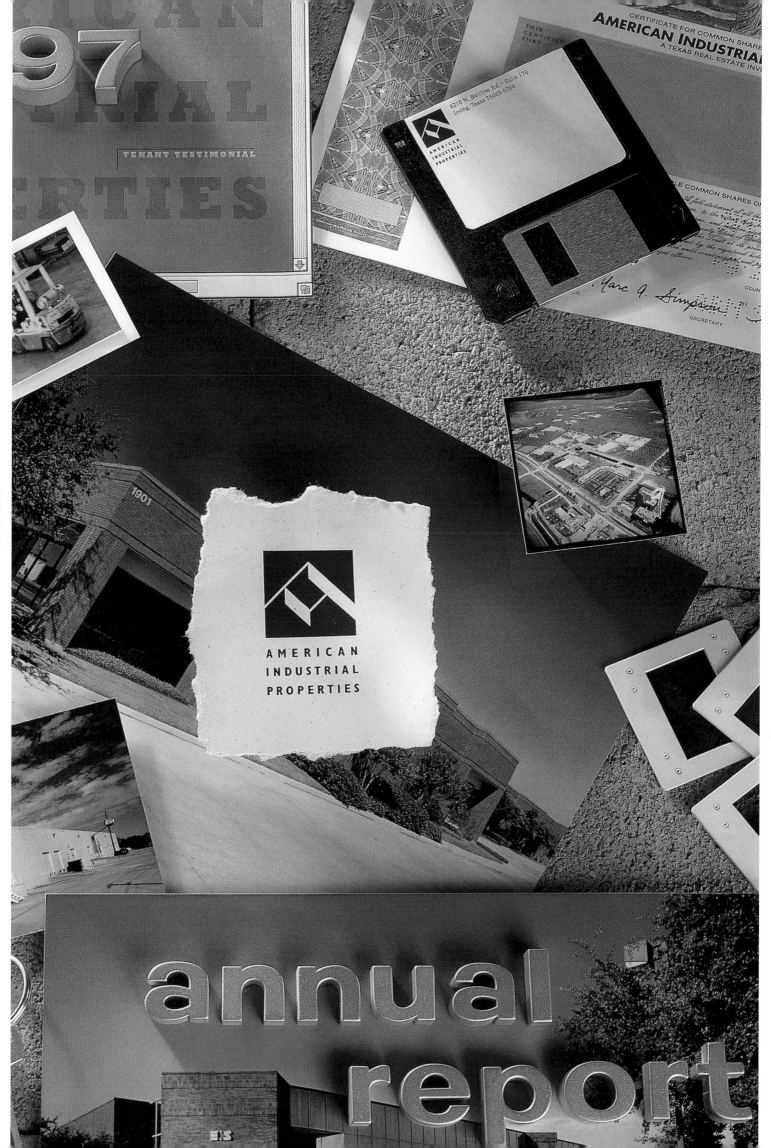

AMERICAN
INDUSTRIAL
PROPERTIES

annual report

CORPORATE

WALL STREET brokerage firms, banks, real estate developers, and insurance companies provide the subject matter for the quintessential annual report, in which the vehicle is perfectly married to the topic.

For years, annual reports have reflected the definitive corporate style. Dressed up in dark blue and muted gray designs with a crisp, white layout accented with power red—this is the corporate wardrobe for annual report design. Or it was.

Conservative design is still in style, but now it sports an edge. Dashes of brilliant color other than red, avant-garde illustration, conceptual photography, and candid shots of people, some even wearing khakis in lieu of a suit, now spice the annual reports of traditionally corporate institutions.

Many rules of corporate style are being rewritten, while others are being broken entirely. We now seek to describe companies by asking, "What is their corporate culture?" The answers are diverse and surprisingly revealing, companies range from altruistic and aggressive to those simply described as having a "Dockers mentality," where every day looks like casual Friday.

All of which leads one to wonder, "What is corporate style?"

Peruse this diverse collection of annual reports and you may find some surprising answers.

"INCREASINGLY, WE'RE SEEING COMPANIES GET MUCH BOLDER WITH THEIR ANNUAL REPORT COVERS TO GET THAT FIRST REACTION. I THINK THIS TRANSITION TO MORE DARING COVER DESIGNS HAS TO DO WITH THE NEED TO STAND OUT AMID ALL THE CONSOLIDATIONS. DIFFERENT DIRECTION FROM THE NEW MANAGEMENT TEAMS THAT RESULT AND YOUNGER MANAGEMENT ARE ALSO HAVING AN INFLUENCE. THEY REALIZE THE IMPORTANCE OF SHOWING THE COMPANY'S STRENGTH, TECHNOLOGY, AND INTERNAL MANAGEMENT."—JESSE WILLIAMSON, PRESIDENT AND CHIEF OPERATING OFFICER, WILLIAMSON PRINTING CORPORATION

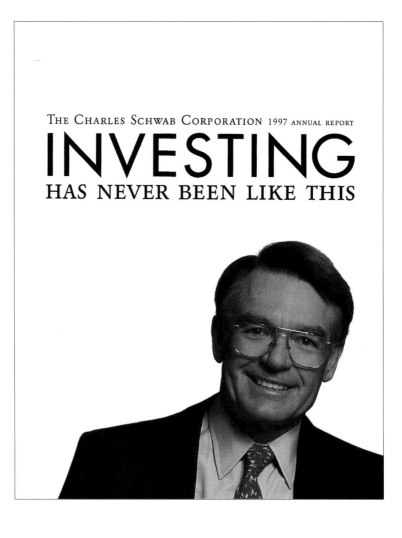

THE CHARLES SCHWAB CORPORATION 1997 ANNUAL REPORT

INVESTING
HAS NEVER BEEN LIKE THIS

The Charles Schwab Corporation Annual Report

IF CHARLES SCHWAB'S GOAL IS TO MAKE THEMSELVES ACCESSIBLE TO THEIR CUSTOMERS, THEY SUCCEEDED WITH THIS ANNUAL REPORT, WHICH IS PERSONABLE, FRIENDLY, AND APPROACHABLE FOR CUSTOMERS AND SHAREHOLDERS ALIKE.

For many, investing can be more than a little intimidating. Charles Schwab's mission is to change that. They want to make investing easy and accessible to the widest variety of people.

The Leonhardt Group's goal was to translate this warm, user-friendly feel to ink on paper. To do so, they modeled much of what you see in the annual report on the company's personality and that of the founder himself—approachable, friendly, objective, and high-tech-oriented.

Tight Copy
The copy, as much as the graphics, play up this point. Bold combination serif and sans serif headlines grab your attention and the key points leap from the page—so even if you are skimming, you get the point.

The headlines are longer than usual, and the quotes from satisfied users tell us what is good about Schwab from personal experience.

Up Close and Personal
The personal angle is enhanced by the design of the report. Reflecting Schwab's goal, the layout is uncluttered and the open white space makes the copy and photos seem downright accessible. The satisfied customers (even they appear likable) seem to have been photographed in mid-conversation—with the reader.

According to The Leonhardt Group, "The 1997 annual, through its messages of 'technology, change, and innovation,' positions the company as an investment catalyst—an entity with endurance and strength that is helping people become better investors."

It also goes far in simplifying the perception of the whole investment process.

CLIENT
The Charles Schwab
Corporation
DESIGN FIRM
The Leonhardt Group
DESIGNER
Renee Sullivan
PHOTOGRAPHER
Thomas Heiner Studio
COPYWRITER
Elaine Floyd
PRINTER
Grossberg Tyler Color
Graphics

PAPER STOCK
Mead Signature Satin
110# cover and 100# text
PRINTING
6 over 6
SIZE
8 ½" x 11" (22 cm x 28 cm),
34 pages
FONTS
Berthold Garamond,
Berthold Garamond Expert,
Futura, Helvetica,
ITC Garamond Condensed,
Mrs. Eaves, Times New
Roman
PRINT RUN
105,000
HARDWARE
Macintosh
SOFTWARE
Quark XPress 4.0

"WE ARE ABOUT TO CHANGE THE FACE OF INVESTING AGAIN. WHAT OUR INDUSTRY WOULD CONSIDER REVOLUTION IS SIMPLY EVOLUTION AT SCHWAB."

[personal, individual, easy, convenient]

"WE CATER TO THE CUSTOMER WHO WANTS TO DO IT ALL: ONLINE INVESTING, TELEPHONE INVESTING, OR WALKING INTO A BRANCH OFFICE. WE CALL THAT TOTAL CUSTOMER ACCESS. IT'S WHAT SCHWAB IS ALL ABOUT."

CHARLES SPENCER, Team Manager, Indianapolis Service Center

"Our customers are busy. They want to REACH US ANYTIME, ANYWHERE, using their telephone or PC. They also want to be able to walk into a local branch and talk to someone who can help."

"After 500 miles on the road, I want everything at my fingertips, just a keystroke or phone call away."

Investing is different today. People are different today. Some people like to punch trades into a telephone or computer and follow their investments online. Others want to sit down in an office with an investment specialist who can help them make decisions. Some people rely on the telephone, doing business with us in English, Spanish or Chinese. Others speak the universal language of stock symbols or use telephone touch tones. Some people do their investing early, before they go to work in the morning. Others do it late, before they go to bed at night.

In the old days – before technology – brokers were the gatekeepers to investing. Customers had to call their brokers during regular business hours if they wanted to complete a transaction. Today – at Schwab – people and technology are redefining investing. Customers can enter orders at any time of the day or night. They can use whatever medium they want – regular telephone, automated or speech-recognition telephone service, computer or face-to-face with a person – and always be assured of quick, responsive service.

And because the same customer may use more than one method of investing over the course of his or her relationship with us – online trading for routine orders and a branch visit for an IRA rollover, for example – we recently gave all of our customers access to low-priced Web trading while continuing to provide the human touch to anyone who calls or walks into a branch. We call it the best of both worlds. Online, investors can get innovative services like the Asset Allocation Toolkit™ and Market Buzz™. In the branches, they can get "Help and Advice the Schwab Way" from an investment specialist who's responsive to their needs. The ultimate goal? Service that is superior in value to what either the computer-only or full-commission brokers can offer.

BILL GANNAWAY, Registered Representative, Orlando Service Center

"Because WE SERVE ALL TYPES OF INVESTORS – beginners, active traders, affluent individuals – customers can stay with us as their investing needs change over the years."

"I sometimes work 18 days straight. Schwab keeps my investing simple."

ANNE MCINTYRE, Columbia River Boat Pilot, Portland, Oregon

[value, power, service, innovation]

"AT SCHWAB, INVESTORS CAN GET A FULL RANGE OF INVESTMENT CHOICES. STOCKS, BONDS, MUTUAL FUNDS, IRAS, CUSTODIAL AND TRUST ACCOUNTS CAN ALL BE HELD UNDER ONE ROOF."

The world of investing is complex enough. People shouldn't have to go to different places for different investments and then keep track of multiple statements for each account type. Instead, they should be able to have one relationship with a single brokerage firm, invest in pretty much anything they want, and have all the assets appear on one statement. And if they want to have different account types – one for retirement, another for college savings, for example – they shouldn't have to go to different financial institutions. That's how Charles Schwab the investor originally envisioned Charles Schwab the Company. It's why Schwab customers can get a full range of investment choices and account options all in one place.

Schwab is constantly expanding its line of products and services to give people more solutions, more convenience and more value. When designing our programs, we take our cues from customers. This is in direct contrast to the traditional way investments have been created, often more to the enrichment of the product sponsor than to the investor. Our decision to offer life insurance and a variable annuity, for example, was guided by our concerns with the high and sometimes hidden fees in traditional insurance and annuity vehicles.

Our Mutual Fund OneSource™ program is still revolutionizing investing. Why should people deal with multiple fund families and multiple account statements when they can buy and sell any of 825 mutual funds with a single phone call and no fee? And with our Schwab index funds and Schwab OneSource™ Portfolios, investors have even simpler ways to achieve their financial goals. Other initiatives, like offering shares of selected IPOs (initial public offerings), may not cater a revolution, but they do give our customers more choices. In addition to stocks and mutual funds, Schwab customers can buy and sell U.S. Treasury securities (at auction and in the secondary market), listed corporate bonds and other fixed-income securities, as well as options.

When it comes to services, we've come a long way from our no-frills beginning as one of America's first discount brokers. Services such as 24-hour, toll-free access, automated quotation service and dedicated investment specialists for active traders appeal to a wide range of investors. Such highly specialized services as Charles Schwab Priority Gold™ for more affluent investors and Web-based research and information for more independent investors prove Schwab's ability to pinpoint the needs of different types of investors and respond with innovative service offerings.

THE CHARLES SCHWAB CORPORATION 11

International Finance Corporation Annual Report

THE LOGISTICS OF CREATING AN ANNUAL REPORT TO PLAY EQUALLY WELL IN FIVE LANGUAGES IS A MAMMOTH UNDERTAKING. DESIGNING IT TO VISUALLY COMMUNICATE AS EFFECTIVELY TO PEOPLE IN THE UNITED STATES, FRANCE, EGYPT, AND ELSEWHERE AROUND THE GLOBE IS ANOTHER CHALLENGE ALTOGETHER.

International Finance Corporation (IFC) is a multilateral organization whose multicultural board of directors oversees its annual report—whose audience is also multicultural.

The report was to be published in English, French, Spanish, Chinese, and Arabic. With so many audiences to consider, how do you coordinate the effort, let alone ensure the message is communicated properly?

Simplifying the Logistics

Grafik Communications managed a seemingly overwhelming design task by breaking the project into smaller parts.

The English version was used as the template for all the annual reports. Special consideration had to be given to the French and Spanish texts because they ran 10 to 20 percent longer than the English. "Our plan was to flow the translated text into the English mechanicals with minimal customization," said Lynn Umemoto, one of several designers on the team.

The Best-Laid Plans...

"The production schedule required working on all three books simultaneously. Late English changes had to be passed on to the translators and incorporated into their versions while we were in pages," Umemoto explained.

But the translations were not the only hurdle in this large report, totaling more than 150 pages. Finding the right visuals to work with every version was another challenge. IFC had never commissioned illustration before, but it was deemed the best way to unify a collection of photos donated by client companies and staff.

"The photos, while all of documentary value, needed a visually unifying element to set the stage and carry the reader forward. New York illustrator Phillippe Lardy produced the amazing illustration that captured the breadth of IFC's reach. We gave him a long wish list, not expecting that he would be able to include all these facets of IFC's activities into one piece—but he did."

CLIENT
International Finance
Corporation

DESIGN FIRM
Grafik Communications

DESIGNERS
Gregg Galviano, Judy
Kirpich, Michelle Mar,
Lynn Umemoto

PRODUCTION
Regino Esposito,
Heath Dwiggins

ILLUSTRATOR
Philippe Lardy

PHOTOGRAPHERS
Gregg Galviano, Judy
Kirpich, Michelle Mar,
Lynn Umemoto

COPYWRITER
Sally Gelston, project
manager and editor,
International Finance
Corporation

PRINTER
S & S Graphics (English,
French, and Spanish
versions)

PAPER STOCK
Strathmore Bright White
Wove 110# cover, Vintage
Velvet 80# text,
Environment Wove Tortilla
80# text

PRINTING
6 over 6; 2 over 2

SIZE
8 ⅜" x 10 ¾"
(21 cm x 27 cm), 152 pages

FONTS
Minion, Syntax

PRINT RUN
42,000 English, 7,000
Spanish, 5,000 French,
3,500 Chinese (printed
in Beijing), 2,000 Arabic
(printed in Cairo)

HARDWARE
Macintosh

SOFTWARE
Quark XPress 3.3,
Adobe Illustrator

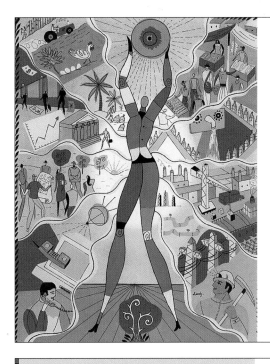

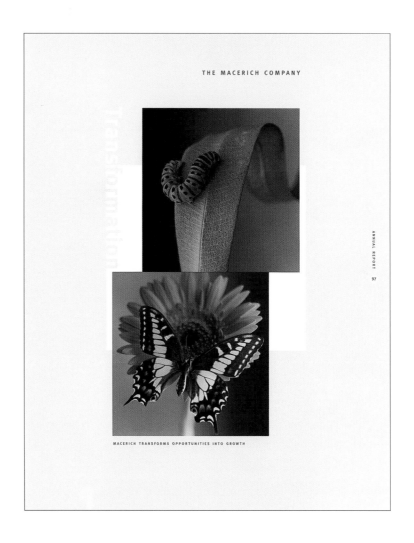

The Macerich Company Annual Report

ANNUAL REPORTS FOR SHOPPING MALL MANAGEMENT COMPANIES TEND TO LEAN TOWARD RETAIL AND CONSUMER-ORIENTED GRAPHICS, BUT THE MACERICH COMPANY WANTED TO AVOID A TRADITIONAL LOOK.

The Macerich Company owns and operates shopping malls, but despite its retail orientation, it did not want to present traditional retail graphics in its report—no images of shoppers, malls, or shopping bags.

Photographing Intrinsic Value

Some ideas are tough to show graphically; intrinsic value is one of them. But that is exactly what The Macerich Company asked Kim Baer Design Associates to do. They wanted the report to capture the company's ability to transform retail centers with intrinsic value into properties of greater worth.

The design solution was to photograph objects with intrinsic value and pair them with objects of greater value to show how one entity can be transformed into the other.

The Transformation

The message of transformation is integral to the report. The cover photos establish the theme with extreme close-ups of the evolutionary duo of a caterpillar and a butterfly. Inside, photographs draw parallels between The Macerich Company and how a piece of carbon yields a diamond and prized grapes are turned into fine wine.

The photography is exquisite, and, according to Kim Baer Design Associates, "helped to reposition the company in a competitive field, framing them as a company with style and sophistication."

CLIENT
The Macerich Company
DESIGN FIRM
Kim Baer Design Associates
DESIGNER
Maggie Van Oppen
ART DIRECTOR
Kim Baer
PHOTOGRAPHER
Mark Laita
COPYWRITERS
Art Coppola,
Michael Lejeune
PRINTER
Donahue Printing

PAPER STOCK
Potlatch McCoy Gloss
100# cover and book,
Fox River Evergreen Vellum
Birch 70# text
PRINTING
cover
8 over 3 (4-color process,
2 PMS, and gloss varnish
over 2 PMS and black);
text
8 over 8 (4-color process,
2 PMS, and dull varnish
over 2 PMS and black);
financials
2 over 2 (1 PMS and black)
SIZE
8 ½" x 11"
(22 cm x 28 cm), 32 pages
FONTS
Meta, Garamond
PRINT RUN
10,000
HARDWARE
Macintosh
SOFTWARE
Quark XPress 4.0

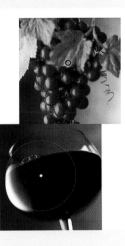

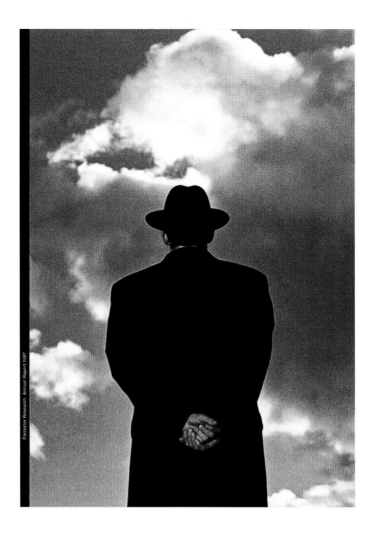

Forrester Research Annual Report 1997

Forrester Research Annual Report

FORRESTER RESEARCH TOOK A DRAMATIC DEPARTURE FROM CONVENTION IN ITS 1997 ANNUAL REPORT AND GENERATED SO MANY RESPONSES THAT THE ANNUAL REPORT ACTUALLY SPUN OFF A FOLLOW-UP PROMOTION.

Forrester Research wanted to show that the company differs from the competitive norm. This message is communicated on the cover, where the mysterious figure of a man is looking toward the heavens as if searching for answers. "Forrester Research is in the business of forecasting technology change, so the black-and-white cover image is a very poetic way to convey this point," said Brian Rogers of the Foster Design Group.

Exclamations Instead of Explanations

Once inside the annual—wow!—bright color and succinct single-word exclamations drive home Forrester's message—without long, drawn-out, copy-intensive explanations.

Each single-word header is coupled with a matching image. All are fun, some are curious, and all are memorable.

So High-Impact, It Generated a Spin-Off

Annual reports are typically one-time deals, and, unfortunately, no matter how well constructed and designed they are, once disseminated they are all too quickly forgotten. Not so with Forrester.

The image of the rubber mother duck with her ducklings in tow that illustrates the concept of "Lead!" was so memorable it prompted a follow-up promotion.

"After the book was distributed, response to the 'Lead!' image was so keen that the marketing team silk-screened the Forrester logo on a few hundred bath duckies to hand out as promotional items at events. It's always nice to drive home corporate branding under the guise of fun," added Rogers.

When an annual report works this well, all one can say is, "Wow!"

CLIENT
Forrester Research, Inc.
DESIGN FIRM
Foster Design Group
DESIGNER
Kelli Walton
ART DIRECTOR
Edwin Foster
PHOTOGRAPHERS
Various
COPYWRITER
Jim Montgomery
PRINTER
Keyprint

PAPER STOCK
Mega Dull 100# cover and
text, Roland Motif White
Screen 80# text
PRINTING
cover and text
4-color process, 1 PMS,
and spot gloss varnish;
financials
black and 1 PMS
SIZE
8 ¼" x 11 ¾"
(20.5 cm x 30 cm),
34 pages
FONTS
Helvetica, Orator,
Adobe Garamond
PRINT RUN
7,500
HARDWARE
Macintosh
SOFTWARE
Adobe Pagemaker,
Adobe Photoshop

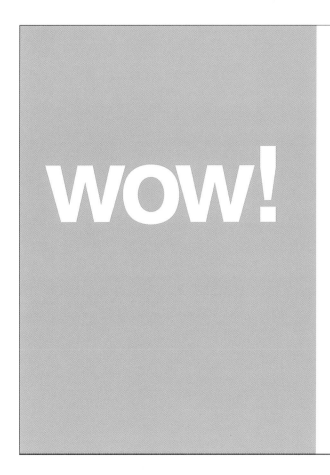

TECHNOLOGY CHANGES EVERYTHING.

Technology these days is everybody's business. The Internet, network computing, telecommunications, software, interactive media — they've all become essential strategic tools in an exploding new economy. And every new use of new technology seems to hatch a dozen more.

Forrester plays right in the center of this $600 billion big bang, where technology and business meet. We have a unique mission: to bring focus to this commotion, to look beyond the technology and offer insight on how it's going to change business, consumers, and society.

From our own business perspective, the faster things change, the better we like it. As our 1997 performance demonstrates:

FINANCIAL HIGHLIGHTS
(In thousands, except statistical and per share data)

YEAR ENDED DECEMBER 31.	1995	1996	1997
Revenues	$14,589	$24,963	$40,421
Operating income	$ 1,784	$ 4,082	$ 6,766
Net income (1)	$ 1,288	$ 2,806	$ 5,598
Basic net income per common share (1)	$ 0.21	$ 0.45	$ 0.67
Diluted net income per common share (1)	$ 0.21	$ 0.44	$ 0.63

DECEMBER 31.	1995	1996	1997
Stockholders' equity	$ 2,047	$33,762	$40,505
Deferred revenue	$11,359	$17,816	$27,074
Agreement value (2)	$17,818	$30,034	$46,582
Client companies (3)	799	885	1,029

(1) Pro forma to give effect to income tax adjustments that would have been made had the Company been taxed throughout 1995 and 1996 as a C corporation.
(2) Agreement value, as measured by the Company, represents the annualized fees payable under all core research and advisory service contracts in effect at a given point in time, without regard to the remaining duration of such contracts.
(3) Client companies represents the total number of companies with which Forrester conducts business at a given point in time. Forrester may provide multiple services to more than one business unit of the client company.

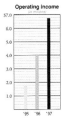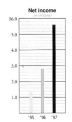

WOW!

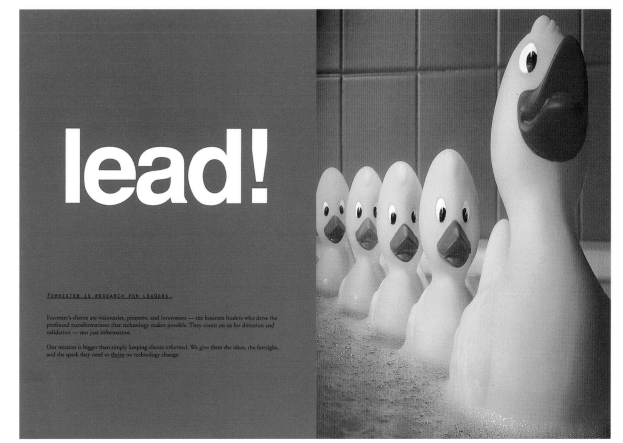

lead!

FORRESTER IS RESEARCH FOR LEADERS.

Forrester's clients are visionaries, pioneers, and innovators — the business leaders who drive the profound transformations that technology makes possible. They count on us for direction and validation — not just information.

Our mission is bigger than simply keeping clients informed. We give them the ideas, the foresight, and the spark they need to thrive on technology change.

zoom!

Fast response, fast study, fast thinking. Forrester is a place where curiosity is raised to a high art. It's a place where strong opinions are highly valued, along with the ability to express them persuasively in 25 words or less.

As a group, we like nothing better than to tear into a problem — the more complex the better — to get at the underlying kernel of significance. Our analysts call it the "so what?" test.

And the answer to that "so what?" is the heart of Forrester's research. New, powerful ideas that our clients use to increase market share, decrease costs, and accelerate revenue.

see!

LOOKING AND SEEING ARE TWO DIFFERENT THINGS.

When a single technology bet is the difference between winning and not even getting in the game, business leaders need to look beyond traditional research. Organizations that simply keep current with technology may not be seeing the entire picture.

To succeed in this no-excuses arena, you need to know what's out in front of the leading edge. What's coming next, beyond that, and where it's going to take you. You have to understand what it means to your organization and what you should be doing about it.

"TECHNOLOGY IS NOT JUST
CHANGING THE WAY CONSUMERS
SPEND TIME. IT'S ALSO
CHANGING THE WAY NEARLY EVERY
COMPANY IS MAKING, SELLING AND
DELIVERING PRODUCTS. WE'VE
GOT TO UNDERSTAND THAT."
— GIL FUCHSBERG,
CORPORATE DIRECTOR,
NEW MEDIA TECHNOLOGY,
INTERPUBLIC GROUP.

hey!

FORRESTER TAKES A STAND.

In focused, finely honed research and high-profile events, Forrester delivers unequivocal answers to vital questions about how emerging technologies are going to change the way we all do business. Yes or no. Black or white.

You might agree or disagree with our analysis and conclusions. You might or might not believe our predictions. But one thing we do guarantee: You will always know where Forrester stands.

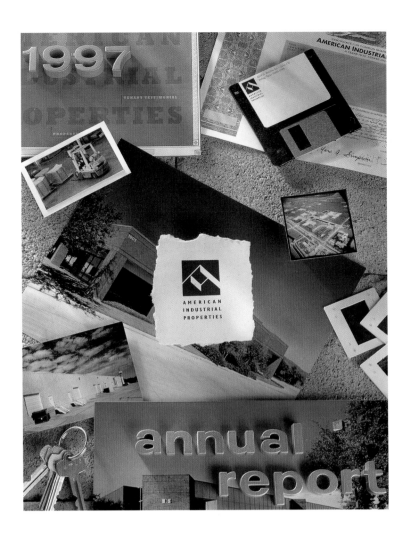

American Industrial Properties Annual Report

AMERICAN INDUSTRIAL PROPERTIES' BUSINESS CENTERS ON LIGHT INDUSTRIAL WAREHOUSES—NOT AN APPEALING GRAPHIC FOR DESIGN. HOW, THEN, COULD NEWMAN FOLEY ENLIVEN THEIR CLIENT'S FIRST ANNUAL REPORT?

According to Jim Foley, American Industrial Properties (AIP) had recently emerged from a few years of struggle and was primed to issue their first report. Newman Foley had created a new logo and marketing materials that they could use for graphic appeal, but the overriding dilemma remained: How do you make virtually identical warehouse properties, the key to the company's future, visually compelling?

Using a Collage for Special Effect

The solution was found in a collage, featuring a variety of properties on a small scale and displaying all the new graphics and activities.

"Glenn Hadsall, senior designer, came up with the collage concept to enhance the look and feel of the property photos, to show that many things were coming together, and to continue branding the look and feel of the logo," said Foley. "The collage pulls together the many aspects of each section of the annual report, just like AIP provides many opportunities in the light industrial market."

Creating an Industrial Feel

The collage approach provided a creative freedom that allowed Newman Foley to show vigorous activity on their client's behalf—a level that could not have been communicated as well in single, warehouse shots.

The technique worked graphically as well. Snapshots, objects, and even the client's new Web site and letterhead system were photographed on a concrete background for a gritty industrial feel. Bold metal lettering, which looks like alphabet paperweights, enhances the look.

Each of five separate collages required considerable time to compile. "We photographed the properties and then created the collages with Dallas photographer Peter Lacker. We propped up the images and cast light across each of them for a dramatic feel," said Foley.

CLIENT
American Industrial
Properties
DESIGN FIRM
Newman Foley Limited
DESIGNER
Glenn Hadsall
ART DIRECTOR
Jim Foley
PHOTOGRAPHER
Peter Lacker
COPYWRITER
Halcyon Associates
PRINTER
Williamson Printing
Corporation

PAPER STOCK
Paralux Cur 92.5# cover,
Paralux 100# book, Classic
Crest 70# text
PRINTING
6 over 6;
financials
2 over 2
SIZE
8 ½" x 11"
(22 cm x 28 cm),
44 pages
FONTS
Gill Sans, Goudy
PRINT RUN
25,000
HARDWARE
Macintosh
SOFTWARE
Quark XPress 3.3, Adobe
Illustrator, Adobe Photoshop

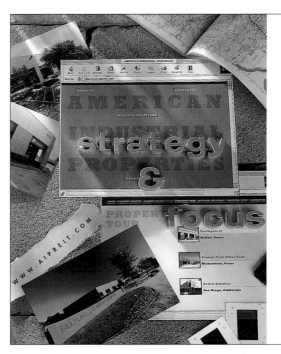

Central Park Office Tech — Richardson, Texas

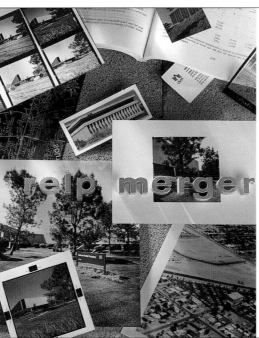

Kodak Building San Diego, California

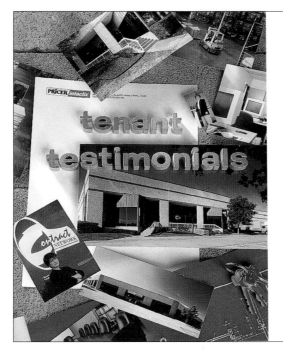

Northgate II — Dallas, Texas, and Gateway Business Center — Irving, Texas

The Chicago Board of Trade Annual Report

THE CHICAGO BOARD OF TRADE (CBOT), THE WORLD'S LARGEST FUTURES TRADING EXCHANGE, IS RENOWNED FOR ITS ANNUAL REPORTS. THIRST HAS DESIGNED ITS REPORT THREE TIMES NOW, AND EVERY YEAR THE RESULT IS RECOGNIZED BY THE INDUSTRY AS AMONG THE BEST. CAN THE 1998 ANNUAL REPORT LIVE UP TO EXPECTATIONS?

While the Chicago Board of Trade's annual reports are familiar in the graphic design community because of their award-winning designs, they are actually disseminated to a very limited audience, namely shareholders, the financial press, and members of the U.S. House and Senate.

A Reflection of Its Readers

However, the 1998 report makes use of an attention-getting cover precisely because of this narrow audience focus. "The seven-mil Mylar is debossed and used to reinforce the message of membership. What you see is who the CBOT is made of," said Thirst designer Rick Valienti.

The book provides a plethora of sensory images, beginning with the reader's face beaming back from the cover. But hold the report in your right hand, and immediately your thumb finds the octagonal die-cut in the back cover. Handy? Yes. Different? Absolutely.

Next, the reader notices the weighty feel of the book itself and that most pages are french-folded. "Budget dictated that we print and photograph less than the last two years, but

perception said we needed to make the book feel as substantial. Uncoated paper, french-folded, seemed to do the trick," said Valienti.

Photos in Motion

Finally, the reader notices the photography. There is no evidence of budget restrictions here. The photos are action-oriented, a look Valienti achieved by photographing individuals separately in a conference room with a hard light on the subject in the foreground, while the subject's colleagues performed mock trading, lit with two lights, in the background.

Many of the photos are designed to be transparent, which gives a feeling of motion, and are layered over other images. "This technique created an expression of the fluid nature found in the CBOT floor's open outcry trading method," Valienti explained.

But that's not all. The board member photo gallery, printed as duotones with a 200-line screen, is equally remarkable.

Has the 1998 *Chicago Board of Trade Annual Report* lived up to expectations? You be the judge.

CLIENT
The Chicago Board of Trade
DESIGN FIRM
Thirst
DESIGNERS
Rick Valienti, chester
ILLUSTRATOR
chester
PHOTOGRAPHER
Wm. Valienti
COPYWRITER
Barbara Kodlubanski
PRINTER
Graphic Arts Studio

PAPER STOCK
Silver Mirrored Mylar 7 mil,
Gilbert Oxford Black 100#
cover, Pure White Gilbert
Realm 80# text, Gilbert
Gilclear 17#, Mead
Signature Dull 100# text,
Mead Signature Gloss
100# text
PRINTING
cover
debossed, die-cut;
intro pages
4-color process, 1 PMS, and
tinted, matte varnish;
message to the membership
2 colors, matte varnish;
board member photo sec-
tion and committee section
2 colors with matte varnish,
die-cut, 2-color offset
SIZE
8" x 12" (20 cm x 30 cm),
56 pages
FONTS
Din, Grionik
PRINT RUN
7,000
HARDWARE
Macintosh
SOFTWARE
Quark XPress, Adobe
Photoshop, Macromedia
FreeHand

YOU, THE MEMBERS, reaffirm every day what the world has known for more than 150 years — that Chicago Board of Trade members are serious about their business and they will take the necessary risk to compete. And they will always be...

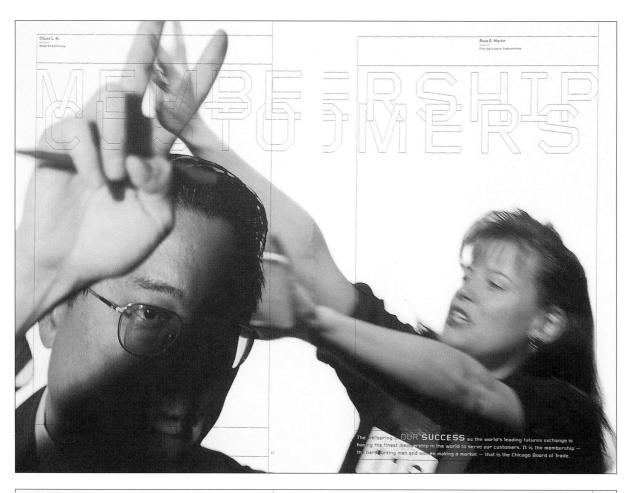

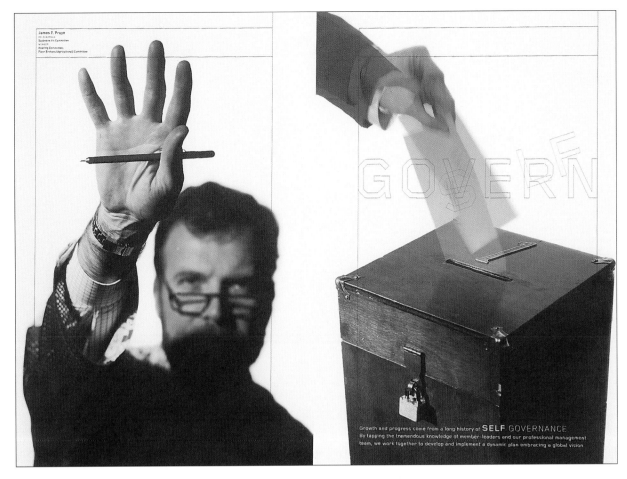

James P. Pruyn
CO-CHAIRMAN
Soybeans Pit Committee
MEMBER
Hearing Committee,
Floor Brokers (Agricultural) Committee

Growth and progress come from a long history of **SELF** GOVERNANCE.
By tapping the tremendous knowledge of member-leaders and our professional management
team, we work together to develop and implement a dynamic plan embracing a global vision.

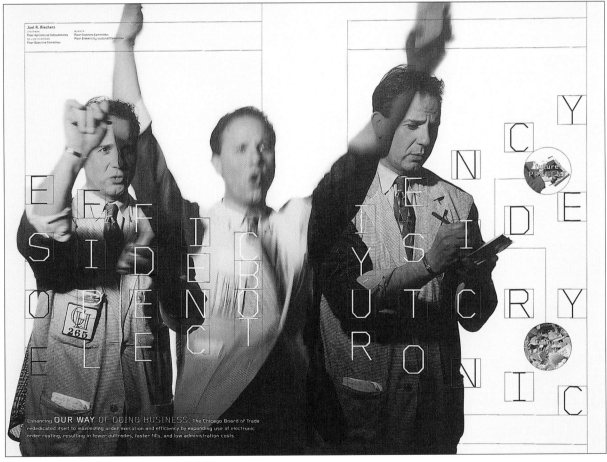

Joel R. Riechers
CHAIRMAN
Floor Agricultural Subcommittee
CO-VICE CHAIRMAN
Floor Executive Committee
MEMBER
Floor Governors Committee,
Floor Brokers (Agricultural) Committee

Enhancing **OUR WAY** OF DOING BUSINESS. The Chicago Board of Trade
rededicated itself to maximizing order execution and efficiency by expanding use of electronic
order routing, resulting in fewer outtrades, faster fills, and low administration costs.

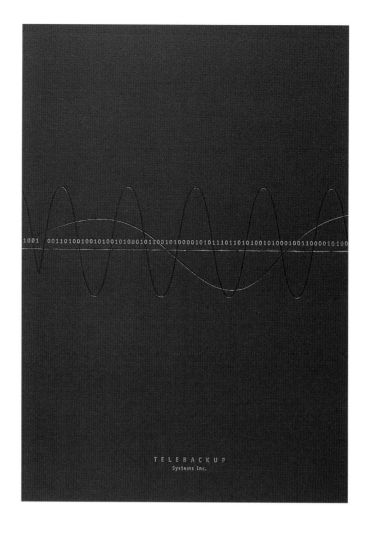

TeleBackup Systems, Inc. Annual Report

TELEBACKUP SYSTEMS TAKES A STRAIGHTFORWARD APPROACH IN ITS 1997 ANNUAL REPORT, NOTEWORTHY FOR ITS STRIKING ILLUSTRATIONS AND ORGANIZED PRESENTATION FRAMEWORK.

Judging from the cover, we can tell this annual report is both special and concise. Two-color foil stamping makes it special. Simple, yet memorable graphics that represent information passed via sound waves and telephone lines to an off-site backup system make it concise.

Direct and to the Point

The cover gives the recipient immediate insight into Tele-Backup Systems, a leader in data retrieval technology, which is making the transition from a research and development focus to a marketing orientation. This changeover is exemplified by the headline that greets readers on the first page: "We are the technology leader, striving to be the market leader."

This refreshingly direct approach is carried throughout the report, even to the simple section headers titled: The Need, The Product, The Potential, and The Company.

Illustration versus Photography

The companies responsible for today's ever-changing, technology-driven world have little to photograph of their efforts. Consequently, they turn to conceptual photography or illustration.

TeleBackup Systems faced the same dilemma, but the resolution came easily. The resulting illustrations are not only innovative, composed of a montage of objects, but they are also "techy" in appearance. They offer up a dash of humor, too. Who wouldn't fear an animated bomb suddenly appearing on the monitor in the middle of an important project? The recurring image of a lifesaver is a not-too-subtle reminder to back up.

CLIENT
TeleBackup Systems, Inc.
DESIGN FIRM
Parallel
DESIGNER/ART DIRECTOR
Therese Miller
ILLUSTRATOR
Mike Grant
COPYWRITER
Bill Hart
PRINTER
Unicom

PAPER STOCK
Pegasus Vellum Midnight
Black 80# cover, Potlatch
Mountie Matte 100# text
PRINTING
cover
black gloss foil 16" x 3"
(41 cm x 8 cm) and gray foil
7" x ¼" (18 cm x .5 cm);
text
4-color process plus 2 PMS
and spot matte varnish
SIZE
8 ½" x 11"
(22 cm x 28 cm),
28 pages
FONT
Officina
PRINT RUN
1,500
HARDWARE
Macintosh
SOFTWARE
Quark XPress 3.32, Adobe
Illustrator 6.0

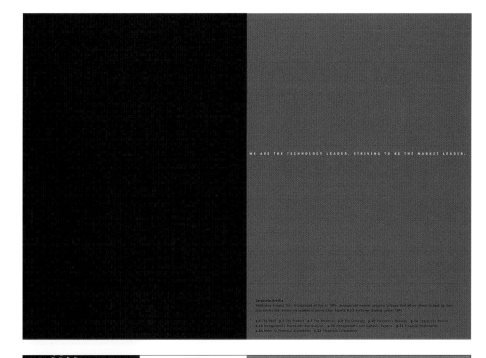

Fransabank Annual Report

CORPORATIONS, SHAREHOLDERS, CONSUMERS, AND DESIGNERS ARE SO ACCUSTOMED TO COLOR THAT WE EXPECT IT AND TAKE IT FOR GRANTED, FORGETTING THAT ONE-COLOR MATERIALS CAN BE JUST AS EFFECTIVE AT COMMUNICATING A MESSAGE.

Simplicity is at the core of this annual report for France's Fransabank. For years, the bank has kept the same one-color format and the same layout for its annual report. It must be working.

Efficient, Purposeful Communication
The construction and layout are always the same: a 38 ¾" x 11" (99 cm x 28 cm) sheet printed both sides in one-color and for-matted into eight fold-out panels. The copy and the ink color change annually, but the clean layout and succinct, no-frills presentation remain consistent.

And, why not? The report tells shareholders, employees, and the market at large all they need to know. The information couldn't be easier to find and scan.

This report exemplifies the maxim that no design exists solely for the sake of design.

One-Color Annual Reports Do Work
The client dictate was, "Be clean. Be efficient," said Didier Saco.

This annual report meets and exceeds its goal. It does not need graphics and photography to sustain reader interest over many pages; it gets in, communicates its message, and gets out.

CLIENT
Fransabank
DESIGN FIRM
Saco Design Graphique
DESIGNER/ART DIRECTOR
Didier Saco

PAPER STOCK
Job Matte 250 g
PRINTING
1 color
SIZE
7 ¾" x 11"
(20 cm x 28 cm), 8 panels
plus cover
FONT
Caslon

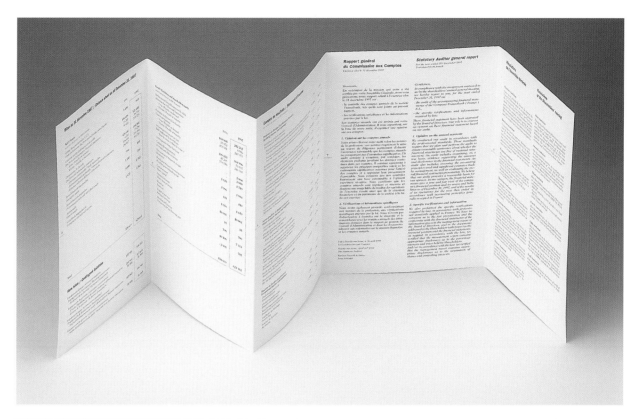

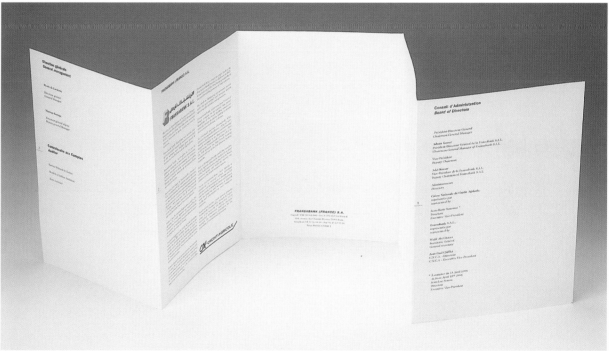

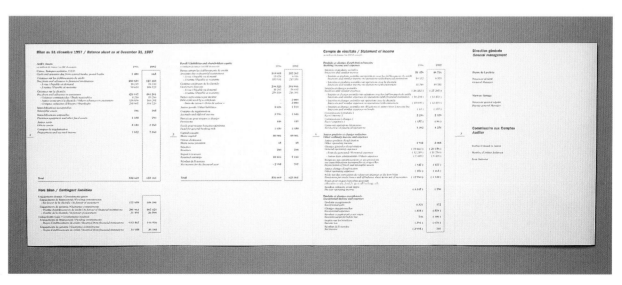

GESCHÄFTSBERICHT 1998

Baden-Württembergische Bank AG

Baden-Württembergische Bank AG Annual Report

THE BADEN-WÜRTTEMBERGISCHE BANK CATERS TO AN EXCLUSIVE CLIENTELE. ITS ANNUAL REPORT IS DESIGNED TO BE EQUALLY UPSCALE.

Simplicity, refinement, and tradition are key to the layout of this 1998 annual report; they define the image the Baden-Württembergische Bank projects to a wealthy group of private investors.

Building on a Thematic Graphic

Past years' reports used visuals depicting shares and historical documents. In 1998, the theme chosen was among the hottest topics in Europe, not just within financial circles, but with every citizen—the Euro.

Images of the Euro are woven graphically throughout the report, beginning with the cover, which is conservative, yet elegant in its choice of typeface and unadorned simplicity.

The design is enlivened with full-page photography, small sidebar graphics, and screens that dress up the pages without detracting from the readability of the copy.

The tight layout of the report, featuring a two-column format with plenty of leading, projects refinement.

Interestingly, many pages are totally free of graphics and color. When those elements do appear, their impact on the reader is magnified because they are used so sparingly.

CLIENT
Baden-Württembergische
Bank AG
DESIGN FIRM
RTS Rieger Team
ART DIRECTOR
Colette Baeker
PHOTOGRAPHER
Peer Oliver Brecht
COPYWRITER
Baden-Württembergische
Bank AG
PRINTER
Druckerei Kohlhammer

PAPER STOCK
Scheufelen Phoenix Motion
Xantur 250 g and 135 g
PRINTING
cover
5 colors;
text
4 colors
SIZE
8 ¼" x 11 ¾"
(20.5 cm x 30 cm),
90 pages
FONT
Times
PRINT RUN
14,000 German,
3,000 English
HARDWARE
Macintosh
SOFTWARE
Quark XPress 3.32

BERICHT DES VORSTANDS

Wirtschaftslage

Turbulenzen an den Kapitalmärkten belasten Weltwirtschaft

Die Auswirkungen der weltweiten Finanzkrisen haben die Weltwirtschaft im Laufe des vergangenen Jahres immer stärker belastet. In der Folge hat die konjunkturelle Expansion in den Industrieländern merklich an Schwung verloren, wobei sich die Entwicklung in den einzelnen Regionen weiter gespalten hat. Während die Konjunktur in Nordamerika und in Westeuropa erneut aufwärtsgerichtet war, verschlechterte sich die Situation in Asien merklich. Ursache war vor allem die dramatische Wirtschaftskrise in Japan und in zahlreichen asiatischen Schwellenländern. Die engen Handelsverflechtungen zwischen diesen Staaten haben eine ökonomische Abwärtsspirale in der gesamten Region in Gang gesetzt.

Rußland gerät in große Finanzierungsschwierigkeiten, nachdem der Rubel unter starken Abwertungsdruck gekommen war. Die hohen Zinsen und der Zusammenbruch des Marktes für Staatsanleihen führten zu einem enormen Vertrauensverlust und schließlich zu einem massiven Abfluß von Auslandskapital. Auch mehrere lateinamerikanische Staaten wurden von den Turbulenzen an den Finanzmärkten erfaßt.

Demgegenüber hat die Konjunktur in Nordamerika nur leicht an Dynamik einge-

büßt. In den Vereinigten Staaten ist die Ausfuhr zwar merklich zurückgegangen, dies wurde aber durch einen stärkeren Anstieg der Inlandsnachfrage kompensiert. Insgesamt präsentierte sich die amerikanische Volkswirtschaft nach wie vor in guter Verfassung. Die Geschäftigung nahm – wenngleich verlangsamt – weiter zu.

In Europa konnte die Konjunktur auf nun breiterer Basis moderat zulegen. Auch hier wird die wirtschaftliche Aktivität verstärkt von der Binnennachfrage getragen. Dadurch hat sich die immer noch unbefriedigende Lage am europäischen Arbeitsmarkt zumindest leicht verbessert.

Im gesamten OECD-Raum blieb das Preisniveau im Berichtszeitraum annähernd stabil. Inflationsrisiken sind dereit nicht zu erkennen.

Wirtschaftswachstum im internationalen Vergleich (Veränderung des realen Bruttoinlandsprodukts gegenüber dem Vorjahr)

- Deutschland
- EU
- USA
- Japan

Entwicklung der Geschäftsbereiche

Privatkundengeschäft

Unsere 1997 im Markt eingeführte Neuausrichtung im Privatkundengeschäft gewann 1998 zunehmend an Kontur. Wir haben unsere Bruttoerlöse um 11 % auf 223 Mio DM steigern können. Insbesondere die Provisionserlöse legten mit 20 % überproportional zu. In diesem turbulenten Börsenjahr lagen unsere Erlöse aus Wertpapiergeschäften mit privaten Kunden deutlich über Plan. Das zu verwaltende Wertpapiervolumen konnte erfreulich ausgebaut werden. Gestiegen sind auch die Zinserlöse, schwerpunktmäßig in der Baufinanzierung.

Unsere Kundengruppenkonzepte, die wir unter den Leistungsmarken BW Privat und BW Plus abbilden, haben zwei unterschiedliche Ansätze. BW Privat verfolgt den ganzheitlichen Betreuungsansatz. Zunehmend hat diese Kundengruppe unsere Finanzplanung genutzt. Hier wird insbesondere die Gesamtvermögensanlage nach Struktur- und Risikogesichtspunkten und Rentabilität betrachtet. Zusätzlich werden der Vorsorgebereich der Kunden wie auch Nachfolgefragen (Testament/Testamentsvollstreckung) individuell analysiert.

Mit diesen Beratungsansätzen haben wir den Verkauf von Vorsorgeprodukten wie Lebensversicherungen, Investmentsparkonten und die neu in den Vertrieb aufgenommenen Altersvorsorgesondervermögen (AS-Fonds) überproportional erhöht.

Im Berichtsjahr wurden zunehmend mehr Anlagen in steuerbegünstigten Auslandsimmobilienfonds, Sanierungsobjekte Ost sowie andere Steuermodelle an unsere Kunden verkauft. Auch Angebote zur individuellen Vermögensplanung und zu Fragen der Vermögensnachfolge sind auf reges Interesse gestoßen.

Mit der Stiftung Liebenau wurde ein Kooperationsvertrag abgeschlossen. Hierdurch wird unsere Kompetenz im Kundensegment der Senioren, für die wir integrierte Versorgungsleistungen entwickelt haben, besonders hervorgehoben. Für alle Frei- und Heilberufler haben wir unsere betriebswirtschaftliche Betreuung weiter ausgebaut. So gelang die Gründung eines Kooperationsverbundes „Unternehmensübergaben" mit dem Verband Beratender Ingenieure. Neben Veranstaltungen, Seminaren und fachspezifischen Publikationen bietet dieser auch Beratung bei der Unternehmensnachfolge aus einer Hand.

BERICHT DES AUFSICHTSRATS

Der Aufsichtsrat und seine Ausschüsse nahmen im Geschäftsjahr ihre nach Gesetz und Satzung vorgeschriebenen Aufgaben wahr und haben die Geschäftsführung der Bank laufend überwacht. Die Beratungs- und Überwachungsfunktion zwischen den Plenarsitzungen des Aufsichtsrats wird vom Aufsichtsratsvorsitzenden und den Ausschüssen gewährleistet bzw. koordiniert.

In drei turnusmäßigen Sitzungen wurde das Plenum des Aufsichtsrats vom Vorstand ausführlich über die wirtschaftliche Situation der Bank und des Konzerns sowie über einzelnen Geschäftsbereiche unterrichtet. Wichtige Einzelthemen betrafen die Krise an den internationalen Finanzmärkten. In diesem Zusammenhang hat der Vorstand umfassend über die Risikosituation der Bank in den Emerging markets sowie die Effizienz der im Handelsbereich verwendeten Risikomodelle berichtet. Die Positionierung der Bank im neuen Wettbewerbsumfeld nach Einführung des EURO, die Strategie im Auslandsgeschäft und die mittelfristige Planung der Bank bildeten weitere Schwerpunkte der Erörterungen.

Der Verwaltungsausschuß bereitete jeweils die Aufsichtsratssitzungen vor.

In vier Sitzungen des Kreditausschusses wurden die zustimmungspflichtigen Kredite und die mit erhöhten Risiken behafteten Engagements besprochen. Dabei fanden die Struktur des gesamten Kreditportfolios

sowie das Risikomanagement besondere Beachtung. Der Kreditausschuß ließ sich darüber hinaus regelmäßig über das Geschäft mit derivativen Finanzinstrumenten berichten.

Der Ausschuß für Vorstandsangelegenheiten behandelte in zwei Sitzungen die Vorstandsverträge, die Nachfolgeplanung im Vorstand sowie in Zusammenarbeit mit der Württembergischen Versicherungsgruppe ein Deferred Compensation-Modell. Der Mitbestimmungsausschuß und der Sozialausschuß haben im Berichtsjahr nicht getagt.

Die Buchführung, der Jahresabschluß und der Konzernabschluß sind unter Einbeziehung des Lageberichts und des Konzernlageberichts von der durch die Hauptversammlung als Abschlußprüfer gewählten HEILBRONNER TREUHAND-GMBH, Wirtschaftsprüfungsgesellschaft, Steuerberatungsgesellschaft, Heilbronn, geprüft worden. Der uneingeschränkte Bestätigungsvermerk wurde erteilt. Der Aufsichtsrat erhielt rechtzeitig vor der Bilanzsitzung die Jahresabschlußunterlagen, den Geschäftsbericht und den Prüfungsbericht. An der Bilanzsitzung des Aufsichtsrats nahm der Wirtschaftsprüfer der Bank teilgenommen. Mit dem Ergebnis der Prüfung, das keine Beanstandungen enthält, erklärt sich der Aufsichtsrat einverstanden.

PRODUCTS

OSTENSIBLY, annual report design for product manufacturing companies seems to have an edge. At the least, a tangible product to photograph exists. Designers love the tangible. We even think and talk in such terms: A concrete idea. Written in stone. A product can be held, examined, and test-marketed. Designers are not forced to wrestle with physical illustrations of abstract services.

Conversely, the physical nature of products can work against good annual report design. If a well-designed product and its award-winning packaging become the focus, the annual report may miss its mark.

Among designers who produce an average of twenty annual reports each year, the consensus is unanimous: the intangible qualities of a company are its essence. A company's management strength, ability to attract and retain creative, dynamic personnel, talent for thinking outside of the box, corporate philosophy, and game plan for growth—these intangibles cannot be delineated on the financial pages of an annual report, but somehow they must be expressed.

But how do you communicate them visually? A product is relatively easy. Boiling down a company's personality, marketing strategy, and engineering savvy into a neat package that is relevant and interesting to its audience—that is the challenge.

Achieving a design where the tangible and intangible work in harmony isn't easy, but it can be done, as these reports demonstrate.

"WE'RE SEEING MORE TEXTURED PAPERS USED FOR ANNUAL REPORT COVERS. TACTILE SURFACES ARE VERY 'COMFORTING' TO HOLD. WHEN ILLUSTRATIONS ARE PRINTED ON THESE TEXTURED STOCKS, THEY IMPLY A FINE-ART APPROACH TO DESIGN, AND THE END PRODUCT HAS AN EXPENSIVE LOOK AND FEEL. PAPER WITH A 'HANDMADE' LOOK IS ALSO APPEALING."—ELLEN SHOOK, VICE PRESIDENT CREATIVE SERVICES, XPEDX SEAMAN-PATRICK GROUP

Earnings Per Share (diluted)

From Continuing Operations

$1.51 — 94
$1.68 — 95
$1.98 — 96
$2.23 — 97
$2.34 — 98

on HSY."

↑27.5%

Favorite product

Mounds
Acquired by Hershey
in 1988

Beringer Wine Estates Annual Report:
"Focus on Quality: A Commitment to Growth"

HOW DO YOU CONVEY BIG BUSINESS, GROWTH, AND CORPORATE MAGNITUDE SIMULTANEOUSLY WITH TIME-HONORED HERITAGE AND CRAFTSMANSHIP? THAT IS THE CHALLENGE MICHAEL PATRICK PARTNERS FACED WHEN THEY TACKLED THIS 1998 ANNUAL REPORT FOR BERINGER WINE ESTATES.

For art director Dan O'Brien, the overriding challenge of the Beringer report was communicating two distinct messages. As the longest-operating winery in California's Napa Valley, Beringer has a heritage rich in the craft of winemaking. Age, however, is not always as good for business as it is for wine. As companies grow older, they can stagnate. Not so with Beringer. Beringer Wine Estates represents big business, and its holdings total eleven wineries. Heritage and corporate growth are often at odds, but O'Brien was determined that they complement each other and communicate a cohesive message.

Blending the Old with the New

The design team decided that the choice and positioning of photography could provide the solution they were seeking. They could effectively present Beringer both as a stable, experienced company and as an innovative market leader with an aggressive growth strategy by juxtaposing new, stylized photographs with vintage shots.

Full-color photographs showing filled glasses, elegant table settings, fruits and vegetables, and glimpses of winemaking techniques are shown on selected right-hand pages, printed on Gilclear Medium and french-folded. On the reverse,

the left-hand page of the next spread, are vintage photos printed as quad-tones with artistic borders. The "tunnel of elms," a tranquil roadway on the company's property that was planted by the Beringer brothers in the late nineteenth century, is among the shots chosen to convey the winery's heritage. The timeline spread details the company's growth with sepia-tone thumbnail photos and is yet another example of how Beringer is a blend of old and new.

A Visionary Approach

According to O'Brien, whose firm produces twenty to twenty-five annual reports a year, annual reports typically require the involvement of corporate upper management, where thinking is usually visionary. This top-down scenario allows designers to push the creative limits.

"An annual report is essentially old information that has to be presented in a new and interesting fashion, said O'Brien. "The financials have to be organized, easy to read and navigate. The copy has to communicate to a broad readership, from customers and employees to shareholders and potential investors.

"Most importantly, each annual report should tell a story and have a unique vision."

CLIENT
Beringer Wine Estates
Holdings, Inc.
DESIGN FIRM
Michael Patrick Partners
DESIGNERS
Matt Sanders,
Connie Hwang
ART DIRECTOR
Dan O'Brien
PHOTOGRAPHER
Holly Stewart
COPYWRITER
Timothy Peters
PRINTER
Graphic Arts Center

PAPER STOCK
Carnival Plus Vellum 80#
cover, Classic Crest
Sawgrass Vellum 70# text,
StarWhite Archiva 100#
text, Gilclear Medium
PRINTING
cover
2 over 2, debossed;
cover label
4-color process, silver-foil
stamped;
text
6 over 6 and 2 over 2
SIZE
8 ¼" x 10 ½"
(21 cm x 27 cm),
50 pages plus cover
FONTS
Trajan, Garamond
PRINT RUN
20,000
HARDWARE
Macintosh
SOFTWARE
Quark XPress 4.0, Adobe
Illustrator 8.0

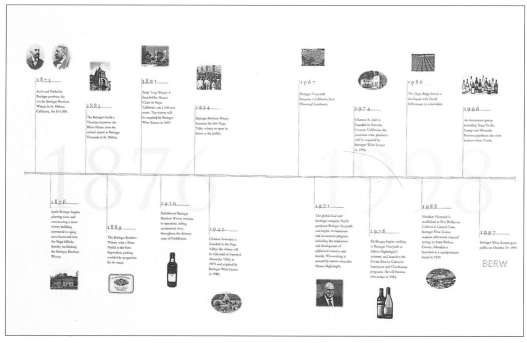

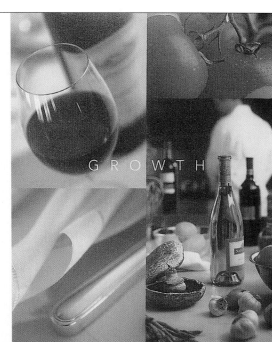

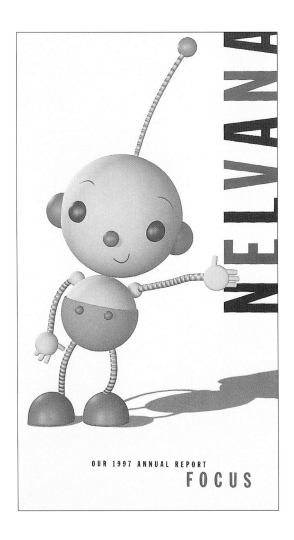

OUR 1997 ANNUAL REPORT

FOCUS

Nelvana Limited Annual Report: "Focus"

WHO SAYS ANNUAL REPORTS ARE SERIOUS BUSINESS? IN A DRAMATIC DEPARTURE FROM PREVIOUS EFFORTS, AND OTHER ANNUAL REPORTS IN GENERAL, TUDHOPE ASSOCIATES GAVE NELVANA, CANADA'S LEADING ANIMATION FILM COMPANY, A NEW IMAGE TAILOR-MADE TO ITS RENEWED FOCUS AND REVAMPED STRATEGY—AND THEY HAD FUN DOING IT.

Nelvana had recently undergone a thorough reorganization and emerged with a new focus and approach that it was eager to communicate. Its annual reports prior to 1997 did not differentiate the company from the competition or show why it was different or interesting.

A Renewed Vigor

"Our goal was to brand Nelvana as a company," said Ian Tudhope. "As always, our biggest challenge is helping a company figure out who they want to be and communicate their personality. Since Nelvana is an animation film company, the answer seemed to be obvious. The annual report was designed to be fresh, bold, and fun—a reflection of their business."

Uncoated Stock = Vibrant Color

The report was limited to four-color process throughout—cover and text pages—and production values were maximized to stay within budget. "We used a lot of color because their business is all about color and their character brands," said Tudhope. An uncoated stock was chosen for the job because

it had a tactile quality, was easy to read, and provided the vibrant color that was wanted.

What? Vibrant color from an uncoated stock? "Convincing Nelvana to use an uncoated stock was tough, but they finally agreed," said Tudhope. To achieve the dramatic color and three-dimensional effect of Donkey Kong, care was taken in the film stage to get the separations exact before going on press.

Focus on the Message

"Focus" is not just the title and overriding theme of Nelvana's 1997 annual report; it is also how Tudhope approaches annual report design.

"We help companies figure out who they are. An annual report is a key vehicle for communicating corporate brand and strategy, but these two elements are often missing. 'Who are you? What are you going to do?' These are the questions we ask and urge our clients to focus upon so that we can help them convey a clear, succinct message."

CLIENT
Nelvana Limited
DESIGN FIRM
Tudhope Associates, Inc.
DESIGNERS
Christopher Campbell,
Sonia Chow
ART DIRECTOR
Ian C. Tudhope
PHOTOGRAPHERS
Michael Mahovlich,
Lorella Zanetti
COPYWRITER
Nelvana Limited
PRINTER
Arthurs-Jones, Inc.

PAPER STOCK
Monadnock Astrolite
Smooth 100# cover
and text
PRINTING
4-color process, overall
inline varnish, and die-
crease cover fold
SIZE
6 ½" x 11 ¾"
(17 cm x 30 cm), 48 pages
plus cover
FONTS
Franklin Gothic,
Bauer Bodoni
PRINT RUN
4,500
HARDWARE
Macintosh
SOFTWARE
Quark XPress 4.04,
Adobe Illustrator 7.0,
Adobe Photoshop 4.0

p.22 NELVANA 1997 ANNUAL REPORT

« FOCUS ON ANIMATION »

NELVANA has returned to its core animation business with a renewed emphasis on producing animation of all types, for all ages, and for all markets. This expanded view of our core animation business has allowed us to pursue emerging opportunities, including 3-D, multimedia and prime time animation, and to re-enter the animated feature film business. Last year we acquired Windlight Studios, a leading 3-D animation studio, announced plans to open our own 3-D facility in Toronto and delivered our first 3-D series, *Donkey Kong Country*. We also began production of *Rolie Polie Olie*, a dynamic 3-D animated series licensed to The Disney Channel in the U.S. The series will be a flagship of Disney's Fall 1998 programming season. *Bob and Margaret*, our first series for the prime time adult animation market, began production late in the year. It has been sold to Global TV in Canada and Comedy Central in the U.S. Our Gemini Award-winning series *Stickin' Around* pushes the boundaries of multimedia computer animation. We intend to expand our capabilities in these leading edge areas to take advantage of growing markets and lower cost production techniques.

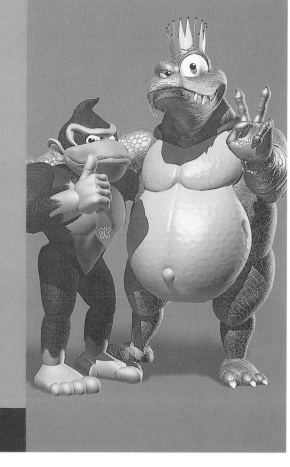

Donkey Kong Country, based on the popular Nintendo video game, was a minority co-production with MediaLab of France. The series has established NELVANA as a leader in the 3-D animation business, one of the fastest growing segments of the animation industry.

p.16 NELVANA 1997 ANNUAL REPORT

« INCREASING LICENSING AND MERCHANDISING »

NELVANA has a proven track record for identifying and acquiring licensing rights to both contemporary and classic character brands — rights we can use to develop a host of new and ancillary revenues for the Company. *Babar* and *Rupert* continued to be strong contributors to NELVANA's merchandising in 1997, reflecting the continuing worldwide interest in classic, book-based characters. During 1997, we signed a *Franklin* master toy license with Irwin Toys in Canada and a master soft toy license with Eden Toys in the U.S. Additionally, we expanded our video distribution with the release of the first *Franklin* video in Canada, the video release of our feature film *Pippi Longstocking* and our series *Stickin' Around* and *Little Bear*. In 1998, we will focus our licensing program on profiling and building three key character brands: *Babar*, *Little Bear* and *Franklin*. We plan to pursue the potential of this business by more closely integrating our merchandising efforts with those of our sales offices in London, Paris and Los Angeles.

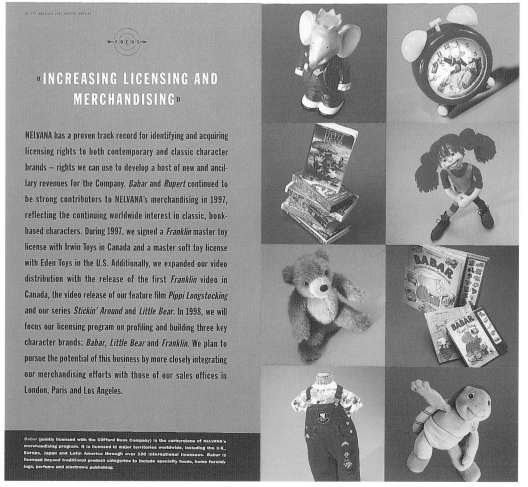

Babar (jointly licensed with the Clifford Ross Company) is the cornerstone of NELVANA's merchandising program. It is licensed in major territories worldwide, including the U.K., Europe, Japan and Latin America through over 100 international licensees. Babar is licensed beyond traditional product categories to include specialty foods, home furnishings, perfume and electronic publishing.

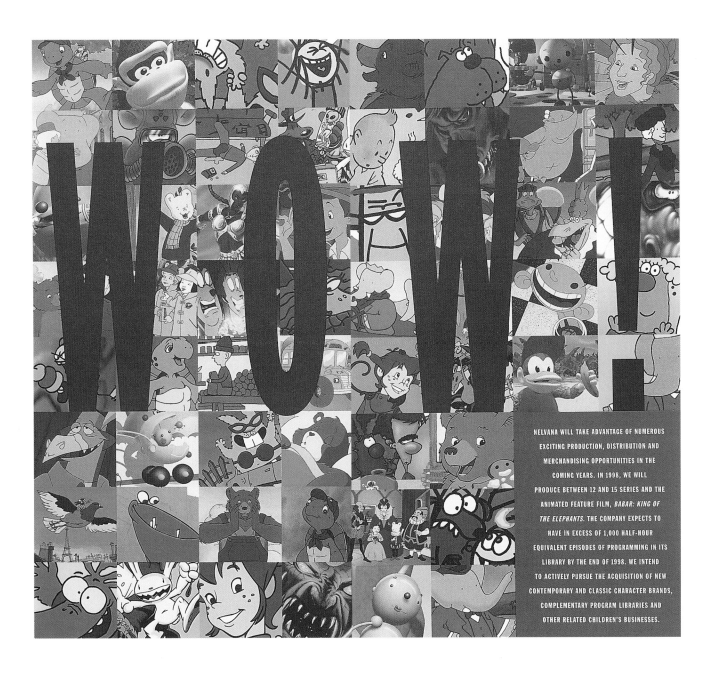

NELVANA WILL TAKE ADVANTAGE OF NUMEROUS EXCITING PRODUCTION, DISTRIBUTION AND MERCHANDISING OPPORTUNITIES IN THE COMING YEARS. IN 1998, WE WILL PRODUCE BETWEEN 12 AND 15 SERIES AND THE ANIMATED FEATURE FILM, *BABAR: KING OF THE ELEPHANTS*. THE COMPANY EXPECTS TO HAVE IN EXCESS OF 1,000 HALF-HOUR EQUIVALENT EPISODES OF PROGRAMMING IN ITS LIBRARY BY THE END OF 1998. WE INTEND TO ACTIVELY PURSUE THE ACQUISITION OF NEW CONTEMPORARY AND CLASSIC CHARACTER BRANDS, COMPLEMENTARY PROGRAM LIBRARIES AND OTHER RELATED CHILDREN'S BUSINESSES.

NELVANA LIMITED
ANNUAL REPORT: "FOCUS"

NELVANA
TORONTO • PARIS • LONDON • LOS ANGELES

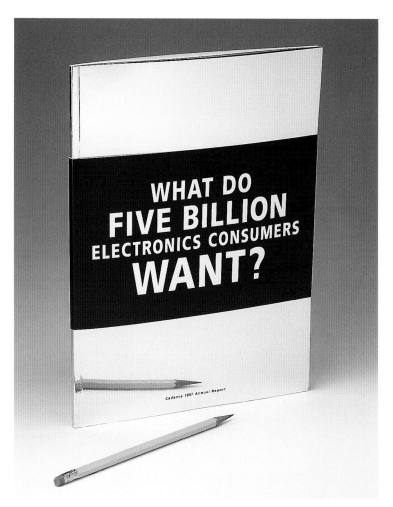

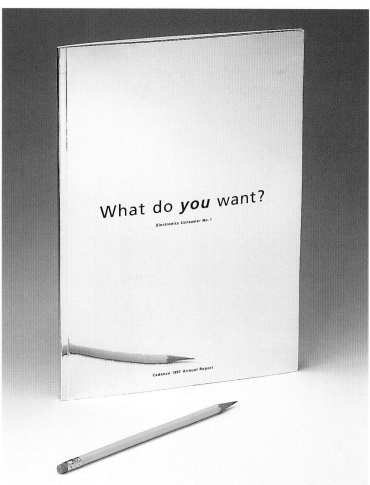

Cadence Annual Report: "What Do Five Billion Electronics Consumers Want?"

WHAT DO ELECTRONICS CONSUMERS WANT? CADENCE DESIGN SYSTEMS, A HIGH-TECH CONSUMER ELECTRONICS COMPANY, ASKED EVERYONE FROM SHEEPHERDERS IN IRELAND TO A TWELVE-YEAR-OLD FROM NEW JERSEY.

Manufacturers know their bottom line depends on giving the customer what they want, but do they ever really ask them? Cadence does in this striking annual report that, at first glance, looks as high-tech as the company. The black belly band around the report asks the overriding question; when slipped off, the foil-stamped cover, reflecting the reader's face, gets more personal: "What do you want?"

Consumer Reports
"Make it different." That was the directive Cadence gave Oh Boy, A Design Company, when embarking on its 1997 annual report. "With five billion electronics consumers champing at the bit for everything from miniature, multifaceted PDAs to smart dishwashers, Cadence boasted a substantial rise in profits and was again well poised to help manufacturers realize their consumers' demands," said Cadence's Chris Groutt.

What were consumers' demands? A cross-section of international consumers gave their own suggestions for the future of electronics. Each request appears as a personal, handwritten letter in its own unique typeface.

"Whatever Needs to Be Done."
Every individual has priorities. "Make it fast. Make it talk. Make it feel." This may be Electronics Consumer No. 1's priority, but Electronics Consumer No. 3,893,374,199 has another agenda. A compilation of wants is delineated on a fold-out spread, reminiscent of scribbles on a blackboard during a brainstorming session.

The overall effect makes consumers believe that Cadence is interested in what they want and that their wishes are, indeed, possible to fulfill.

CLIENT
Cadence Design Systems
DESIGN FIRM
Oh Boy, A Design Company
DESIGNERS
Ted Bluey, David Salanitro
ART DIRECTOR
David Salanitro
PHOTOGRAPHERS
Ty Allison, Russell Monk
COPYWRITER
John Mannion
PRINTER
Hemlock Printers

PAPER STOCK
Zanders Mirri, Mead
Signature Dull
PRINTING
cover
foil stamped;
text
8 colors
SIZE
8 ¼" x 11 ½"
(21 cm x 29 cm),
57 pages
FONTS
Frutiger, Bembo
PRINT RUN
60,000
HARDWARE
Macintosh
SOFTWARE
Adobe Photoshop,
Adobe Illustrator

I could really use a virtual cashier — a wireless countertop self-service checkout device with touchscreen menus, a multi-lingual recipe builder, an automatic inventory and reorder system, and a profit and loss calculator with a friendly face and voice — so I can retire.

Electronics Consumer No. 451; Hong Kong, China
Make it fast. Make it talk. Make it feel.

The things people want. The things the world wants. ⇥

Seems like just about everybody on the planet has a request—and sooner or later, people expect their dreams to come true. ⇥

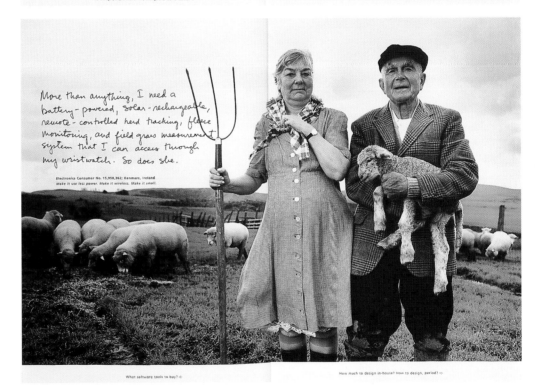

More than anything, I need a battery-powered, solar-rechargeable, remote-controlled herd tracking, fleece monitoring, and field grass measurement system that I can access through my wristwatch. So does she.

Electronics Consumer No. 15,958,362; Kenmare, Ireland
Make it use less power. Make it wireless. Make it small.

What software tools to buy? ⇥

How much to design in-house? How to design, period? ⇥

Whatever needs to be done.

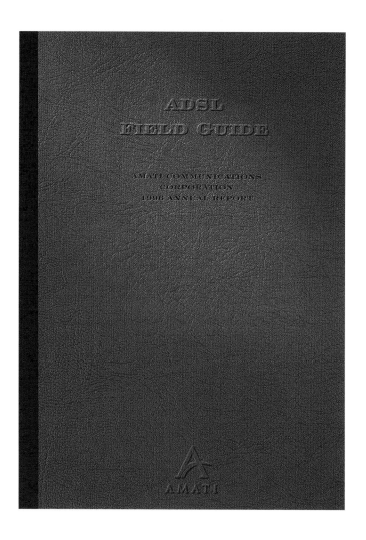

Amati Communications Corporation ADSL Field Guide

MCKOWN DESIGN'S CHARTER, WHEN EMBARKING ON AMATI COMMUNICATIONS CORPORATION'S 1996 ANNUAL REPORT, WAS TO EDUCATE AND ENTERTAIN, ALL WITHIN A TIGHT BUDGET.

Amati manufactures the hardware and software that allow the transmission of digital information over standard phone lines at very high speeds, so it stands to reason that plenty of technical information would appear in their annual report. Specifically, Amati requested the design be "interesting, but not frivolous; technical, but not dry."

Simplifying the Complex

By formatting the annual report as a field guide, McKown Design felt they could condense and simplify what otherwise would read as complicated techno-jargon to many nontechnical shareholders.

The physical size and layout go far to relieve the intimidation factor characteristic of annual reports of many high-tech companies. The hand-applied bookbinder's tape on the binding gives the report a texture that simple perfect binding could not.

A Fine Specimen

Complex charts and graphs were avoided. Instead, the technical data were translated into diagrams seemingly scribbled on whatever scrap of paper was handy. As a result, the concept of Amati's ADSL technology is strikingly clear, even at first glance.

Because the budget was lean, stock photography was used to add eye-catching, unexpected graphic elements to each page—from a magnifying glass and compass to a beetle and butterfly.

The field guide is a fine specimen of a portable pocket guide to the company, neatly packaging information for quick comprehension and retrieval on the fly.

CLIENT
Amati Communications, Inc.
DESIGN FIRM
McKown Design
DESIGNER/ART DIRECTOR
Alice Baker McKown
ILLUSTRATORS
Bronson Baker (calligraphy),
Bob Pleasure (Photoshop)
PHOTOGRAPHER
Mel Lindstrom and stock
COPYWRITERS
Carol Felton, Tac Berry
PRINTER
Bayshore Press, Inc.

PAPER STOCK
Potlatch Vintage Velvet
Cream 100# cover and text
PRINTING
4-color process with
spot gloss varnish and
hand-applied black book-
binder's tape
SIZE
6 ⅜" x 9" (16 cm x 23 cm),
44 pages
FONTS
Garamond 3, Garamond 3
Italic, Cochin, Bondini
PRINT RUN
20,000
HARDWARE
Power Computing Power
Tower Pro 200
SOFTWARE
Quark Xpress 3.32, Adobe
Photoshop 5.0, Adobe
Illustrator 5.0

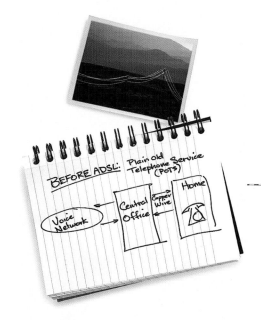

AMATI'S FIELD GUIDE TO ADSL

FIELD GUIDE OVERVIEW

Your house is linked to the outside world through a series of external connections—the power wires for electricity, antenna (or cable) for video, and phone lines for voice. Until today the phone lines (copper wires actually) allowed you to do a few very specific things: talk to other people, of course, fax maybe, and within limits send information from your computer to any computer in the world. But computers talking to computers over phone lines has been slow and tedious.

So some engineers decided if they could make your phone lines go faster, they would be much more valuable for your computer. In fact, if the phone lines could go fast enough you could probably send video (TV, movies) over them as well.

This faster phone line is what's known as ADSL (Asymmetric Digital Subscriber Line). With ADSL there's no change to your house's copper wire. ADSL is just a method (service really) that makes that copper wire act like a much "bigger pipe" for sending computer bits and digital information (like movies and TV channels), while still carrying the voice traffic it was intended for.

WHY ADSL?

With this faster phone line, you will be able to get many new and exciting services. Today the main application appears to be high-speed connectivity for computers. High speed to "surf" the Internet, to work at home, and to connect to other computers. Higher speed than now available without adding special wires and services to every house. An ADSL modem can carry information 200 times faster than the typical analog modem used today.

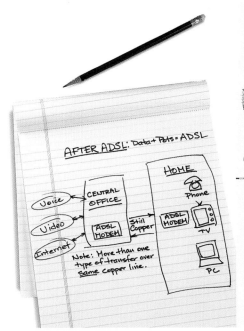

AMATI'S FIELD GUIDE TO ADSL

**DMT—
A WHOLE NEW ANIMAL**

Amati has developed special technology to design ADSL products. The company has developed a series of patents that define what is known as Discrete Multi-tone Technology, a better mousetrap for ADSL products. DMT has been accepted as an industry standard (Standard # T1.413) for service providers needing ADSL equipment. It's this DMT expertise on which Amati has based its business strategy.

This strategy calls for Amati to allow other companies to license the technology, to build products (modems and software products) that can be sold to phone companies and/or the customer of the service, work with other companies to help them develop their own products, and use DMT in the development of future products and services.

EXPLORE THE COMPETITION

ADSL has a number of advantages over competing technologies such as analog modems, HFC, cable modems and wireless. To wit:
Analog modems—millions are now in use, but they're much slower.
Hybrid Fiber Coax (HFC)—another new technology, but it requires adding fiber optic and coaxial cables from the phone company office to the house. That's expensive.
Cable modems—the cable TV wire is already a "bigger pipe" so why not use it to carry more than TV? This idea is being tested (although having the cable TV become a 2-way system poses engineering challenges.) It may, however, be the best answer for non-phone companies.
Wireless connection—no new cables are needed but it has less bandwidth potential than HFC or ADSL, and the frequencies required are not readily available.

AMATI'S FIELD GUIDE TO ADSL

THE HUNT FOR ADSL

You should be able to buy ADSL service from your local phone service provider in the future. ADSL service will be offered by a local telco, or an ISP (Internet Service Provider), or even an IXC (Inter-exchange Carrier). Amati will make equipment that permits connection to the service, but until the service is offered, there is no place to connect the Amati modems.

AMATI

To Our Shareholders,

As I look back on 1996, I recognize exciting changes have occurred in our company. Our metamorphosis from an R&D to a manufacturing firm, our strategic alliances, coupled with our emergence as a public company, have changed the way the world views us. I am proud of Amati's leading role as a provider of ADSL modems to the telecommunications world. It is therefore with pleasure that I highlight Amati's evolution.

Late last year, ICOT and Amati successfully completed a merger to focus on the future development of the Amati DMT technology. This enabled the technology of Amati to be combined with the manufacturing capabilities of ICOT and move that technology beyond research to products. I believe the merger has worked out well. In addition to manufacturing operations, it has allowed the internetworking expertise of ICOT to be part of the future Amati product solutions.

Earlier this year, Amati announced strategic alliances with Motorola and NEC Corporation, and more recently with Texas Instruments. We consider these to be significant for a number of reasons.

First, Motorola, Texas Instruments and NEC are recognized leaders in the market. By endorsing Amati's technology, they can help establish our products as industry standards. In addition, the agreements make crucial semiconductor technology available to us, allowing us to advance towards our goal—lower prices and higher performance.

This year also saw the introduction of several new products and, in particular, the Overture 8 ADSL/DMT modems. We believe the Overture 8 is a revolutionary product that will drive company growth over the next years. It is the industry's first 8 Mbps ADSL modem. Market interest has been extremely strong.

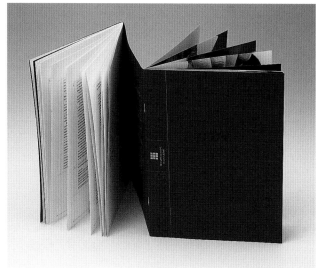

Swiss Army Brands, Inc. Annual Report

ANNUAL REPORTS ARE ESSENTIALLY TWO BOOKS IN ONE—THE LETTER TO SHAREHOLDERS AND COMPANY REPORT AND THE REQUIRED FINANCIAL SECTION. COMBINING THE TWO IS COMMONLY ACCEPTED PRACTICE. SAMATAMASON TOOK A DIFFERENT TACK WITH THEIR ANNUAL REPORT FOR SWISS ARMY BRANDS, INC. BY TREATING THESE TWO ENTITIES AS SEPARATE BOOKS.

Together Yet Separate

The book is constructed in two parts. "Icons" is the name of what is typically the upfront section of an annual report, while "Innovations" is the title of the financial section. One 21 ¾" x 10" sheet of Fox River Black Quest cover is printed in one color, embossed, and folded into two accordion folds. The two sections of the book are saddle-stitched into the folds, allowing the reader to start from the front or the back.

The cover, while distinctive, is simple in design, as are the financial pages, which are presented in clean Helvetica type. These elements are in sharp contrast to the dramatic black-and-white high-gloss photography.

Form Follows Function

Swiss Army® watches, knives, and sunglasses are shown in extreme close-ups that highlight their utilitarian features. So finely focused are the photographs that one can appreciate every nuance of the products and their features and even observe the fine lines on the hands that hold them.

"The book was designed to embody the essence of what Swiss Army Brands stands for—that form follows function not only in their products but also in their corporate structure," said Dave Mason.

The same can be said for the annual report.

CLIENT
Swiss Army Brands, Inc.
DESIGN FIRM
SamataMason
DESIGNERS
Pamela Lee, Dave Mason
ART DIRECTOR
Dave Mason
PHOTOGRAPHER
Victor John Penner
COPYWRITER
Steven Zousmer
PRINTER
H. MacDonald Printing

PAPER STOCK
Fox River Quest Black 80#
cover, Mead Signature
Gloss 100# text, Resolve
Premium Opaque 80# text
PRINTING
cover
1 color plus embossing;
text
3 colors
SIZE
7 ¼" x 10"
(18.5 cm x 25 cm),
56 pages plus 6-page cover
FONT
Helvetica
HARDWARE
Macintosh
SOFTWARE
Quark XPress

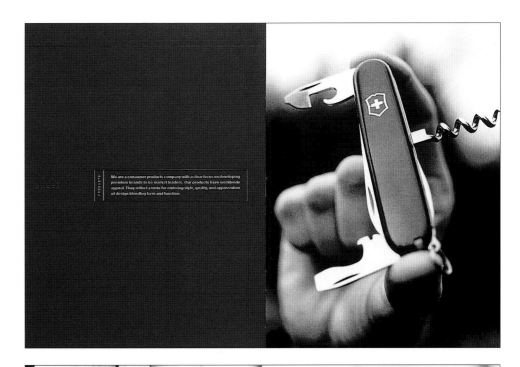

We are a consumer products company with a clear focus on developing premium brands to be market leaders. Our products have worldwide appeal. They reflect a taste for enduring style, quality, and appreciation of design blending form and function.

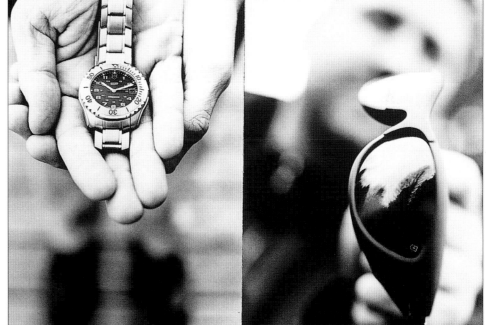

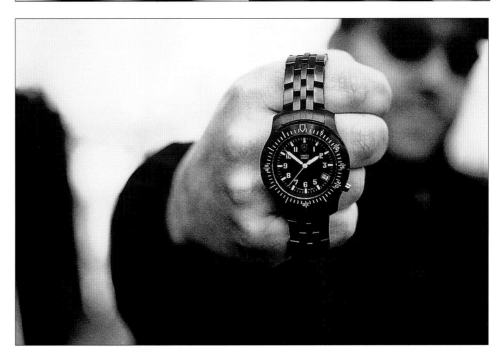

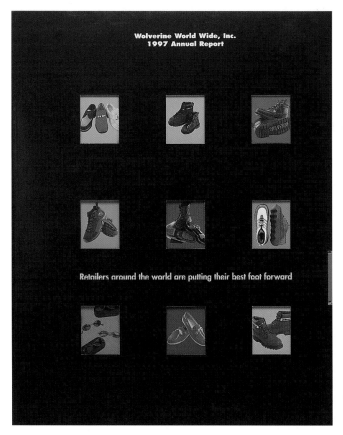

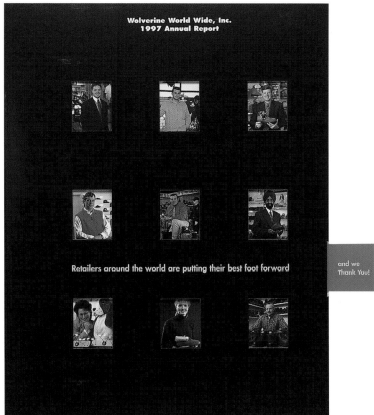

Wolverine World Wide, Inc. Annual Report:
"Retailers Around the World Are Putting Their Best Foot Forward"

THE WOLVERINE WORLD WIDE 1997 ANNUAL REPORT IS AS COMFORTABLE TO LOOK AT AND READ AS A PAIR OF HUSH PUPPIES® IS TO WEAR.

Michigan-based Wolverine World Wide offers a number of footwear lines, including Hush Puppies®, Wolverine®, Caterpillar®, and Coleman®. It made sense to communicate Wolverine's strong global distribution of its brands and thank retailers for their support at the same time—all in the 1997 annual report.

A Well-Heeled Design

Pangborn Design determined that they could emphasize the variety and breath of Wolverine's markets by photographing retailers in their own stores and in their own countries— alongside Wolverine products. These photos are featured within the text of the report, as well as on the front cover. In their sixth year of designing reports for Wolverine, Pangborn takes pride in creating covers so engaging that they beckon the recipient to read the book immediately. The 1997 cover was no exception.

The concept—to die-cut the cover and construct a pullout so that both products and customers could be seen through nine die-cut windows—came easily enough, but production proved tricky.

The sliding sheet kept jamming no matter how it was constructed. Ultimately, Pangborn redesigned the cover like an envelope to free the insert from the outside pressures caus-

ing the jams. Because the cover folds are designed to rest completely free from external pressure, the pullout slides smoothly every time.

Fortunately, the production budget was roomy, but the timetable was not. Printing and assembly of the cover began even before the report's interior was finalized.

A Shoe-In

Regardless of the production glitches, the report shows the care that went into the project. The cover pullout is reminiscent of a children's book. Because it is interactive, it cannot help but get the recipient involved. The inside front spread lays out Wolverine's brands and gives a quick overview of the company's activity. Beyond that, the report reads like a well-organized magazine. The photography is consumer–oriented, and the layout is easy to navigate.

As a bonus, an order form in the back provides a discount on orders from the annual report. Apparently, Wolverine knows how to give something back.

"No matter how inventive or sophisticated the design, we also choose typography with legibility in mind," said Dominic Pangborn. " It is important to remember the primary objective of an annual report is to communicate."

CLIENT
Wolverine World Wide, Inc.
DESIGN FIRM
Pangborn Design, Ltd.
DESIGNER/ART DIRECTOR
Dominic Pangborn
ILLUSTRATOR
Hong Choi
PHOTOGRAPHERS
Various
COPYWRITERS
L. James Lovejoy,
Thomas Mundt
PRINTER
Colortech Graphics, Inc.

PAPER STOCK
Potlatch McCoy Gloss
120# cover, 100# cover,
and 80# text
PRINTING
cover
4-color process, 1 PMS
plus varnish, die-cut;
cover pull-out
4-color process, varnish,
and die-cut;
text
6 colors plus varnish
SIZE
8 ½" x 11"
(22 cm x 28 cm),
44 pages, plus 4-page cover
FONTS
Futura, Times New Roman,
Democratica
PRINT RUN
20,000
HARDWARE
Macintosh
SOFTWARE
Quark XPress 3.32,
FreeHand 5.5 and 7.0,
Adobe Photoshop 4.0

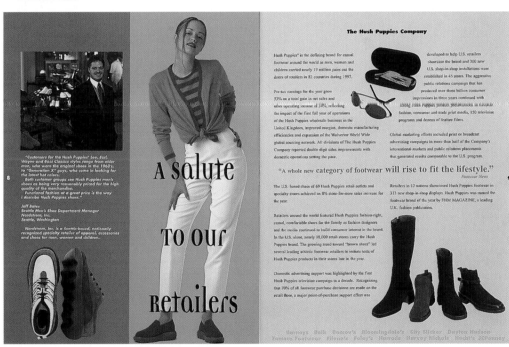

The Hush Puppies Company

A salute to our retailers

Wolverine Slipper Group

Apogee Enterprises, Inc. Annual Report

IT IS POSSIBLE TO PROJECT CONFIDENCE IN AN ANNUAL REPORT WITHOUT THE EFFORT APPEARING TOO EXPENSIVE. THAT IS EXACTLY WHAT LITTLE & COMPANY ACCOMPLISHED FOR APOGEE IN 1998.

This report is remarkably efficient without sacrificing elegance. For Apogee, a manufacturer of glass products for autos, computer screens, nonresidential construction, and picture frames, 1998 was not a stellar year. Nevertheless, they had to reassure stockholders that Apogee was still a modern, technology-driven company and had not lost its vision.

Color-Cued Photos
Because the budget was limited and the design team did not want the report to look too pricey, photography from other Apogee projects was used to maximum effect along with original photography.

The cover is clean and its photo shows a clear view of the road ahead—as seen through Apogee auto glass, the reader assumes. To be given the inside track from Apogee's viewpoint, literally and figuratively, is a nice touch.

The cover gatefold presents a concise overview of the diverse product lines. Inside, the photos, while few in number, are expertly positioned and color-cued by topic to matching headlines, subheads, and captions. The photos complement each other perfectly, a seamless mix of old and new.

A Confident Air
The layout is contemporary and the leading is wide-open, so while the message is fairly copy-intensive, it does not intimidate. Also adding to the book's elegance without adding to the cost are the metallic touches throughout the text.

Unfortunately, this addition proved challenging on press. The metallic inks were not varnished, which increases the risk of offsetting. The printer avoided problems by using a soft metallic ink. He also gave the job extended drying time and took exceptional care during the binding process.

CLIENT
Apogee Enterprises, Inc.
DESIGN FIRM
Little & Company
DESIGNER
Scott Sorenson
ART DIRECTOR
Jim Jackson
PHOTOGRAPHERS
Steve Niedorf, Mark
LaFavor, Corbin Images
COPYWRITER
Larry Stein
PRINTER
Watt-Peterson, Inc.

PAPER STOCK
Potlatch McCoy Silk Cover
100#, Potlatch McCoy
Velvet 100# text,
Champion Carnival
Vellum Sky 70# text
PRINTING
cover
5 colors plus spot varnish;
text
5 colors including metallics,
metallic quadratones
SIZE
8 ⅞" x 11 ¾"
(22 cm x 29.5 cm),
32 pages plus gatefold
cover
FONTS
Trade Gothic, Mrs. Eaves
PRINT RUN
23,000
HARDWARE
Macintosh
SOFTWARE
Quark XPress, Adobe
Photoshop, Adobe Illustrator

Engineering Animation, Inc. Annual Report

ENGINEERING ANIMATION WANTED TO SHOW OFF IN ITS FIRST-EVER ANNUAL REPORT. PATTEE DESIGN'S CHALLENGE: PORTRAY AN ANIMATION-DIRECTED MESSAGE IN A STATIC ENVIRONMENT.

A manufacturer of high-tech software, Engineering Animation approached its annual report with the intent of showing off their best. Of course, wanting to do something and actually doing it can be two different things.

Pulling a Report Together

The first challenge was to give the book a three-dimensional effect. The next was to compile the information required of an annual report. "Annual reports are built around gathering a lot of information from a lot of people with different personalities," said Steve Pattee. "Merging all the information you receive into a cohesive presentation can be difficult."

Giving Paper Three Dimensions

"Translating three-dimensional animation into two-dimensional print is also not an easy thing to do," added Pattee. "So, to give the book its 3-D attitude, we decided to use multiple layers of vellum stock, all printed in six colors. The technique also allowed readers some interaction."

The text pages include three layered sections printed with high-impact colors in a bold, sans serif typeface. Headlines span spreads and are treated individually with innovative letterforms.

The result is a clean, effective report. The cover is conservative—perhaps a wise approach for a report's debut—and it is dressed up by the choice of stock. Pattee managed to bring the report and its components seamlessly together.

CLIENT
Engineering Animation, Inc.
DESIGN FIRM
Pattee Design, Inc.
DESIGNERS
Kelly Stiles, Steve Pattee,
Trenton Burd, Erika Brask,
Troy Overstreet
ART DIRECTOR
Steve Pattee
ILLUSTRATOR
Engineering Animation, Inc.
PHOTOGRAPHER
Studio Au
COPYWRITER
Mike Condon
PRINTER
Watt-Peterson, Inc.

PAPER STOCK
Benefit White cover, Utopia
Glama text
PRINTING
6 colors
SIZE
8 ½" x 11"
(22 cm x 28 cm),
45 pages
FONTS
Garamond, Officina Sans
PRINT RUN
20,000
HARDWARE
Macintosh
SOFTWARE
Quark XPress,
Adobe Photoshop,
Adobe Illustrator

SOFT
WARE

EAI VISUALIZATION PRODUCTS HAVE EVOLVED INTO A REMARKABLE COLLECTION OF
BREAKTHROUGH ADVANCEMENTS FOR CREATING, PRESENTING AND INTERACTING WITH
INFORMATION ACROSS AN ENTIRE ENTERPRISE. VISPRODUCTS ENABLE PEOPLE TO SEE,
TO COLLABORATE AND TO INTERACT WITH PRODUCTS BEFORE THEY'RE PRODUCED. THEY
ENABLE COMPANIES TO EXPERIENCE LEAPS IN PRODUCTIVITY, DRAMATIC COST SAVINGS
AND SIGNIFICANT PERFORMANCE IMPROVEMENTS. TOGETHER, VISPRODUCTS FROM EAI
CREATE A COLLABORATIVE VISUALIZATION ENVIRONMENT.

EAI custom animations
enable

people to see

CUSTOM
ANIMATION

TO BE THERE. TO SEE A VIRUS ATTACKED BY A SUICIDE GENE. OR THE MOMENT OUR
SOLAR SYSTEM WAS CREATED. TO EXPERIENCE A JET CRASH FROM THE CO-PILOT'S
PERSPECTIVE. OR THE INCREDIBLE CHALLENGE OF BUILDING THE WORLD'S LARGEST
OFFSHORE PLATFORM. TO INFORM OR ENTERTAIN. TO LAUNCH A NEW PRODUCT. OR
VISUALIZE A MOMENT IN HISTORY.

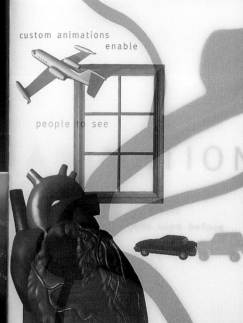

people to see

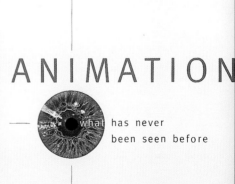

ANIMATION

what has never
been seen before

SEDA Specialty Packaging Corporation Annual Report

FINDING THE COMMON THREAD AMONG A MULTITUDE OF PRODUCTS CAN LEAD TO INTERESTING DESIGN SOLUTIONS, AS SEDA SPECIALTY PACKAGING CORPORATION, A PLASTICS MANUFACTURER, DEMONSTRATES IN ITS 1996 ANNUAL REPORT.

This family-owned business went public in 1994. When planning their 1996 annual report, they narrowed the field of objectives to two: show the operations and manufacturing aspects of the business and show a variety of finished products.

Finding a Creative Solution

Typically, such a request might elicit groans from designers hoping for a more creative opportunity, but designer Scott Lambert proved that client mandates and creativity do not have to be at odds.

Lambert tackled his client's preference for showing the manufacturing process via a series of twelve small 1 ¾" x 1 ¼" black-and-white photographs that run across the bottom of two spreads and provide a step-by-step demonstration of plastics manufacturing.

Everything That Goes A–Round

Lambert observed that everything SEDA manufactured was round, which provided the inspiration for his second design solution. The products were photographed from the top and the shots printed on clear vellum paper. The pages were die-cut into quarters and halves, allowing the reader to flip through them to view a variety of products, each page revealing a portion of another. A wire binding was used so that the pages would lay flat, crucial to the flip-page effect.

Traditional product group shots were included, too, placed in the corners of the die-cut sheets. They allow readers to step back from the close-up top shot to see what the product is.

The report is clever, interactive, and bright. It uses lots of vibrant colors that match SEDA's plastic products. From its looks, one would never guess that the budget was limited. To contain costs, the financial and operations sections were printed on the same press form.

CLIENT
SEDA Specialty Packaging
Corporation
DESIGN FIRM
Martin Design Associates
DESIGNER/ART DIRECTOR
Scott Lambert
PHOTOGRAPHER
Andrew Kitchen
COPYWRITERS
Lou Alkana, Ron Johnson
PRINTER
Franklin Press
PAPER STOCK
Potlatch Karma White 80#
cover and 100# text, Gilbert
Gilclear medium weight
PRINTING
cover
6 colors;
text
5 and 6 colors
SIZE
8 ¾" x 10 ¾"
(22 cm x 27 cm),
34 pages
FONTS
Bauer Bodini, Orator
PRINT RUN
12,000
HARDWARE
Macintosh
SOFTWARE
Quark XPress

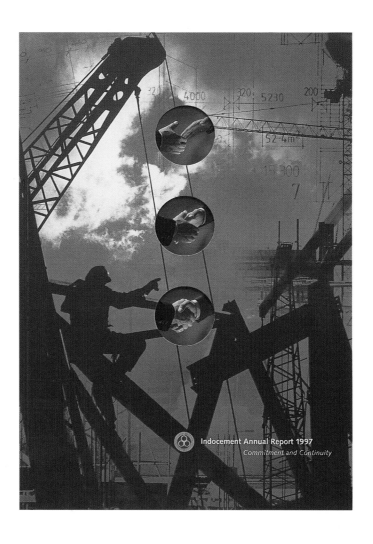

Indocement Annual Report

EVERYONE LOVES TO PREPARE ANNUAL REPORTS WHEN BUSINESS IS GOOD. BUT WHAT HAPPENS WHEN BUSINESS IS BAD AND THE ECONOMY IS IN AN UPHEAVAL, AFFECTING NOT JUST AN INDUSTRY BUT THE ENTIRE COUNTRY? IN THIS SITUATION, CAN A DESIGN INSPIRE CONFIDENCE AND REFLECT FORWARD MOVEMENT WHEN SEVERELY LIMITED BY BUDGET?

Trying Economic Times Call for Resourceful Design
Indocement is Indonesia's second largest and lowest-cost cement producer and, like the rest of the country and the region in 1997, was struggling with difficult economic times.

It had not always been this way. In fact, the economy had changed dramatically just since the previous year's report. The new report had to reflect this change, distancing itself from the previous year while inspiring confidence and optimism.

Inspiring Confidence on a Shoestring
The theme for the annual was grounded in commitment and continuity—commitment to the country's economic development, sound management practices, the environment, shareholder values, and the welfare of its employees, and continuity of purpose within a turbulent economy.

The Bonsey Design Partnership's charter was to develop a design that reflected these values. The design team began by taking a number of significant cost-saving measures in recognition of the economic strife. Location shots were kept to a minimum and expensive records of distant sites were omitted.

Instead, Bonsey used available photographs and stock library shots to reinforce and graphically illustrate the theme. For example, a doctor's stethoscope was used for the section headed, "Our People and Their Welfare." The effect was more conceptual than the previously year's, which effectively distanced the 1997 report from the days before the downturn.

A construction theme dominates the cover photo, accented with three round die-cuts that focus the eye on a stop-motion montage of a handshake, a straightforward metaphor for confidence. Inside, the three-circle pattern is repeated, photographically, illustrating works in progress ranging from mortaring a brick wall and planting a tree to feeding a baby.

CLIENT
PT Indocement Tunggal
Prakarsa
DESIGN FIRM
The Bonsey Design
Partnership
DESIGNERS
Damien Thomasz,
Marcel Heijnen
ART DIRECTORS
Jonathan Bonsey, Chris Lee
PHOTOGRAPHERS
Alex Kai Keong (still life),
Peter Champion (location)
COPYWRITER
Derek Murphy
PRINTER
Saik Wah Press

PAPER
Invercote Creato Artcard
270 gsm, Nymolla Art 150
gsm, Simili 115 gsm
PRINTING
cover
4-color process, 1 special
silver, black overprint of sil-
ver, matte lamination on
front/back cover, die-cut
holes on front cover, matte
varnish on silver inside
front/back;
text
4-color process, 1 special
silver;
financials
1 over 1
SIZE
8 ¼" x 11 ¾", 64 pages
FONTS
Sans, Scala
PRINT RUN
3,000 English, 2,000
Bahasa
HARDWARE
Macintosh
SOFTWARE
Quark XPress 3.0

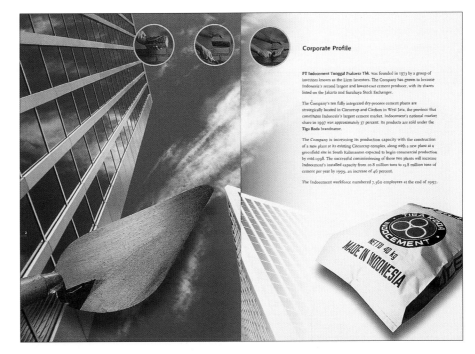

Corporate Profile

PT Indocement Tunggal Prakarsa Tbk. was founded in 1975 by a group of investors known as the Liem Investors. The Company has grown to become Indonesia's second largest and lowest-cost cement producer, with its shares listed on the Jakarta and Surabaya Stock Exchanges.

The Company's ten fully integrated dry-process cement plants are strategically located in Citeureup and Cirebon in West Java, the province that constitutes Indonesia's largest cement market. Indocement's national market share in 1997 was approximately 37 percent. Its products are sold under the Tiga Roda brandname.

The Company is increasing its production capacity with the construction of a new plant at its existing Citeureup complex, along with a new plant at a greenfield site in South Kalimantan expected to begin commercial production by mid-1998. The successful commissioning of these two plants will increase Indocement's installed capacity from 10.8 million tons to 15.8 million tons of cement per year by 1999, an increase of 46 percent.

The Indocement workforce numbered 7,360 employees at the end of 1997.

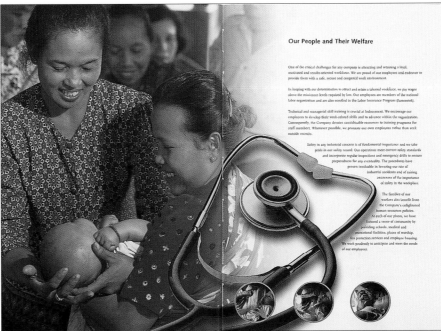

Our People and Their Welfare

One of the critical challenges for any company is attracting and retaining a loyal, motivated and results-oriented workforce. We are proud of our employees and endeavor to provide them with a safe, secure and congenial work environment.

In keeping with our determination to attract and retain a talented workforce, we pay wages above the minimum levels required by law. Our employees are members of the national labor organization and are also enrolled in the Labor Insurance Program (Jamsostek).

Technical and managerial skill training is crucial at Indocement. We encourage our employees to develop their work-related skills and to advance within the organization. Consequently, the Company devotes considerable resources to training programs for staff members. Whenever possible, we promote our own employees rather than seek outside recruits.

Safety in any industrial concern is of fundamental importance and we take pride in our safety record. Our operations meet current safety standards and incorporate regular inspections and emergency drills to ensure preparedness for any eventuality. The procedures have proven invaluable in lowering our rate of industrial accidents and of raising awareness of the importance of safety in the workplace.

The families of our workers also benefit from the Company's enlightened human resources policies. At each of our plants, we have fostered a sense of community by providing schools, medical and recreational facilities, places of worship, fire protection services and employee housing. We work prudently to anticipate and meet the needs of our employees.

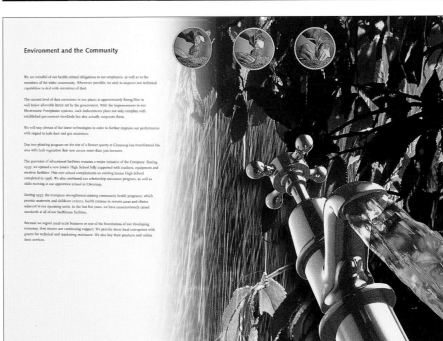

Environment and the Community

We are mindful of our health-related obligations to our employees, as well as to the members of the wider community. Whenever possible, we seek to improve our technical capabilities to deal with emissions of dust.

The current level of dust emissions in our plants at approximately 80mg/Nm³ is well below allowable limits set by the government. With the improvements in our Electrostatic Precipitator systems, each Indocement plant not only complies with established government standards but also actually surpasses them.

We will stay abreast of the latest technologies in order to further improve our performance with regard to both dust and gas emissions.

Our tree-planting program on the site of a former quarry at Citeureup has transformed the area with lush vegetation that now covers more than 300 hectares.

The provision of educational facilities remains a major initiative of the Company. During 1997, we opened a new Junior High School fully supported with teachers, equipment and modern facilities. This new school complements an existing Junior High School completed in 1996. We also continued our scholarship assistance program, as well as skills training at our apprentice school in Citeureup.

During 1997, the Company strengthened existing community health programs, which provide maternity and childcare centers, health stations in remote areas and clinics adjacent to our operating units. In the last few years, we have conscientiously raised standards at all of our healthcare facilities.

Because we regard small-scale business as one of the foundations of our developing economy, they receive our continuing support. We provide these local enterprises with grants for technical and marketing assistance. We also buy their products and utilize their services.

the future is growing

weyerhaeuser 1998 annual report

Weyerhaeuser Annual Report

THE WEYERHAEUSER ANNUAL REPORT IS BEAUTIFUL. ONE WOULD NEVER GUESS HOW CHALLENGING IT WAS TO COMMUNICATE AN AGGRESSIVE MESSAGE THROUGH THE SOFTNESS OF WATERCOLOR—AND RESURRECT AN AGE-OLD PRINTING TECHNIQUE IN THE PROCESS.

When Weyerhaeuser retained Rigsby Design to produce their annual report, the company's advertising agency had just launched a new national branding campaign that revolved around a watercolor theme created by Japanese artist Ning Yeh. The watercolors were beautiful and exuded a soft, appealing gentleness, but their mood was distinctly at odds with the strong message the new CEO wanted to communicate.

Can an Aggressive Message Work with Delicate Visuals?

The CEO wanted to communicate three key messages: speed, simplicity, and decisiveness. Rigsby Design wrestled with using watercolor paintings to project an aggressive strategy. After spending a day watching and photographing the artist at work, the designers realized the parallels between the three messages and the art of painting. In hindsight, the metaphor was a natural—choosing a brush among the dozens of artists' tools available is akin to choosing a marketing strategy and implementing it effectively.

"The CEO has an engineering background but was very comfortable with using painting as an analogy for his strategic plans," said Lana Rigsby. "He was comfortable with the metaphor and conveying his ideas in an abstract sense."

Resurrecting the Lost Art of Mezzotints

The next challenge lay in reproducing the watercolors on press. "We wanted the effect to be very light, so we revived the mezzotint process," said designer Thomas Hull. "It was hard finding a printer to do this because the movement has been away from random dot patterns."

The designers located a printer who could do the job and worked closely with the platemaker and the manufacturer of printers' direct-to-plate technology and software to get the screen pattern desired. There was no film; only digital files were used.

Proofing the job was a challenge, too. "We proofed from the plates which is like looking at photographic negatives," said Hull. The result is soft watercolors that possess an airy mix of light and shadows.

"We don't do a lot of four-color on paper," said Rigsby. "So it's wonderful when we can find a printer who is able to collaborate technically."

CLIENT
Weyerhaeuser
DESIGN FIRM
Rigsby Design
DESIGNER
Thomas Hull
ART DIRECTOR
Lana Rigsby
ILLUSTRATOR
Ning Yeh
PHOTOGRAPHER
Chris Shinn
COPYWRITER
Bruce Amundsen
PRINTER
Graphic Arts Center

PAPER STOCK
Weyerhaeuser Cougar
Opaque 80# cover and text
PRINTING
cover
4 over 4 plus 1 PMS, spot
dull varnish, and
deboss/emboss lift;
text
4 over 4 plus 1 PMS and
overall dull varnish
SIZE
7 ½" x 11 ⅛"
(19 cm x 28.3 cm),
76 pages
FONTS
Didot, Helvetica Neue
PRINT RUN
165,000
HARDWARE
Macintosh
SOFTWARE
Quark XPress 4.0

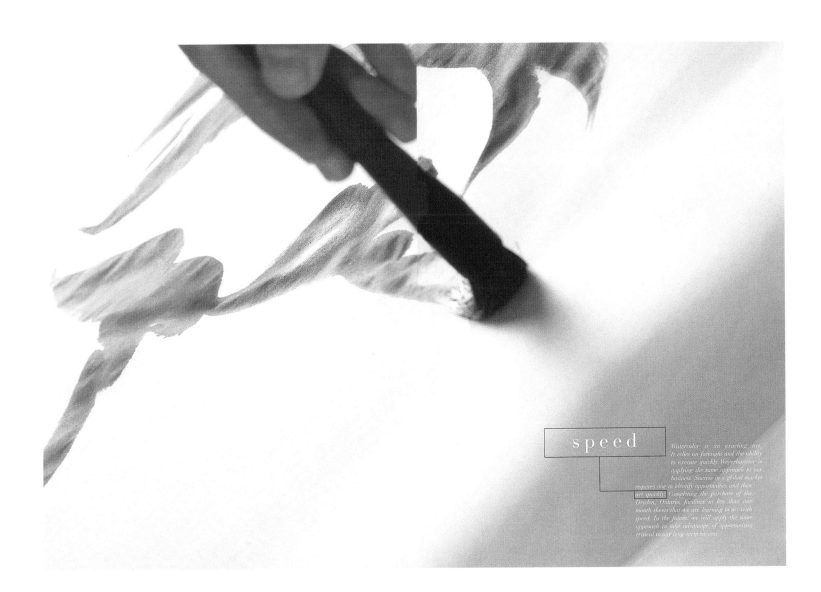

speed

Watercolor is an exacting art. It relies on foresight and the ability to execute quickly. Weyerhaeuser is applying the same approach to our business. Success in a global market requires one to identify opportunities and then act quickly. Completing the purchase of the Dryden, Ontario, facilities in less than one month shows that we are learning to act with speed. In the future, we will apply the same approach to take advantage of opportunities critical to our long-term success.

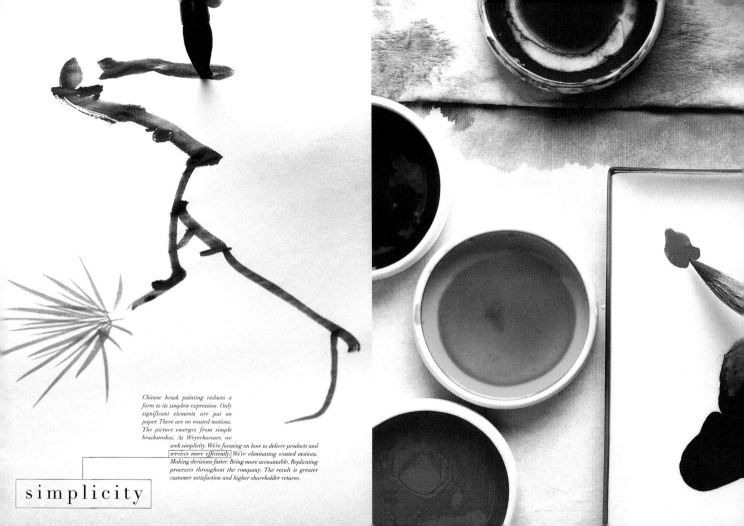

Chinese brush painting reduces a form to its simplest expression. Only significant elements are put on paper. There are no wasted motions. The picture emerges from simple brushstrokes. At Weyerhaeuser, we seek simplicity. We're focusing on how to deliver products and services more efficiently. We're eliminating wasted motions. Making decisions faster. Being more accountable. Replicating processes throughout the company. The result is greater customer satisfaction and higher shareholder returns.

simplicity

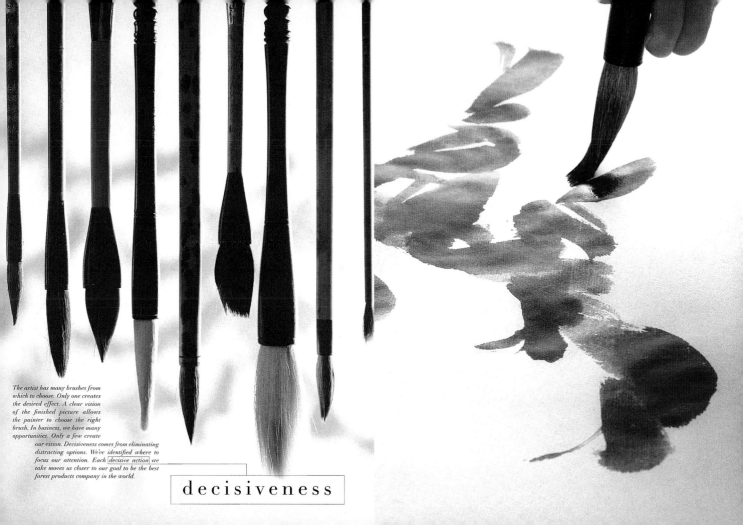

The artist has many brushes from which to choose. Only one creates the desired effect. A clear vision of the finished picture allows the painter to choose the right brush. In business, we have many opportunities. Only a few create our vision. Decisiveness comes from eliminating distracting options. We've identified where to focus our attention. Each decisive action we take moves us closer to our goal to be the best forest products company in the world.

decisiveness

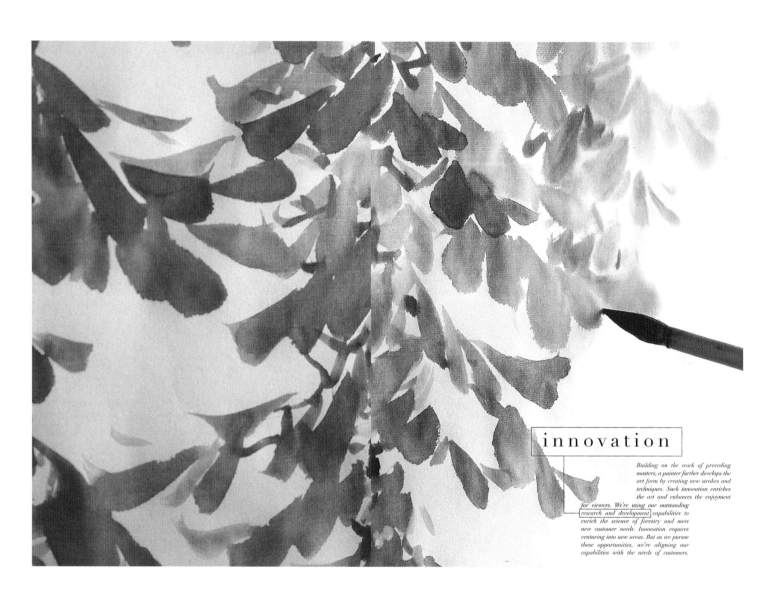

innovation

Building on the work of preceding masters, a painter further develops the art form by creating new strokes and techniques. Such innovation enriches the art and enhances the enjoyment for viewers. We're using our outstanding research and development capabilities to enrich the science of forestry and meet new customer needs. Innovation requires venturing into new areas. But as we pursue these opportunities, we're aligning our capabilities with the needs of customers.

WEYERHAEUSER ANNUAL REPORT

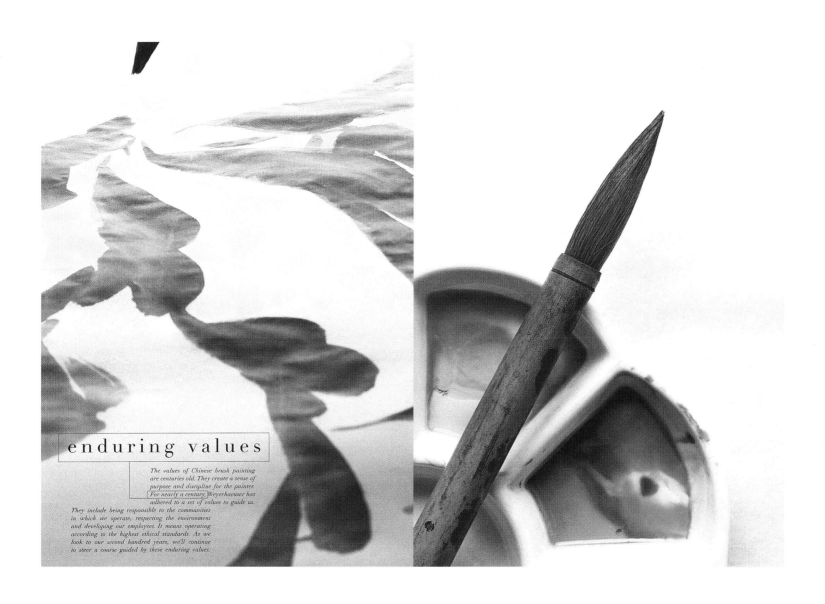

enduring values

The values of Chinese brush painting
are centuries old. They create a sense of
purpose and discipline for the painter.
For nearly a century, Weyerhaeuser has
adhered to a set of values to guide us.
They include being responsible to the communities
in which we operate, respecting the environment
and developing our employees. It means operating
according to the highest ethical standards. As we
look to our second hundred years, we'll continue
to steer a course guided by these enduring values.

Nintendo Co., Ltd. Annual Report: "HYPERLINK http://www.nintendo.com/corp/annual98"

NO OTHER PRODUCT MAY LEND ITSELF AS WELL TO AN ONLINE ANNUAL REPORT AS NINTENDO.

Leimer Cross Design Corporation produced a print and an online version of Nintendo's 1998 annual report. While both are exceptional, perhaps never before has the subject matter of an annual report been so perfectly suited to an Internet venue.

A Perfect Pairing of Technologies

Many companies post their annual reports online, and they are just that—a static computer-generated version of the printed page. To see something really unusual, surf over to Nintendo's site.

Nintendo's product emphasis—electronic games viewed on a computer or television screen—and the interactivity of the Internet make a perfect pair. Rather than offering a staid replication of its print annual report, Nintendo posted an online version as dynamic and interactive as its computer games.

"The greatest challenge in designing the online annual report was creating a Web interface to feel like part of Nintendo's own physical game interface while keeping in step with the design of the printed book," said designer Anne Conners.

Ready? Set? Go!

Because Web sites can attract a diverse audience, the goal was to keep the site easy to navigate and the message intact while exploiting the capabilities of the online environment whenever possible. Visitors are welcomed to the annual report page with a large image of a game controller. It is readily apparent how the Web site is navigated—simply point and click on the controller buttons. That's a fun and interesting twist on the usual menu bar.

"Static printed charts gain greater impact by engaging the user in retrieving the data in a different way," said Conners. "Static renditions of the games can't express the real gaming experience, but streaming media allows people to see real game footage in action online—the next best thing to being able to actually play the games."

CLIENT
Nintendo Co., Ltd.
DESIGN FIRM
Leimer Cross Design
Corporation
DESIGNER
Anne Conners
ART DIRECTOR
Kerry Leimer
ILLUSTRATOR
Nintendo EA3
COPYWRITERS
Don Varyu, Kerry Leimer

FONTS
Franklin Gothic; html fonts
Arial, Verdana, Geneva
HARDWARE
Dell WorkStation 400
SOFTWARE
Adobe Photoshop, Adobe
Pagemaker, Microsoft
FrontPage, RealMedia

Microsoft Corporation Annual Report

WANT TO BUILD TRAFFIC AT A WEB SITE? FOLLOW MICROSOFT'S EXAMPLE AND DIRECT READERS OF YOUR ANNUAL REPORT TO GO ONLINE FOR THE FULL STORY.

Few readers want to get bogged down in a copy-intensive annual report, no matter how well written. Nevertheless, the information it contains may be important and educational.

Keeping the Message Short and Sweet

Microsoft wanted to communicate seven messages succinctly. The messages ranged from how the company enables personal success in business, education, and leisure and addresses specific concerns of small businesses to how it enriches the consumer educational experience.

Full Disclosure Online

Instead of presenting each of these topics in depth, the annual report provides the key information in abbreviated headlines and copy.

"These topics were given an almost advertising-like presentation based on the assumption that greater product-level and policy-level detail was available in abundance online," said Kerry Leimer. "The underlying goal was to be direct, compact, and succinct, thereby encouraging readers to seek additional information from microsoft.com."

Accordingly, the graphics are as lively as the color palette. In fact, the book was issued with four different covers showing combinations of Microsoft's four corporate colors.

CLIENT
Microsoft Corporation
DESIGN FIRM
Leimer Cross Design
Corporation
DESIGNER/ART DIRECTOR
Kerry Leimer
PHOTOGRAPHER
Jeff Corwin
COPYWRITER
Kerry Leimer
PRINTER
George Rice & Sons

PAPER STOCK
Potlatch Karma 80# cover
and 100# text
PRINTING
cover
8 over 8 plus dull varnish,
produced in four versions
of brand colors;
text
6 over 6 inline web
SIZE
7" x 9 ½" (18 cm x 24 cm),
46 pages
FONT
Microsoft-modified Franklin
Gothic
PRINT RUN
1,200,000
HARDWARE
Macintosh
SOFTWARE
Adobe Pagemaker 6.5

Generating ideas and making discoveries is so integral to what we do that exciting **new possibilities emerge every day**. Possibilities for offering the flexibility that makes work rewarding for the individual while at the same time helping businesses increase the manageability of their information and their systems. Possibilities for making the way people interact with systems, and systems with people, more natural. Possibilities for continually lowering the cost of PC ownership while increasing the value. Possibilities for enhancing functionality and features while making everything instantaneous, transparent and simple. Possibilities for making everything integrated, compatible and intuitive. All our opportunities come from continuing to discover new possibilities. Our success is based on listening to our customers and turning these possibilities into valuable, marketable products capable of making the impossible, completely possible.

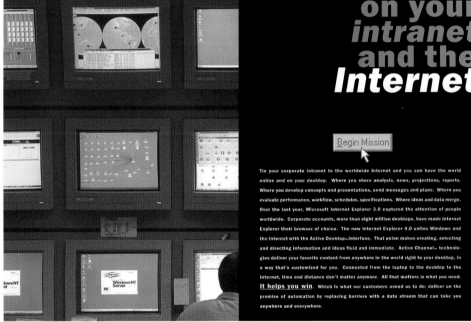

Tie your corporate intranet to the worldwide Internet and you can have the world online and on your desktop. Where you share analysis, news, projections, reports. Where you develop concepts and presentations, send messages and plans. Where you evaluate performance, workflow, schedules, specifications. Where ideas and data merge. Over the last year, Microsoft Internet Explorer 3.0 captured the attention of people worldwide. Corporate accounts, more than eight million desktops, have made Internet Explorer their browser of choice. The new Internet Explorer 4.0 unites Windows and the Internet with the Active Desktop™ interface. That union makes creating, selecting and directing information and ideas fluid and immediate. Active Channel™ technologies deliver your favorite content from anywhere in the world right to your desktop, in a way that's customized for you. Connected from the laptop to the desktop to the Internet, time and distance don't matter anymore. All that matters is what you need. **It helps you win**. Which is what our customers asked us to do: deliver on the promise of automation by replacing barriers with a data stream that can take you anywhere and everywhere.

Zale Corporation Annual Report: "Creating the Perfect Setting"

ZALE CORPORATION'S 1998 ANNUAL REPORT REPRESENTS THE EPITOME OF ELEGANCE AND GLAMOUR THROUGH A DESIGN THAT SHOWS ATTENTION TO DETAILS.

Zale's annual report theme, "Creating the Perfect Setting," evokes the craftsmanship that goes into jewelry making as well as the timing of gift giving at its most intimate. In both instances, careful attention to detail is required for success.

Attention to Enriching the Photography

The outline of the report is straightforward, focusing on the company's three retail divisions: Zales Jewelers, Gordon's, and Bailey Banks & Biddle. Each division is represented by one of three gift occasions—engagement, birthday, and anniversary—as photographed by Nancy Moran.

Scogin Mayo shot the exquisite product photography, which was enhanced by a process developed by Williamson Printing that integrates metallic inks into a four-color printed image. The result gives images—and jewelry in particular judging from

the results here—a luster and three-dimensional effect hard to find in even the most upscale jewelry catalogs.

Attention to Subtleties

The fine script and clean serif typeface is refined and the layout is polished, but the finishing touches add a special dash of interest. A line-art rendering of a ring encircles each page number, metallic inks distinguish the charts, and fancy endpapers lead in and out of the book.

"The final accent to the book was printing the table of contents on a translucent vellum fly sheet to be reminiscent of a wedding invitation," said designer David Beck. "This was one of the client's favorite parts to the annual report."

This annual report pays homage to the adage, "It's the little things that count."

	1998	1997	1996	1995	1994
			(In thousands except per share amounts)		
NET SALES	$1,313,710	$1,253,818	$1,137,377	$1,036,149	$ 920,307
EBITDA	$ 155,596[1]	$ 129,978	$ 103,242[1]	$ 78,038	$ 58,503
% of sales	11.9%	10.4%	9.1%	7.5%	6.3%
OPERATING EARNINGS	$ 133,391[1]	$ 115,956	$ 95,704[1]	$ 77,657	$ 62,888
% of sales	10.2%	9.2%	8.4%	7.5%	6.8%
NET EARNINGS					
Excludes unusual and extraordinary items	$ 63,345	$ 50,553	$ 42,109	$ 31,470	$ 23,125
Includes unusual and extraordinary items	$ 68,937	$ 50,553	$ 43,898	$ 31,470	$ 21,557
EARNINGS PER SHARE					
Excludes unusual and extraordinary items	$ 1.70	$ 1.38	$ 1.15	$.88	$.66
Includes unusual and extraordinary items	$ 1.84	$ 1.38	$ 1.20	$.88	$.62

(1) EBITDA and Operating Earnings exclude unusual credits of $5,947 related to the sale of the leased division and the sale of land in 1998 and $4,486 related to reorganization recoveries in 1996.

NET SALES
(IN MILLIONS)

EBITDA IN MILLIONS
(EXCLUDES UNUSUAL AND
EXTRAORDINARY ITEMS)

EARNINGS PER SHARE
(EXCLUDES UNUSUAL AND
EXTRAORDINARY ITEMS)

CLIENT
Zale Corporation

DESIGN FIRM
Sibley Peteet Design

DESIGNER/ART DIRECTOR
David Beck

PHOTOGRAPHERS
Nancy Moran, Scogin Mayo

COPYWRITER
Laura Moore

PRINTER
Williamson Printing
Corporation

PAPER STOCK
Strobe Gloss 100#

SIZE
8 ¾" x 11 ¼"
(22 cm x 28.5 cm),
30 pages

FONTS
Bauer Bodini, Caslon Open
Face, Copperplate, Gill
Sans, Helvetica

PRINT RUN
20,000

HARDWARE
Macintosh

SOFTWARE
Quark XPress 4.0, Adobe
Illustrator, Adobe Photoshop

Z A L E S J E W E L E R S

Known as Zales, The Diamond Store®, we opened our first store in Wichita Falls, Texas, almost 75 years ago. Among our customers, Zales stands for trust, credibility and reliability – an everlasting tradition embodied by all within our organization. Today, when Americans think of fine jewelry, they think of Zales Jewelers, one of the most prominent national specialty brands in the country.

The power of Zales is felt by men and women of all ages who are looking for a very special fine jewelry gift that is classic and traditional. The bridal category makes up a whopping 35 to 40 percent of our business, giving us the introduction to serve a customer for all of life's special occasions, while the remaining 60 percent represents fashion jewelry and watches. With our signature product offerings such as the holiday Keepsake box and the Zales Holiday Edition Collectible Bear® benefiting the Make-A-Wish Foundation of America, we give customers creative gift

ideas and incredible values year round that are rarely found in the fine jewelry industry.

In fact, Zales has led the way in innovative merchandising, which has contributed to our double-digit comparable store sales increases. Net sales rose by 19 percent this year to hit $738 million, an all-time high, while our average purchase continues to remain steady at $250.

To reach our broad customer base, we utilize a three-tiered media approach that balances item distinction, brand awareness and promotional stance. As our primary marketing medium, we use network television advertising that is product and price focused. We also use newspaper inserts, and for the first time this past year we placed insertions in national papers. Finally, we take full advantage of database marketing and send direct mailings to current and prospective customers throughout the year.

With the addition of 65 new stores this past year, we now operate 701 Zales stores nationwide and are clearly a national brand positioned to increasingly expand our market share. Our plan is to continue growing over the next five years and begin building our Zales Outlet concept. Direct fulfillment via our mail and phone order at 1-800-311-JEWEL, and our Internet site at www.zales.com, while small at this time, will continue to play important roles in Zales' future.

Today, when Americans think of fine jewelry, they think of Zales Jewelers, one of the most prominent national specialty brands in the country.

AVERAGE SALES PER STORE (IN THOUSANDS)

Classic
Traditional

A GIFT THAT SAYS, "I LOVE YOU." More people buy their diamond jewelry from Zales Jewelers than from any other jeweler in America. So it's no wonder that we have attended millions of weddings throughout our lifetime and today remain synonymous with trust, credibility and the beginning of a beautiful relationship.

G O R D O N ' S J E W E L E R S

Regional distinction that is fashion-forward and contemporary sets Gordon's Jewelers apart in the marketplace. From our spacious and inviting stores to our upper-moderate merchandise selection, Gordon's capitalizes on regional differences to provide a shopping experience that attracts up-market customers.

Building on its 93-year heritage, we have established Gordon's strength across the country. We continue to intensify our regional distinction in merchandising and marketing, a move that has pushed our average purchase to $300, well beyond last year's $274. Total sales increased to $309 million, up 10 percent, as average sales per store approached the million-dollar mark, giving further credence to Gordon's recognized brand identity.

Offering a regionalized merchandise assortment that makes up approximately 20 percent of our inventory, we have fine tuned our ability to tailor our product mix

to suit the tastes of our customers. Today, our sales consist of product that is stylish and contemporary, with fashionable jewelry and watches representing about 60 percent of our business. In addition, we have further distinguished ourselves by placing an emphasis on heightened customer service and superior salesmanship.

Gordon's regional approach also extends to its marketing program, where both broadcast and print are used to reach customers. This tiered media plan allows us to select the appropriate marketing vehicles tailored to each individual market.

With 317 stores, Gordon's Jewelers is the fourth largest fine jewelry chain in the country. Clearly re-established as a major retailing force, we are now poised for expansion when the right opportunities arise.

Regional distinction that is fashion-forward and contemporary sets Gordon's Jewelers apart in the marketplace.

AVERAGE SALES PER STORE (IN THOUSANDS)

S T Y L I S H
C O N T E M P O R A R Y

A GIFT THAT SAYS, "EVERY DAY'S A HOLIDAY." There is no better way to symbolize a significant occasion than with a radiant gift of fine jewelry from Gordon's Jewelers. Since 1905, we have helped create special moments that speak from the heart.

B A I L E Y BANKS & B I D D L E
FINE JEWELERS

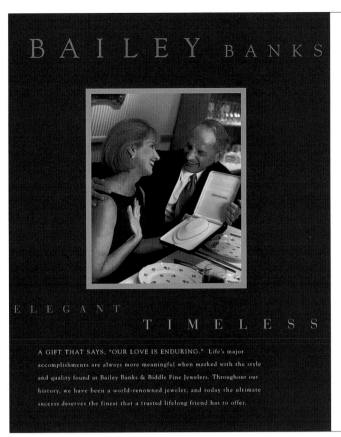

E L E G A N T
T I M E L E S S

A GIFT THAT SAYS, "OUR LOVE IS ENDURING." Life's major accomplishments are always more meaningful when marked with the style and quality found at Bailey Banks & Biddle Fine Jewelers. Throughout our history, we have been a world-renowned jeweler, and today the ultimate success deserves the finest that a trusted lifelong friend has to offer.

Today, Bailey Banks & Biddle Fine Jewelers reflects a style that is classic, traditional and timeless.

Since 1832, Bailey Banks & Biddle Fine Jewelers has assisted generation after generation in selecting the finest gift to celebrate life's most important occasions. Today, Bailey Banks & Biddle reflects a style that is classic, traditional and timeless. In the realm of fine jewelry, watches and giftware, this refined approach leads to a national upscale jewelry brand that is as distinctive as it is respected.

Our affluent customers know that they will find high-quality fashion product, including key designers, and a vast assortment of high-end branded Swiss watches when they shop with us. They will also find our service standard unlike any in retailing today. These characteristics are why we have a unique position in the marketplace and why our average sales per store reached $2.3 million this year, up from $2 million last year.

With 107 stores coast to coast, we continue to fine tune our merchandise assortments with each store's customers in mind. This transcends to marketing, too, where we reach out to customers primarily through targeted direct mail and upscale national magazine insertions. With an average purchase of $525, and net sales of $241 million, up 7 percent from last year, we are indeed touching our customers – those who seek value and trust from their jeweler.

As the Bailey Banks & Biddle name is unleashed in all markets across the United States, we will be uniquely positioned to capture significant market share as a national upscale specialty jewelry brand.

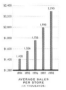

AVERAGE SALES
PER STORE
(IN THOUSANDS)

F I N A N C E

A strategic blend of planning and measuring res‑ ᵗhat provides for a solid financial foundation.

O VER THE PAST FOUR YEARS, ZALE CORPORATION HAS COME A LONG WAY IN IMPROVING ITS FINANCIAL OUTLOOK, AND THIS PAST YEAR WAS NO EXCEPTION. WE TOOK OUR CONTROLLED EXPENSE STRUCTURE TO EVEN GREATER HEIGHTS, TURNING IN AN IMPRESSIVE SELLING, GENERAL AND ADMINISTRATIVE EXPENSE OF 36.2 PERCENT OF SALES AGAINST LAST YEAR'S 38.3 PERCENT.

We turned our attention toward establishing a culture focused on improving return on investment, including all investment decisions for store openings, renovations, stock repurchases and other capital expenditures. And, in a bold strategic move, we divested ourselves of our leased business and redirected these important resources to our core mall-based business where we achieve a much higher rate of return. Throughout Fiscal 1998, we implemented significant financial initiatives that produced a solid capital base to further position our business for long-term growth.

Breaking away from the seasonality of the jewelry industry, Fiscal 1998 saw Zale record profits in each of the four quarters. This achievement marked another milestone as we demonstrated our ability to drive revenues and manage expenses year round.

Predictability was evidenced not only in earnings, but also with balance sheet improvements. Our forces went to work to ensure that all of our assets were generating optimal returns. In addition to the sale of our leased division, non-operating assets were sold and improvements were made in inventory management. All of these moves put us in a favorable cash position during the year, giving us the opportunity to capitalize on a $40 million share repurchase program. All totaled, we ended Fiscal Year 1998 with in excess of $170 million in cash. Now, with a very sound balance sheet, we can be assured that our internal store growth plans will be met and that we will be poised and ready to seize opportunities as they arise.

The financial organization continually searches for ways to bring improvements to the forefront that either create efficiencies or generate savings for the Company. This past year, a major systems initiative tied all financial systems together, enabling the financial areas to operate on a common platform. On top of that, a major overhaul in our daily banking procedure led to a bank account consolidation that will save half a million dollars, a direct net increase to the bottom line.

All of the accomplishments contributed by Zale's finance team undoubtedly strengthened our organization and gave us the wherewithal to continue growing our business and capturing even greater market share.

In a bold strategic move, we divested ourselves of our leased business and redirected these important resources to our core mall-based business where we achieve a much higher rate of return.

SG&A AS A % OF SALES

the new blue

the new blue

IBM Corporation Annual Report: "The New Blue"

IT'S HIP. IT'S FUN. IT'S MINIMALIST. IT DOESN'T LOOK LIKE YOUR FATHER'S IBM.

For years, IBM was the pinnacle of all that a successful enterprise should be. So dominant was IBM, it even influenced the fashion industry, setting new definitions for business fashion and corporate style. Those were the days of power suits and shoulder pads. Then the company lost its footing.

Amid a barrage of young upstart computer companies, IBM started to show its age, and what had previously defined corporate power styling now looked a little stodgy.

The New Blue
Today, IBM is back with a vengeance, proving that brilliant minds, innovative ideas, and youth are not the exclusive domain of California's Silicon Valley or the Pacific Northwest, hip techies can be found in Armonk, New York, too.

"After its fabled turnaround in the mid-1990s, IBM was positioned to regain industry leadership," said Matt Rollins, creative director. "The 1997 annual report was charged with

depicting this quest. IBM employees, as much as its technologies, are a primary source of the company's revitalized innovations, growth, and profitability. They are 'the new blue.'"

To prove the point, the 1997 annual report pictures more than one hundred IBM employees the world over. The cover, two versions of which were produced, is minimalist. Gone are the power suits. Instead, we see a male and female in jeans and khakis.

The balance of the photography is also lively and casual, as are the graphics and accompanying copy. The reader is irresistibly drawn in.

IBM seems a tad reluctant to give up entirely on its power suit image; it snuck in one photo of IBM specialists suited up and ready to do battle. It is a comforting photo. IBM may be new, but at heart, it's still "Big Blue."

CLIENT
IBM Corporation
DESIGN FIRM
EAI/Atlanta
DESIGNERS
Todd Simmons,
David Cannon
CREATIVE DIRECTOR
Matt Rollins
ILLUSTRATOR
Scott Menchin
PHOTOGRAPHERS
Norman Jean Roy,
George Lange, Carl Zapp
COPYWRITERS
Various
PRINTER
Anderson Lithograph

PAPER STOCK
Potlatch Mountie Matte
80# cover and text,
Mohawk Vellum 60# text
PRINTING
cover
duotone, 1 PMS,
and varnish;
editorial text
4 colors, 1 PMS,
and varnish;
financial text
4 PMS colors
SIZE
8 ½" x 11 ⅛"
(22 cm x 28.3 cm),
80 pages
FONTS
Bodoni, Helvetica Neue
PRINT RUN
1,600,000
HARDWARE
Macintosh
SOFTWARE
Quark XPress 4.0,
Adobe Illustrator 7.0,
Adobe Photoshop 4.0

Of course the world is changing.
It never stops.
The technology.
The pace.
The players.
What's far more interesting is
what incites change.
Every revolution,
Every school of philosophy,
Every movement worth joining,
Every defining enterprise
starts the same way.
Not with the grand or distant,
but with something near and personal.
It starts the same way. Every time.

It starts **here.**

Java **didn't** start here

THAT'S OK. Occasionally, you've got to be big enough to tip your cap to a competitor, and smart enough to build on something that can reshape the way software is developed and shared.

So we didn't do Java first. But IBM and Lotus are doing plenty of firsts with Java. Lotus's new eSuite "applets" are redefining personal productivity applications like word processors and spreadsheets. With

Enterprise JavaBeans, IBM and Lotus are taking Java into the world of high-volume transaction processing. And more than 200 software developers are working with IBM to create Java frameworks for general ledger, order entry and other business functions as a part of IBM's "San Francisco" project.

Two years ago, IBM had two Java professionals. Today, nearly 2,500, more than any other company.

Our people are busy right now, in more than 20 locations in 13 countries, including China, Latvia, Belarus, India, Canada, the United States and the United Kingdom. Because Java represents a revolution. And we've taken a stand.

22 IBM Java professionals from Austin, Texas, and Hursley, United Kingdom. 23

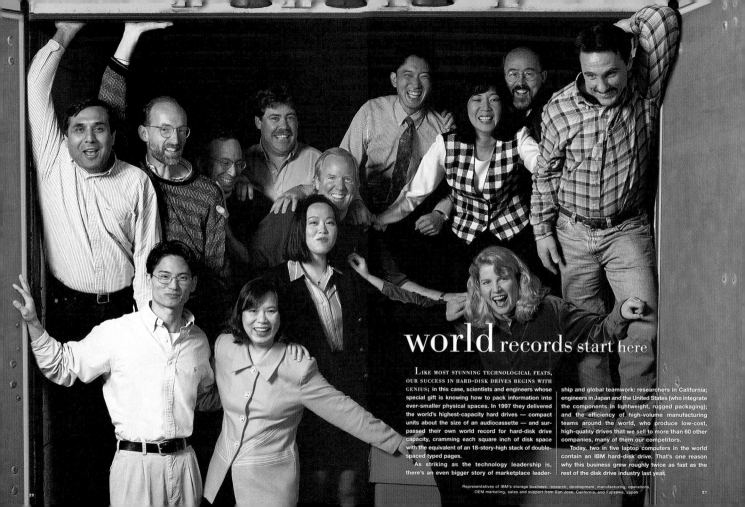

world records start here

Like most stunning technological feats, our success in hard-disk drives begins with genius; in this case, scientists and engineers whose special gift is knowing how to pack information into ever-smaller physical spaces. In 1997 they delivered the world's highest-capacity hard drives — compact units about the size of an audiocassette — and surpassed their own world record for hard-disk drive capacity, cramming each square inch of disk space with the equivalent of an 18-story-high stack of double-spaced typed pages.

As striking as the technology leadership is, there's an even bigger story of marketplace leader-ship and global teamwork: researchers in California; engineers in Japan and the United States (who integrate the components in lightweight, rugged packaging); and the efficiency of high-volume manufacturing teams around the world, who produce low-cost, high-quality drives that we sell to more than 60 other companies, many of them our competitors.

Today, two in five laptop computers in the world contain an IBM hard-disk drive. That's one reason why this business grew roughly twice as fast as the rest of the disk drive industry last year.

Representatives of IBM's storage business: research, development, manufacturing, operations, OEM marketing, sales and support from San Jose, California, and Fujisawa, Japan

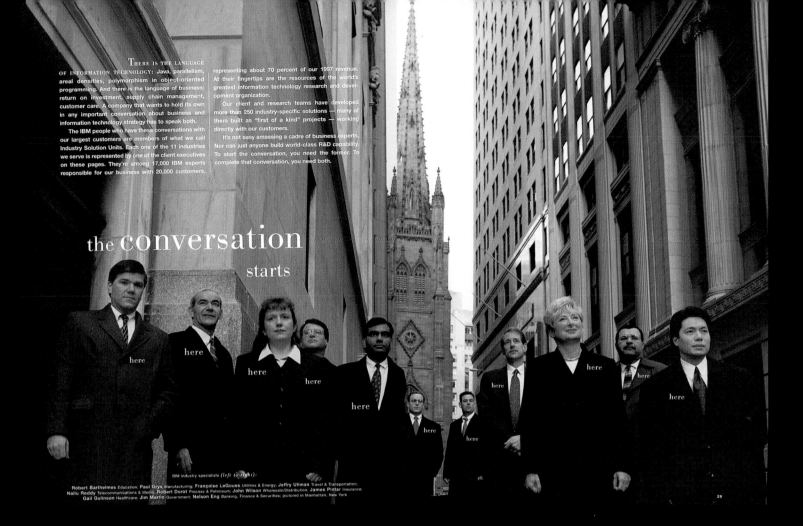

THERE IS THE LANGUAGE OF INFORMATION TECHNOLOGY: Java, parallelism, areal densities, polymorphism in object-oriented programming. And there is the language of business: return on investment, supply chain management, customer care. A company that wants to hold its own in any important conversation about business and information technology strategy has to speak both.

The IBM people who have these conversations with our largest customers are members of what we call Industry Solution Units. Each one of the 11 industries we serve is represented by one of the client executives on these pages. They're among 17,000 IBM experts responsible for our business with 20,000 customers,

representing about 70 percent of our 1997 revenue. At their fingertips are the resources of the world's greatest information technology research and development organization.

Our client and research teams have developed more than 250 industry-specific solutions — many of them built as "first of a kind" projects — working directly with our customers.

It's not easy amassing a cadre of business experts. Nor can just anyone build world-class R&D capability. To start the conversation, you need the former. To complete that conversation, you need both.

the conversation starts

here · here · here · here · here · here · here · here · here · here · here

IBM industry specialists *(left to right):*

Robert Barthelmes Education; Paul Grys Manufacturing; Françoise LeGoues Utilities & Energy; Jeffry Ullman Travel & Transportation; Nallu Reddy Telecommunications & Media; Robert Durot Process & Petroleum; John Wilson Wholesale/Distribution; James Pintar Insurance; Gail Gulinson Healthcare; Jim Martin Government; Nelson Eng Banking, Finance & Securities; pictured in Manhattan, New York

29

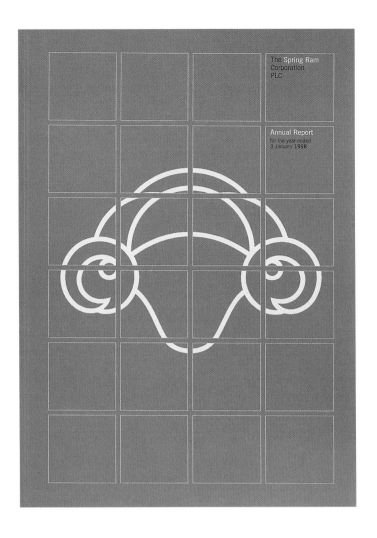

The Spring Ram Corporation plc Annual Report

SPRING RAM CORPORATION, ONE OF THE UNITED KINGDOM'S LARGEST MANUFACTURERS OF KITCHEN CABINETRY, BATHROOM FIXTURES AND ACRYLICS, AND FURNITURE, ASKED WPA PINFOLD TO KEEP DESIGN AND PRODUCTION COSTS FOR ITS 1997 REPORT AT 1994 LEVELS. WITH A LITTLE INGENUITY, THE DESIGN TEAM PULLED OFF THIS FEAT.

To minimize costs, extravagant photography and illustration were out. Without these visual elements, the design team recognized that a sound layout and, above all, typography would be vital to the report's graphic appeal.

Adhering to a Grid Layout
To achieve a clean, uniform design, designers often adhere to a grid-based layout, the guidelines of which are hidden from all but the computer layout program.

This report takes a different tact. The grid is not only visible but integral to the overall design. Designers Andy Probert and Phil Morrison created a report that is graphically defined by its type choice and based on a physical representation of a twenty-four-tile mosaic grid.

The cover, which has a mustard hue somewhat atypical of annual reports, features Spring Ram's logo, segmented within the tiles. Inside the report, portions of the ram's-head logo are repeated, creating a puzzle reminiscent of the old television game show *Concentration*.

Facilitating Photo Placement
The obvious grid layout not only organizes the report's contents and provides graphic interest but allows the designers to drop in photos of Spring Ram's products and mix and match them at will with the copy.

As a budget-conscious report, it works exceedingly well on all counts.

CLIENT
The Spring Ram Corporation
plc
DESIGN FIRM
WPA Pinfold
DESIGNERS
Andy Probert, Phil Morrison
ART DIRECTOR
Andy Probert
PHOTOGRAPHER
Rohan Van Twest
COPYWRITER
The Spring Ram Corporation
PRINTER
Cavendish Press

PAPER STOCK
Modo Graphic 300 gsm
and 155 gsm
PRINTING
cover and text
2 colors;
selected pages
4-color process
SIZE
8 ¼" x 11 ¾"
(20.5 cm x 30 cm),
52 pages
FONT
News Gothic
PRINT RUN
16,000
HARDWARE
Macintosh
SOFTWARE
Quark XPress

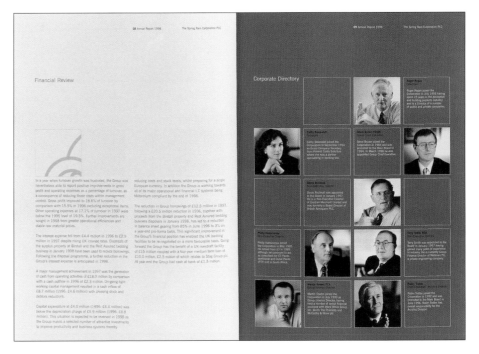

Hershey Foods Corporation Summary Annual Report: "Remember Your First Kiss?"

"REMEMBER YOUR FIRST KISS?" THIS CATCHY HEADLINE INVITES RECIPIENTS TO OPEN HERSHEY FOOD CORPORATION'S 1998 ANNUAL REPORT AND SETTLE BACK WITH THE FEELING THAT THIS IS GOING TO BE FUN.

Who doesn't remember their first kiss? It is something everyone can relate to, and even though readers know that they are talking about the foil-wrapped chocolate drop with the familiar white flag, they are enticed.

From the beginning, this report is something to be savored. The small size, the advertising headline are not the usual stuff of annual reports. But when your products inspire brand loyalty—and few do this as well as Hershey products—and are identified with memorable experiences—a first kiss—many of the rules change.

Asking Your Readers a Question
"What is your favorite candy?" This question is sure to inspire rapt attention and reap interesting answers. So this is exactly the question Hershey posed a sampling of stockholders. Their answers are seen in several vignettes that prompt readers to agree or voice a contradictory opinion on their favorite Hershey treat.

The photos are charming and the color palette is reminiscent of the hues in an old-fashioned ice cream parlor.

Sweetening the Financial Charts
The treatment of the financial charts is especially striking. Typically, the financials are the ho-hum portion of annual reports. There simply isn't much room for creativity.

Nevertheless, the design team at Addison managed to sweeten the financial section with Hershey products. Twizzlers of various lengths represent earnings per share, and stacks of Reese's Peanut Butter Cups indicate the amount of annual free cash flow.

Why do graphs seem so delectable when brown and orange Reese's Pieces track the EVA (economic value added) as compared to the stock price?

CLIENT
Hershey Foods Corporation
DESIGN FIRM
Addison
DESIGNER
Chris Yun
ART DIRECTORS
Leslie Segal, Chris Yun
PHOTOGRAPHER
David Katzenstein
COPYWRITERS
James A. Edris,
Natalie D. Bailey
PRINTER
L. P. Thebault

PAPER STOCK
Gleneagle Osprey Gloss
80# recycled cover and
100# recycled book,
Hammermill Bright Hue Sun
Yellow 60# recycled book
PRINTING
cover
4-color process, spot dull
and spot gloss varnish;
text
4-color process, 1 PMS,
and spot varnish;
back pages
2 PMS
SIZE
5 ¾" x 8 ¾"
(15 cm x 22 cm),
40 pages
FONTS
Helvetica Neue Rounded,
Helvetica
PRINT RUN
150,000
HARDWARE
Macintosh
SOFTWARE
Quark XPress 4.0, Adobe
Illustrator 8.0, Adobe
Photoshop 5.0

Or your first *Hershey's* Milk Chocolate Bar? Or *Reese's* Peanut Butter Cup? We asked a few of our stockholders to go back in time and share their thoughts about Hershey's products. Here is what they said.

"We love Reese's Peanut Butter Cups because they taste great and come two in a pack!"

| Marissa and Maria McDonald | Stockholders since 1992 | Compound Annual Growth Rate of stockholder value on 12/31/98: | 20.1% | Favorite product | Reese's Peanut Butter Cups Hershey's #1 Brand |

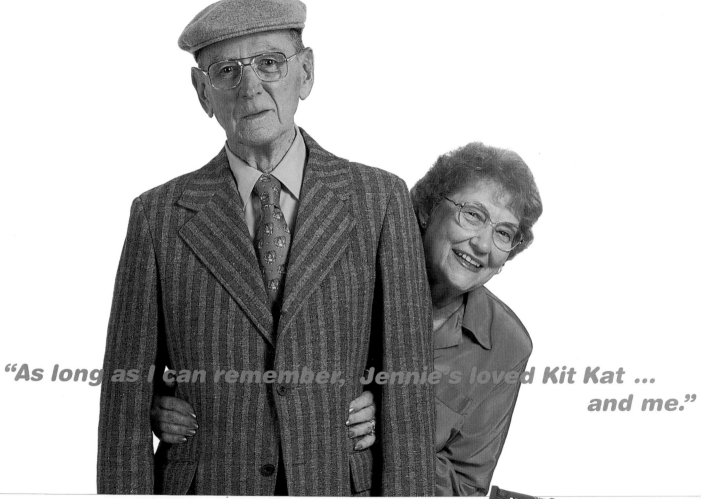

"As long as I can remember, Jennie's loved Kit Kat ... and me."

Walter and Jennie Horstick
70-something

Stockholders
since 1971

Compound Annual Growth Rate
of stockholder value on 12/31/98:
↑14%

Favorite
product

Kit Kat
CRISP WAFERS IN CHOCOLATE

Kit Kat
Sold in the U.S. by Hershey since 1970

Earnings Per Share (diluted)

From Continuing Operations

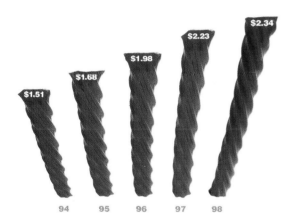

$1.51 — 94
$1.68 — 95
$1.98 — 96
$2.23 — 97
$2.34 — 98

Free Cash Flow

Dollars in Millions

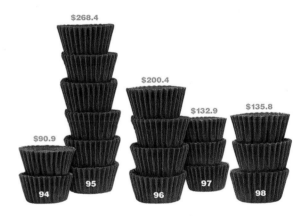

$90.9 — 94
$268.4 — 95
$200.4 — 96
$132.9 — 97
$135.8 — 98

Favorite product

Mounds
Acquired by Hershey
in 1988

Favorite product

Reese's Pieces
E.T.'s favorite candy

ANNUAL REPORT 1997

Schmalbach-Lubeca AG Annual Report

ANNUAL REPORTS BY NATURE ARE OLD NEWS, AND WHEN A REPORT IS COUPLED WITH AN ANNIVERSARY YEAR, ONE RISKS BECOMING MIRED IN THE PAST. FOR SCHMALBACH-LUBECA, CELEBRATING ITS HUNDREDTH ANNIVERSARY IN 1997, IT WAS IMPERATIVE THAT THE REPORT NOT LOOK BACK AT THE PAST BUT AHEAD, POSITIONING THE COMPANY AS FORWARD THINKING.

Schmalbach-Lubeca makes containers of all kinds—PET containers for soft drinks, hot-filled products, and foods, beverage cans, and closures for oxygen-sensitive, vacuum-packaged food and beverages.

Photographing the Invisible
"The challenge was to symbolize the innovation in a photo because packaging innovation takes place as abstract functions or in invisible dimensions," explained Felizitas Peters, art director, citing as examples the lightness of a PET container, a package's compatibility to lifestyle, or its closing and opening features.

"To visualize these abstract dimensions, we chose common symbols and combined them in one photo of pure photography. The photos were not edited in Photoshop."

A Balancing Act: Layout with Dominant Photography
To balance the typography and the dominant artistic photo treatment, the designer used a minimalist approach to layout. Strong vertical elements and large initial capitals on a white field create a delicate balance between text and graphics.

"The client's expectations were met since there was an intense cooperation in the creation process and the choice of products and symbols that were visualized," added Peters.

CLIENT
Schmalbach-Lubeca AG
DESIGN FIRM
HGB Hamburger
Geschäftsberichte
GmbH & Co.
DESIGNER
Anna Twes
ART DIRECTOR
Felizitas Peters
PHOTOGRAPHER
Jens Waldenmaier
COPYWRITER
Dr. Bernhard Löhn
PRINTER
Druckerci Wilhelm Zertaini

PAPER STOCK
Stora-Enso Multiart Silk
250 gsm and 135 gsm
PRINTING
6 colors, varnish, laminated
gloss foil on cover
SIZE
8 ¼" x 11 ¾"
(20.5 cm x 30 cm),
84 pages plus 8 page cover
FONTS
Univers, Meta
PRINT RUN
8,000 German, 5,000
English
HARDWARE
Macintosh
SOFTWARE
Quark XPress 4.0, Adobe
Illustrator, Adobe Photoshop

MANAGEMENT REPORT
FOR THE GROUP

Economic environment

Sales

Result

Investment

Financing

Employees

Research & development

Outlook

SCHMALBACH-LUBECA GROUP

PET CONTAINERS

The PET product group is the world's leading supplier of PET containers and preforms. PFT containers for soft drinks, mineral water, liquors, edible oil and other food products as well as for household cleaning agents and cosmetics are produced in 37 production facilities in Europe, the Americas and Asia. The product range consists of disposable and returnable PET containers in many different sizes and individual shapes. The PET product group works constantly on increasing the number of potential applications so that it can meet the needs of a dynamically growing market. The leading international position that is held in technology, development and quality will enable the PET product group to achieve strong growth in future as well.

SCHMALBACH-LUBECA GROUP

BEVERAGE CANS

The Schmalbach-Lubeca Group is one of Europe's leading beverage can manufacturers. Beverage cans are environmentally compatible, recyclable packaging containers that continue to be extremely popular all over the world. The product range of this product group consists of aluminium and tinplate cans with capacities of 150 to 500 millilitres for soft drinks, fruit juice drinks, mineral water, beer and a variety of what are known as "new age" drinks. The range has been increased and optimised on an ongoing basis over the years by introducing many different innovations and improvements. The Beverage Cans product group now produces at locations in Europe (France, Germany, Great Britain, the Netherlands and Poland) as well as in China.

growing

product

people

potential

Scheid Vineyards

1998 Annual Report

Scheid Vineyards Annual Report

BATHED IN A WASH OF SOFT PASTELS ACCENTED WITH ROYAL PURPLE, THIS REPORT FOR SCHEID VINEYARDS OFFERS RICH IMAGERY THAT APPROPRIATELY PROFILES A COMPANY THAT BEAT MOTHER NATURE.

"El Niño made 1998 agriculturally disastrous and therefore financially challenging for Scheid Vineyards," said Petrula Vrontikis, noting that despite the tough year, Scheid remained profitable—a considerable feat considering the circumstances.

Spreading the Good News
Holding steady and remaining profitable despite the travails was good enough news to necessitate an increase in the annual report budget, allowing for more use of stock and custom photography than in past years.

"The client remained interested in giving shareholders as much insight as possible into the world of growing and harvesting grapes for wine making," said Vrontikis.

A Two-Color Palette
The investment in the photography was worthwhile. The cover sets the stage with a photograph of leaves that appear almost gilded alongside lush purple grapes. The photo is set atop a pale green canvas screened with an illustrated vine pattern.

Inside the report, the vine pattern is repeated with considerable impact on a purple background with lively photos illustrating the earth, nature, and time. It is repeated again on the financial pages, dressing up already positive numbers.

Throughout the report, the pale green and royal purple beautifully complement one another, and although the report is printed in four-color process, these two shades are at its heart. However, because these two colors are so distinctive and integral to the design, they were tough to print as process colors.

"There were many challenges on press as many PMS to process match tints needed to be recalculated to print properly on uncoated paper," said Vrontikis.

The layout is based on an easy-to-read three-column grid, and the facing photo pages echo the tricolumn format through placement of square-cut photos.

The color palette is both soothing and lush, and Vrontikis's choice of Mrs. Eaves as the primary typeface is simple and elegant.

CLIENT
Scheid Vineyards

DESIGN FIRM
Vrontikis Design Office

DESIGNER/ART DIRECTOR
Petrula Vrontikis

PHOTOGRAPHER
Various

COPYWRITER
Heidi Scheid

PRINTER
Color Service

PAPER STOCK
Neenah Classic Crest
Solar White 65# cover

PRINTING
4-color process

SIZE
11" x 8 ½"
(28 cm x 22 cm),
26 pages

FONTS
Mrs. Eaves, Officina Sans

PRINT RUN
5,000

HARDWARE
Macintosh

SOFTWARE
Quark XPress 3.31

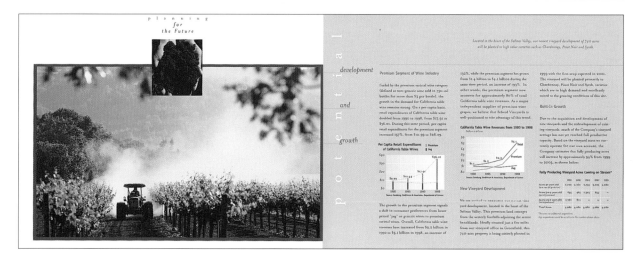

SERVICES

IN THE GLOBAL marketplace, people lament, "Service isn't what it used to be." No, it isn't.

Perhaps that's why we buy books and trade stocks online, buying and selling shares at a click of the mouse. We can even buy clothes, cosmetics, and drugstore sundries at virtual shopping malls. We navigate complex hierarchies of voice mail until we reach the automated information we seek. We opt for automatic teller machines over the bank teller and can conduct all our banking from the computer. We don't need to visit the library; all the reference materials we might want can be found on the Internet.

Almost everything we need or want can be delivered overnight or downloaded instantaneously. Is there really any need for personal interaction?

There is no doubt about it—service and how it is delivered has changed. While consumers may be encountering less one-on-one service, whether by preference or not, in many cases the quality of the service received may actually be improving.

Competition is vigorous, and service-oriented companies know it. They understand that if they are not only to survive but prosper, they must offer service at its best or risk losing customers to a competitor. To maintain customer loyalty, service companies must differentiate themselves. They must pay close attention to detail.

When a service company can do all this—and make it personal—it shows. It's evident in everything they do—including their annual reports—the perfect mirror of the corporate personality.

"DESIGNERS CONTINUE TO RAISE THE LEVEL OF EXCELLENCE WITH RESPECT TO ANNUAL REPORT DESIGN. THE QUALITY OF ANNUAL REPORTS IS IMPROVING EACH AND EVERY YEAR AS COMPANIES REALIZE THE ADVANTAGES THAT A HIGH-QUALITY ANNUAL REPORT OFFERS."—JERRY FRENCH, PRESIDENT, FRENCH PAPER

BIG

FUTURE

ROCKET Racer

KBH

Policy Management Systems Corporation Annual Report

AS A PROVIDER OF ENTERPRISE SOFTWARE AND SERVICES TO THE GLOBAL INSURANCE AND FINANCIAL SERVICE INDUSTRIES, POLICY MANAGEMENT SYSTEMS CORPORATION (PMSC) APPROACHED ITS ANNUAL REPORT CONSERVATIVELY, BUT WITH STYLE.

PMSC's 1997 annual report is conservative, stylish, and forthright.

The cover introduces the "+" theme, the concept of in-house designer Barry Townsend, symbolizing the company's newly added facilities, employees, and products. The cover artwork is engraved in black over a white opaque foil stamp, giving the cover a crisp, clean appearance that would have been less effective if offset printed on the uncoated paper. Moreover, the engraving gives the cover texture and a focal point on an otherwise smooth, uncoated sheet devoid of other imagery.

All the Elements Add Up

Inside the report, Townsend uses conceptual photos of adding machines, so that, as the reader turns the pages, the adding machines evolve from antique models to computer laptops. This progressive action reinforces the addition theme while illustrating the company's constant innovation.

The pages are tabbed for easy access to the four sections of the book; the tabs even resemble the buttons on an adding machine. The copy is easy to access, too, presented in large, justified blocks of sans serif type.

CLIENT
Policy Management
Systems Corporation
DESIGN FIRM
In-house
**DESIGNER/ART DIRECTOR/
ILLUSTRATOR**
Barry Townsend
PHOTOGRAPHER
George Fulton
COPYWRITERS
Tom Poland, Sam Morton,
Cal Harrison
PRINTER
State Printing

PAPER STOCK
French Speckletone
Standard Silver 80# cover,
French Construction
Recycled White 70# text,
French Dur-o-Tone Newsprint
White 70# text
PRINTING
cover
1-color lithography, opaque
white foil stamp, black
engraving, rounded corners;
text
6 colors
SIZE
8" x 11" (20 cm x 28 cm),
72 pages
FONTS
Trade Gothic, Adobe
Garamond
PRINT RUN
30,000
HARDWARE
Macintosh
SOFTWARE
Quark XPress 4.0,
Macromedia FreeHand 7.0

POLICY MANAGEMENT SYSTEMS CORPORATION IS HEADQUARTERED IN COLUMBIA, SOUTH CAROLINA. THE COMPANY, TRADED ON THE NEW YORK STOCK EXCHANGE UNDER THE SYMBOL PMS, IS A LEADING PROVIDER OF ENTERPRISE SOFTWARE AND ELECTRONIC COMMERCE, RELATED PROFESSIONAL SERVICES, AND BUSINESS PROCESS OUTSOURCING, DESIGNED TO MEET THE NEEDS OF THE GLOBAL INSURANCE AND FINANCIAL SERVICES INDUSTRIES.

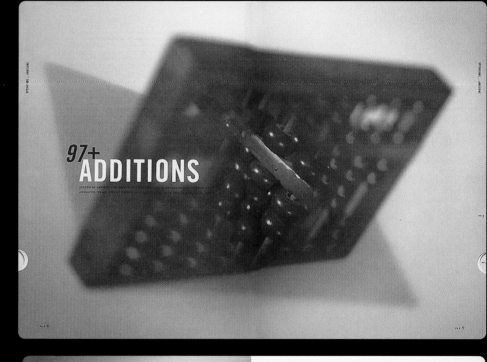

97+
ADDITIONS

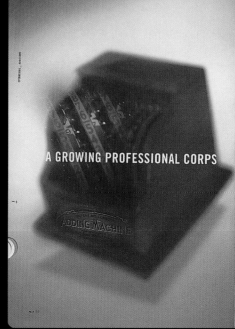

A GROWING PROFESSIONAL CORPS

A GROWING PROFESSIONAL CORPS Strong demand for our products and services grew the employee base from 5,093 full-time employees to 6,017. To better serve our clients and execute our missions, we delivered over 100,000 hours of training that enabled our employees to further develop their skills and professionalism. By the end of 1997, our employees held more than 860 insurance and financial services professional designations. By expanding our partnership with a leader in educational interactive software for information technology, we significantly increased global, enterprise-wide training opportunities. Over 100 new course titles were added to the PMSC University curriculum to increase the skills and capabilities of our employees—a distinct, competitive advantage for the Company.

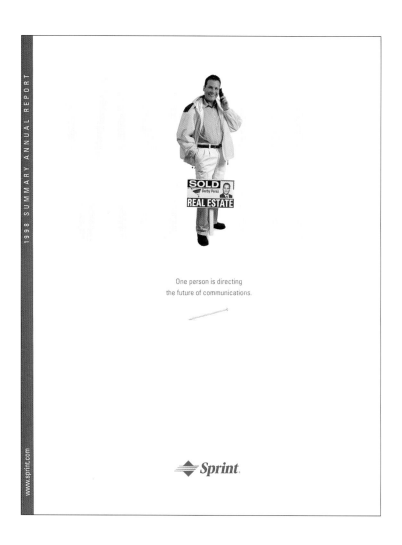

One person is directing
the future of communications.

Sprint.

Sprint Communications Annual Report

DID YOU EVER WANT AN ANNUAL REPORT TAILORED JUST TO YOU? WELL, SPRINT DELIVERS JUST THAT IN ITS 1998 ANNUAL.

Sprint Communications, a recognized industry leader with local, long distance, wireless, Internet, data, and international capabilities, says they have something for everyone. Their goal, or vision, is to enable each individual to define their own communications universe.

Collect All Eight

Falk Harrison Creative breathes life into this lofty objective by personalizing the annual report with eight different covers. Eight individuals, each with their own lifestyle and specific telecommunications needs—from a teenage girl to a real estate salesman on the go to a young "Webmeister"—aptly demonstrate that Sprint "takes you right where you want to be."

Sprint's Vision

The title of the report, *Vision,* communicates that Sprint is different from its competitors and is correctly positioned to compete in a changing marketplace in the near- and long-term. As evidence of this, stories of Sprint's partnerships and new business endeavors are told in copy that pulls the reader in.

Did you know that the Bellagio Resort and Casino, which opened on the Las Vegas strip on October 1998, uses what is believed to be the largest telephone switch in North America?

For more little-known Sprint facts, check out one of the company's 1998 reports. Better yet, collect all eight.

CLIENT
Sprint Communications
DESIGN FIRM
Falk Harrison Creative
DESIGNERS
Kenneth J. Kuehnel,
Jennifer L. Sagaser
ART DIRECTORS
Robert J. Falk,
Kenneth J. Kuehnel
ILLUSTRATORS
Various
PHOTOGRAPHERS
Mark Joseph,
Humberto Ramirez
COPYWRITER
Sprint Corporate
Communications
PRINTER
Avanti Case-Hoyt

PAPER STOCK
Mead Nature Gloss 100#
cover and book
PRINTING
4-color process plus
two PMS
SIZE
8 ½" x 10 ⅞"
(22 cm x 27 cm),
46 pages
FONTS
Univers, Adobe Garamond
PRINT RUN
525,000
HARDWARE
Macintosh
SOFTWARE
Quark XPress 3.32

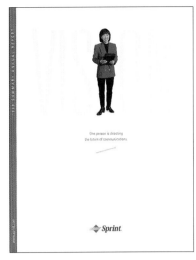

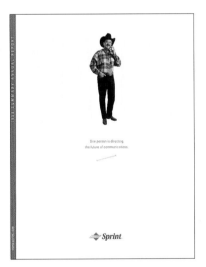

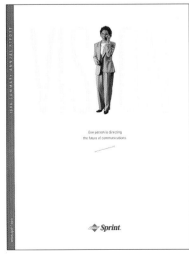

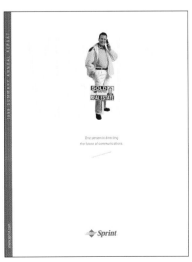

Sprint is a global communications company, at the forefront in integrating long distance, local, wireless and Internet communications services.

Sprint developed and operates the United States' only nationwide, all-digital, fiber-optic network and is a leader in advanced data communications services. The company is also one of the world's largest carriers of Internet traffic. In addition, Sprint operates the largest 100% digital, 100% PCS nationwide wireless network in the United States.

Sprint has more than $17 billion in annual revenues and serves more than 17 million business and residential customers.

Founded in 1899, Sprint is celebrating its 100th anniversary of telecommunications service. Sprint's world headquarters is in metropolitan Kansas City.

You have a life and a vision all your own.
You need to communicate exactly how and when you choose.
Sprint lets you define your own communications universe,
and takes you right where you want to be.

William Hornbuckle Impressive Impresario
Allison Tess High Flyer
Emily Veth Connected Entrepreneur
Josh Jakubo Web Meister
Julie Postal Fabulous Friend
Mike Murad Big Thinker
Tammy Lambert Modern Mom
Derby Perez Digital Dealmaker

Sprint 1998 Summary Annual Report 1

→ In 1998, Sprint introduced a new communications concept — *Sprint Unlimited*. The new standard for residential long distance pricing gives consumers unlimited long distance calling on weekends for a flat rate of $25 a month.

→ Sprint Solutions is a package of discounted local toll calling and custom calling features. Based on 1998 success in North and South Carolina, Sprint has expanded the Sprint Solutions package to seven other states. Katrina Murphy, right, a Sprint sales representative in New Bern, North Carolina, sells the bundled package that includes such features as Caller ID and Three-Way Calling.

Treating you as one customer

You are the one person directing the future of communications. Sprint is pulling together to serve you as one visionary company.

Sprint is listening to you, the customer, and this is what we hear you saying:

"I am one communications customer: not a local customer over here, a long distance customer over here, a wireless customer over here, or a data customer over there."

"Splitting me up into pieces is confusing. A hassle. An insult, even. So treat me as one person."

"Give me one easy-to-use connection that changes moment-to-moment to meet my individual needs, and follows me wherever in the world I choose to go."

"Give me one place to call for assistance when I need it."

"And give me one bill that's easy to understand and easy to pay."

Indeed, you are one demanding customer.

Sprint is ahead in the race to be the one and only company you need to satisfy your communications demands.

Of course, you also are, in all probability, a shareholder of Sprint. So we will tell this story from two points of view. We will show how Sprint is using its diverse assets to serve you as one customer. We will also show how Sprint's strategy is adding value to your investment.

1998 Year in Review

February 10
Sprint and Global One announced a $43 million contract to provide worldwide communications for Siebe plc, one of Britain's largest diversified engineering groups. The 42-month contract will improve Siebe's business performance by consolidating the company's voice, data and international communications worldwide.

6 Sprint 1998 Summary Annual Report

Sprint 1998 Summary Annual Report 7

The Bellagio Resort and Casino, which uses what is believed to be the largest installed telephone switch in North America, opened on the Las Vegas Strip in October 1998. Sprint has contracted a total Sprint solution for all Mirage properties, which include the Bellagio, Mirage, Golden Nugget and Treasure Island in Vegas. Sprint's business efforts are led by Jaime Jones, left, and Liz Byland, vice president and general manager.

Sheldon G. Adelson is chairman of the board for Las Vegas Sands, Inc., the developer of the new Venetian Hotel. The Venetian will open in April 1999 as an all-suite hotel and casino with more than 3,000 rooms and a 1.6 million square-foot convention center.

William Hornbuckle, right, is president and chief operating officer of the MGM Grand in Las Vegas — the world's largest hotel — and Corey Sanders is MGM Grand's senior vice president and chief financial officer. Sprint has a three-year agreement to be the official telecommunications provider for all MGM Grand Inc. properties.

Richard J. Goeglein is president and CEO of Aladdin Gaming, LLC. Sprint will serve the property, which is being rebuilt on the existing site where the old Aladdin was imploded. The 2,600-room Aladdin will open in April 2000, to be followed with the development of a 1,000-room, music-themed hotel/casino property.

Brian McMillan is president of THE RESORT AT SUMMERLIN, which will open in the second quarter of 1999. Sprint not only will provide local, long distance and PCS services to the resort and casino, but also is delivering broadband services to the entire 50,000 new home Summerlin planned community.

Las Vegas: A Showcase for One Sprint in Action

"Sprint has become the essential ally with the newest luxury resorts in Las Vegas. The most dynamic businesses in Vegas demand access to the latest and the best telecommunications services," says Eric Tom, area vice president for Sprint Business.

Residents and businesses throughout Las Vegas use Sprint's local, long distance and wireless networks for a full portfolio of products and services — from telecom equipment, local access and data networking to Internet and video services, PCS phones, pay phones and prepaid long distance calling cards.

SPRINT COMMUNICATIONS
ANNUAL REPORT

we have something to say

Jacor Communications, Inc. Annual Report

WHEN COMPANIES HAVE A BANNER YEAR, THEY WANT TO BROADCAST THE NEWS FROM THE ROOFTOPS, BUT SOMETIMES THEY HOLD BACK AND APPROACH THEIR ANNUAL REPORTS CONSERVATIVELY. JACOR COMMUNICATIONS, A RADIO HOLDING COMPANY, HAD A BIG YEAR—AND NOTHING COULD HOLD THEM BACK FROM SHOUTING IT TO THE WORLD.

"The theme of this annual report is "The Voice of Jacor." It is large," said Robert Petrick of the annual report that covers half the reader's desk. Its size, the cover's extreme close-up of a mouth in mid-shout, and the headline grab our attention— "We have something to say."

Okay, We'll Listen

Jacor does not beat around the bush. The forthrightness of this annual report is refreshing. After all, the purpose of annual reports is to describe the company's performance, provide the necessary financial information, disclose what it has done and is planning to do, and, if the year was a good one, boast a little.

This was the case with Jacor Communications. They announced mergers and acquisitions totaling $1 billion, boosting them from the number nine spot to the number four spot of American radio companies and propelling them to a position among key players in their industry.

Tell It Big

Contrary to traditional annual reports, where the financials are tucked in the back of the book, Petrick Design puts Jacor's on the inside front cover so there is no missing the message. Graphically, the imagery is larger-than-life. The copy is equally to the point. On one spread, the copy reads, "Jacor stations do a great job of grabbing target listeners' attention with sometimes outrageous, always creative billboards, TV ads, and listener events."

Reading this annual report is like a study in popular culture, reminding the reader of the many surprising, often bizarre events of the year. Jacor played a role in all of them.

CLIENT
Jacor Communications, Inc.
DESIGN FIRM
Petrick Design
DESIGNERS
Robert Petrick, Laura Ress
ART DIRECTOR
Robert Petrick
ILLUSTRATORS
Mark Heckman, various
PHOTOGRAPHERS
Paul Ellidge, various
COPYWRITER
Kirk Brewer
PRINTER
The Hennegan Company

PAPER STOCK
Finch Fine VHF White
80# text
PRINTING
4-color process with special
red and yellow
SIZE
19 ½" x 26"
(50 cm x 56 cm),
16 pages plus cover
FONT
News Gothic
PRINT RUN
15,000
HARDWARE
Macintosh
SOFTWARE
Quark XPress 3.3

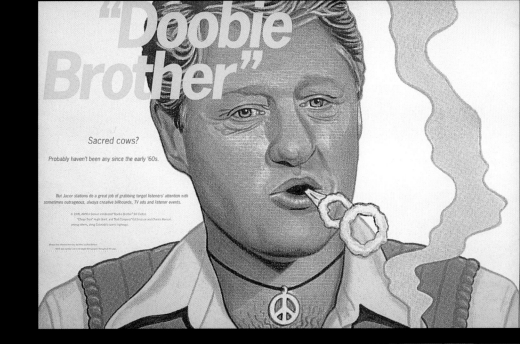

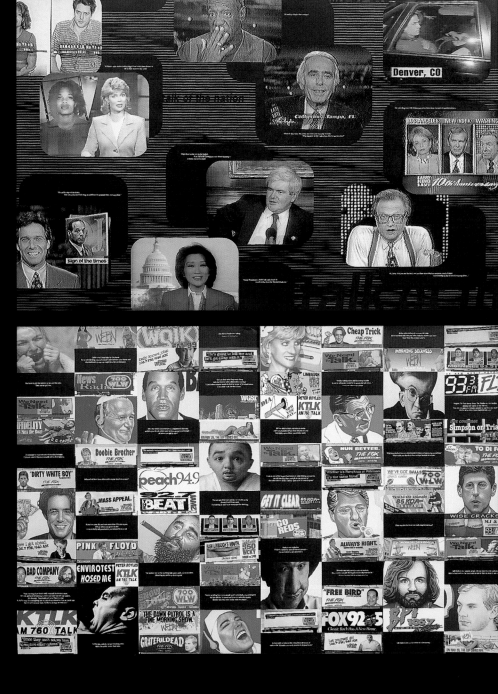

The Registry, Inc. Annual Report

INNOVATIVE, MULTI-IMAGE PHOTOGRAPHY ACCENTED WITH ABUNDANT COLOR MAKES THE REGISTRY'S ANNUAL REPORT, DESIGNED BY WEYMOUTH DESIGN, STAND OUT.

The Registry, a leader in the field of knowledge management consulting, wanted to take an innovative approach to its first-ever annual report.

As with any company that does not have products to illustrate its promotional materials and annual report, conceptual photography is vital to grab and sustain reader interest. However, conceptual photos are often beautiful to look at but communicate little.

Using Photography to Differentiate

Weymouth Design's idea was to create a series of targeted photographic images representing various business concepts associated with knowledge management consulting and to juxtapose these with duotone images of key management.

In the company's capabilities brochure produced before going public, photographer Bruce Rogovin had demonstrated his knowledge of the business and his expertise, so he was the natural choice to work on the annual.

Creating in the Darkroom

Rogovin created five montages, each consisting of five or six photographic images, layered, blended, and inextricably linked in a single memorable graphic. "Bruce's montages are created in the darkroom, as opposed to on a computer, so each image is one of a kind and requires considerable time and effort to create," said art director and designer Tom Laidlaw. "This forced us to be very specific with our concepts and selection of imagery for the book."

The paper stock further enhances the photography. The four-color photography is printed on a cream-colored coated paper to obtain maximum color fidelity and faces a text page printed on a matching uncoated stock chosen for maximum readability.

According to Laidlaw, a significant portion of the budget was allocated to photography because Weymouth Design felt strongly that it would make a significant impact on the report's readers. The Registry's first annual report is evidence that the investment paid off.

CLIENT
The Registry, Inc.
DESIGN FIRM
Weymouth Design
DESIGNERS
Sheri Bates, Tom Laidlaw
ART DIRECTOR
Tom Laidlaw
PHOTOGRAPHERS
Bruce Rogovin Photography,
Mike Weymouth
COPYWRITERS
George Bates at
Renaissance, The Registry
PRINTER
MacDonald & Evans

PAPER STOCK
Karma Natural 80# cover
and text, Mohawk Vellum
80# text
PRINTING
6 colors
SIZE
7 ¼" x 10 ¾"
(18.5 cm x 27 cm),
46 pages
FONTS
Bembo, Franklin Gothic
PRINT RUN
7,500
HARDWARE
Macintosh
SOFTWARE
Quark XPress 3.32

We offer service excellence by understanding our customers' business challenges and applying information technology to enhance their competitive advantage.

Our vision allows us to understand changing industry dynamics and proactively identify better ways to serve our customers.

We have developed a culture of absolute integrity built around a philosophy of continuous improvement, challenge and responsibility.

GaSonics International Annual Report

STERILE IS NOT NECESSARILY A DESIRABLE DESIGN ELEMENT, BUT IN THE CASE OF GASONICS INTERNATIONAL ANNUAL REPORT, IT WAS EXACTLY THE LOOK CAHAN & ASSOCIATES WANTED TO CONVEY AT FIRST GLANCE.

GaSonics International specializes in high-tech semiconductor cleaning, a critical component in semiconductor manufacturing. As manufacturers introduce new materials, GaSonics develops new cleaning processes to remove tougher residues from increasingly smaller areas.

The Closest Thing to Cleanliness

To promote the idea of cleanliness, Cahan & Associates appear to have modeled the outside of the annual report after a clean room—white, uncluttered, sterile, and antiseptic. The report comes sealed in an opaque vellum envelope perforated along the edge for easy opening.

To heighten the effect, GaSonic's name is vertically blind embossed, leaving the cover blank except for the small red type at the bottom.

High-Impact Color

Inside the book, the calm purity of the theme is offset with high-impact color that provides the backdrop for innovative charts and graphs. The company's complex technology is rendered in relatively simple diagrams saturated with red, green, yellow, and blue.

The charts are accented with a cast of characters from a 1960s sitcom—the efficient housewife, nosy neighbor, and businessman husband. The humorous approach, combined with skilled copywriting, make this annual infinitely readable.

CLIENT
GaSonics International
DESIGN FIRM
Cahan & Associates
DESIGNER
Sharrie Brooks
ART DIRECTOR
Bill Cahan
PHOTOGRAPHER
Various
COPYWRITER
Thom Ellkjer of Executive
Communications
PROJECT MANAGER
Liza Thomson
PRINTER
George Rice & Sons

PAPER STOCK
Starwhite Vicksburg Tiara
Hitech 80# cover, Cougar
70#, Curtis Parchment
49#, Cougar Opaque Vellum
80# text
PRINTING
4-color process
SIZE
8 ¾" x 11 ¾"
(22 cm x 30 cm),
42 pages
FONTS
Univers 55, Adobe Caslon
PRINT RUN
10,000
HARDWARE
Macintosh
SOFTWARE
Quark XPress, Adobe
Illustrator, Adobe Photoshop

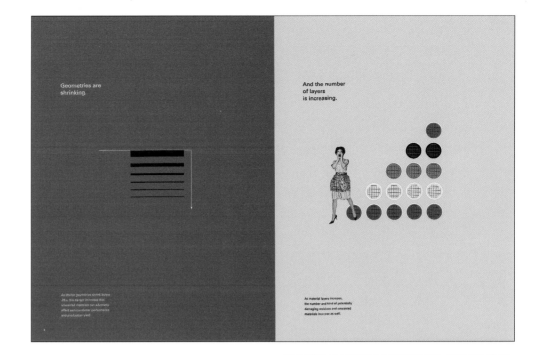

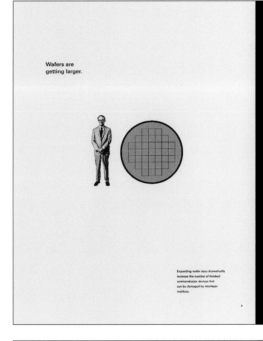

Removing unwanted materials from the etched wafer is a more challenging and fragmented process than ever. GaSonics cuts through the complexity with advanced process technology and integrated solutions.

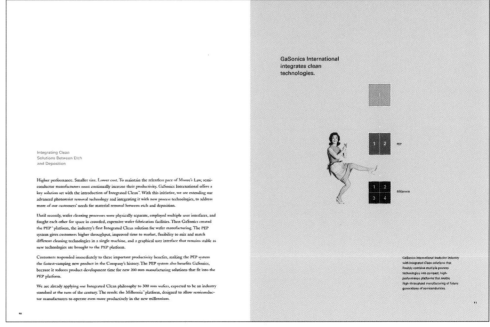

CAUTION: CONTAINS AN EXPLOSIVE
IDEA THAT MAXIMIZES
CORPORATE PERFORMANCE
AND SHAREHOLDER VALUE.

Kaufman and Broad Home Corporation Annual Report

THINK BIG! THAT'S EXACTLY WHAT THE LOUEY/RUBINO DESIGN GROUP DID WHEN THEY TIED THE ANNUAL REPORT FOR THE KAUFMAN AND BROAD HOME CORPORATION INTO THE CLIENT'S EXISTING ADVERTISING PROGRAM.

Often, annual reports are treated as stand-alone entities, independent of the company's ongoing communications programs and promotional campaigns. Kaufman and Broad Home Corporation was no different—until the time came to ready its 1998 annual report, and it was decided that the report should tie into the advertising program.

Think Big!
"Think Big" was not only the advertising and marketing theme currently in place for Kaufman and Broad, it also reflects the company's core philosophy. Moreover, in recent years, Kaufman and Broad had undergone a significant restructuring, now complete, and the company was poised to present its new self.

These factors, coupled with the need to accommodate the increased amount of information without looking complex or text-heavy, all played into the "Think Big" theme for the report and prompted the oversized layout.

Presenting Big!
The impact is powerful and immediate. The cover is big and bright red with "kb98" in a distinctive deboss. Next, the eye travels to the wraparound label that seals the annual with copy that piques our interest. Inside, the "Think Big" slogan is spelled out in a collage that repeats the message in different-sized fonts and colors on the page.

The photography is vivid and realistic, appearing three-dimensional in many of the shots. The 3-D's effect is emphasized by overprinting the headlines in metallic silver ink screened back to 70 percent for a translucent effect. The copy is large, as are the graphics, and the colors are bold. The huge, oversized format of the financial charts, in particular, are a delight. It's like looking at the figures under a giant magnifying glass.

"Going to a larger format immediately gave the pages more space as well as making Tyler Boley's photography more dynamic," said Robert Louey. "Using bright primary colors set on black backgrounds made the charts larger, adding the emphasis to already extraordinary growth figures. Each spread throughout the book acts as a poster, highlighting complex information in a simple and colorful fashion."

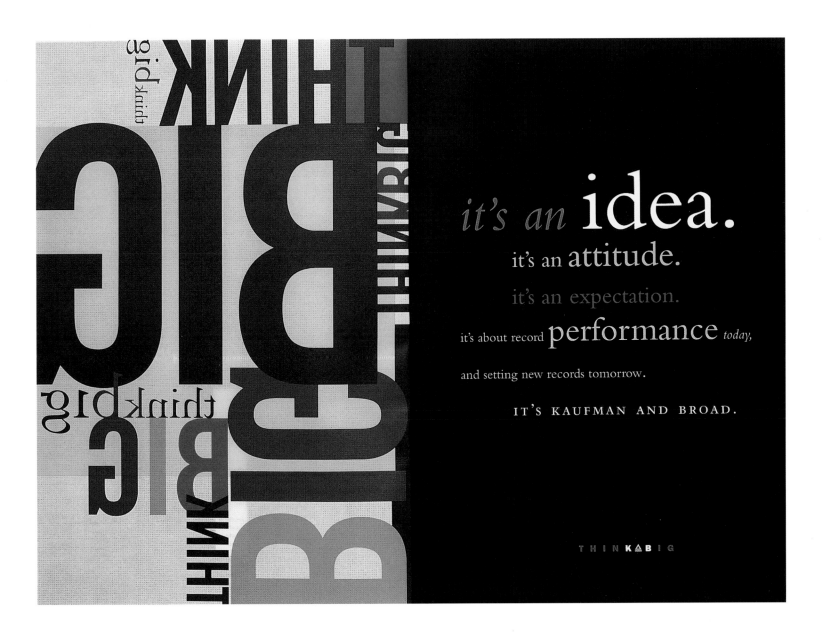

it's an idea.
it's an attitude.
it's an expectation.
it's about record performance today,
and setting new records tomorrow.

IT'S KAUFMAN AND BROAD.

THIN K▲B I G

CLIENT
Kaufman and Broad
Home Corporation
DESIGN FIRM
Louey/Rubino Design
Group Inc.
DESIGNERS
Robert Louey, Alex Chao
ART DIRECTOR
Robert Louey
PHOTOGRAPHER
Tyler Boley
COPYWRITERS
Jeffrey Charney,
David Berger
PRINTER
Lithographix, Inc.

PAPER STOCK
Gilbert Oxford 80# cover,
Gilbert Gilclear medium
weight, Signature Dull 80#
and Gilbert Voice 80# text
PRINTING
cover
4 over 3, a double-hit of
red, black, and varnish,
and deboss;
text
6 over 6, 4-color process
plus metallic silver
screened at 70% and
varnish
SIZE
9" x 13" (23 cm x 33 cm),
70 pages
FONTS
Bembo, Trade Gothic
PRINT RUN
2,400
HARDWARE
Macintosh
SOFTWARE
Quark XPress 4.0

It's a simple, powerful idea. "Thinking big" fueled a three-year journey which began with our purchase of San Antonio-based Rayco, gathered momentum from our commitment to fundamentally reshape our business, and will lead us to become the nation's largest, most disciplined homebuilder in 1999.

BIG RESULTS

The numbers alone tell much of the story of 1998. Our results were, well, *very* big.

- EXCEPTIONALLY STRONG DILUTED EARNINGS PER SHARE OF $2.32 – 60.0% higher than our 1997 EPS. We've now had 14 straight quarters of earnings growth – and our compound annual EPS growth rate over the past three years stands at 58.7%.
- DELIVERIES SOARED 32.9% TO 15,213. We've nearly doubled our total unit deliveries since 1995. On average, almost 42 families are moving into a Kaufman and Broad home every day of the year. To put it another way, by the time you've finished this letter, another family has received their new home in a new community in one of our markets.
- ALL-TIME RECORD NET INCOME OF $95.3 MILLION, a 63.6% increase over 1997.
- REVENUE ALSO JUMPED, UP 30.4% over last year to $2.45 billion.
- BACKLOG AT THE END OF OUR FISCAL YEAR STOOD AT 6,943 UNITS – a 64.8% increase over 1997 and almost *five times* our year-end backlog just three years ago.
- HOUSING GROSS MARGIN REACHED 20.2% IN THE 4TH QUARTER OF 1998, AND 19.2% FOR THE YEAR. These margins increased every quarter during the year, and stood 1.3 percentage points higher in the 4TH quarter of 1998 than in the 4TH quarter of 1997.
- RETURN ON AVERAGE STOCKHOLDERS' EQUITY ROSE TO 22.2%, UP 6.1 PERCENTAGE POINTS COMPARED TO 1997. The 1998 performance exceeded our goal of 20% for the first time in almost 10 years.
- NET DEBT TO TOTAL CAPITAL RATIO AT YEAR END STOOD AT APPROXIMATELY 43% – slightly below our 45%–55% target range despite five major acquisitions made or announced during the course of the year.

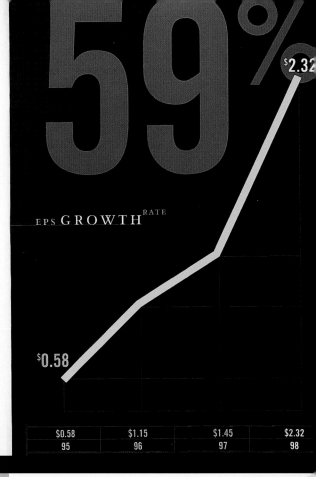

59%

$2.32

EPS GROWTH RATE

$0.58

$0.58	$1.15	$1.45	$2.32
95	96	97	98

TO OUR SHAREHOLDERS,

When I sat down to compose this message to you, I knew it would be one of the most ambitious letters I'd ever write.

I knew it would be hard to capture the pace of our change, the force of our strategic initiatives, and the extent of our record performance. I thought it would be almost impossible for words to convey the energy and drive displayed by our employees every day.

But when I looked at our results and reviewed our strategies and the talent of our people, I realized that we've already written the definitive summary of 1998. It's been captured in two words that have become an essential part of our corporate culture: *think* big.

KAUFMAN AND BROAD
SHARE AND RANK
IN KEY MARKETS

ENDING NOVEMBER 1998

MARKET	RANK	SHARE
Southern California	1	7.1%
Lewis Homes	8	3.1%
TOTAL		10.2%
Northern California	1	9.0%
Lewis Homes	18	1.7%
TOTAL		10.7%
Las Vegas	2	8.3%
Lewis Homes	1	11.1%
TOTAL		19.4%
Phoenix	5	4.9%
Denver	2	8.1%
San Antonio	1	44.4%

SOURCE: THE MEYERS GROUP, SHAW-LANDATA, INC., AMERICAN METRO STUDY

potential purchase, which includes ensuring it's accretive to earnings per share in the first full year, has an operational model that's either compatible with or easily adaptable to KB2000, has an attractive lot position, and is consistent with our 20% ROE and debt leverage objectives. As a result, we knew we could effectively manage our acquisitions and have them benefit our stockholders within the first year.

As it turned out, our acquisition strategy succeeded beyond any of our expectations. A string of acquisitions of homebuilders in Houston, Denver, and Phoenix/Tucson culminated in October with the announcement of our agreement to purchase Lewis Homes – one of America's largest and best-run family-owned homebuilders. In total, we acquired five companies in less than one year that are expected to deliver more than 6,500 homes, while keeping our net debt to total capital ratio well within our target range. Since our 1996 Rayco acquisition, we've made approximately $776.8 million worth of acquisitions, representing close to $1.5 billion in revenue.

These acquisitions do more for us than simply add to our deliveries and earnings. They also ensure that we can sustain our growth over the long term. In buying these great companies, in many instances we're also acquiring the talents of the people who made them great, who bring with them experience that adds to our operating knowledge. We're also discovering best practices which we're quickly incorporating into the rest of the company. Already, some great employees at the companies we've acquired are taking leadership roles in Kaufman and Broad.

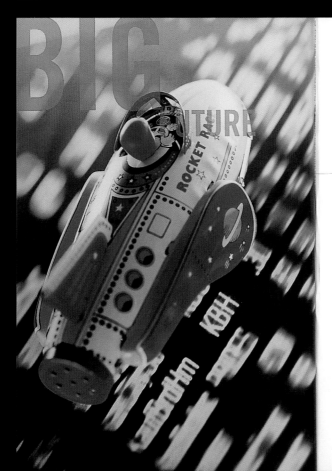

choice, great value, and more than 40 years' experience in building quality homes. These messages become even more essential in new markets or markets where we've increased our visibility through acquisitions.

RAISING OUR SIGHTS. In last year's annual report, I mentioned that we were pushing to deliver 13,500 homes in 1998 and 16,000 homes in 1999. Well, with more than 15,200 deliveries under our belt in 1998 and an estimated 21,500 1999 deliveries in the works, we've blasted through those projections. We'll continually raise our sights, and in light of our consistent record-breaking accomplishments, I challenge anybody to say that we're not capable of achieving any goal we set for ourselves.

THINK BIG

Despite our remarkable success, despite becoming America's leading homebuilder in 1999, despite our record performance and profits, the most important event in my life this past year occurred much closer to home – the birth of my first grandchild, Juliette.

Over the years, as I watch my granddaughter grow from a beautiful baby to a little girl to a young woman, I know I'll have many opportunities to offer her my advice on life, business and everything in between. But if I could only give one message to her, it would be this: WHEN SETTING YOUR GOALS, REMEMBER THAT YOU CAN ALWAYS ACHIEVE MORE THAN YOU THINK YOU CAN.

We'll always be thinking big at Kaufman and Broad. We'll always look for new ways to maximize the returns we can offer our stockholders. In KB2000, we've got an operating model that's also a core value of the company, enabling us to achieve increasingly higher levels of performance — and establishing Kaufman and Broad as the standard against which all other homebuilders are judged.

On behalf of the more than 3,000 big thinkers at Kaufman and Broad, I'd like to thank you for entrusting your investment dollars with us. We'll be working hard to justify your confidence, as we continue on a journey fueled by big thoughts and even bigger dreams.

Sincerely,

Bruce Karatz

CHAIRMAN AND CHIEF EXECUTIVE OFFICER

Coherent, Inc. Annual Report: "More Than Meets the Eye"

OF ALL THE ANNUAL REPORTS RECEIVED BY INDIVIDUALS THE WORLD OVER, THE 1997 REPORT FOR COHERENT, INC. IS LIKELY TO BE AMONG THOSE THAT ARE KEEPERS, SQUIRRELED AWAY ON A BOOKSHELF FOR LATER RETRIEVAL.

Coherent manufactures lasers for myriad uses, from medical applications to the Mars Pathfinder Rover. The company wanted to demonstrate their ability to dream up new applications for lasers in its annual report—but how?

"The CEO, a technical engineer by profession, suggested we take a look at a typical engineer's notebook and offered his as an example," said Rick Klein. "In the notebook was a hodgepodge of stuff, from scribbled writings in the margins to sketches to notes to pasted pictures. It was truly a diary of this man's life for the past few years. So it was based on this that we developed the concept."

From a Humble Notebook

All the elements of a notebook are there—the Wire-O binding, deemed the best and most cost-effective choice, a mixture of paper textures from notebook pages to graph paper, and odd-sized inserts. Intermingled with the notebook pages are shorter die-cut pages of various sizes, resembling snapshots and ideas picked up randomly and tucked in the notebook. These were printed on one 26" x 40" (56 cm x 102 cm) press sheet. "It was a trim and die-cut nightmare," added Klein.

The cover stock came from an actual notebook manufacturer. More than twice the stock needed had to be purchased, but the look was so perfect, the CEO gave his blessing.

The overall look of this report is refreshing with its unique insider's perspective. Even the typewriter font Courier looks new, so seldom is it used today. The pencil sketches and handwritten notes further personalize the report.

It is just the kind of notebook one would expect of a technically minded innovator—organized, informative, and engaging. The rest of us can only wish our notes looked this good.

CLIENT
Coherent, Inc.
DESIGN FIRM
RKD, Inc.
DESIGNER
Staff
ART DIRECTOR
Richard Klein
PHOTOGRAPHER
Various
COPYWRITER
Jon Rant
PRINTER
Woods Litho

PAPER STOCK
Brownville Type 2
Pressboard, Mohawk
Superfine
PRINTING
cover
2 colors;
text
8 colors
SIZE
7 ½" x 11"
(19 cm x 28 cm),
48 pages
FONT
Courier
PRESS RUN
25,000
HARDWARE
Macintosh
SOFTWARE
Quark XPress

New Meanings for Micromachining

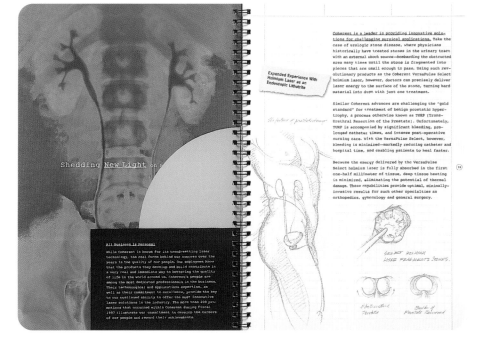

Shedding New Light on

MISSION: IMPOSSIBLE ~~POSSIBLE~~ BLE

Fiery® – The Technology Behind Digital Printing

3.31.98

ELECTRONICS FOR IMAGING, INC.
1997 Annual Report

Electronics for Imaging, Inc. Annual Report: "Mission (Im)Possible"

"MISSION (IM)POSSIBLE," THE THEME OF ELECTRONICS FOR IMAGING, INC.'S ANNUAL REPORT, PLAYS TO THE COMPANY'S REVOLUTIONARY FIERY® TECHNOLOGY THAT MAKES POSSIBLE BUSINESS COMMUNICATIONS THAT WERE IMPOSSIBLE JUST A FEW SHORT YEARS AGO.

The approach is thoroughly entertaining, making it impossible for a reader to resist thumbing the pages of this report.

Top Secret

The book comes in an unobtrusive white wrapper, and with its Mono Space typeface and red stamp reading "Possible," it feels like we're sneaking a look at a top-secret confidential file right out of the 1960s television series on which its title is based.

This creates an important first impression, carried solely by the book jacket, as the report's cover is unprinted.

Inside the File

The editorial content is a blend of text and razor-sharp color images, as expertly printed as one would expect from a com-

pany providing the technology behind digital printing. Fine rules outline pages so they resemble a file folder. Color gels add visual interest and emphasis to key messages.

Concise copy blocks present "missions" tackled with ease by Electronics for Imaging. The precision of the language, including specific dates and times, brings the *Mission Impossible* theme full circle.

One almost expects to hear that the report is scheduled to self-destruct in thirty seconds.

CLIENT
Electronics for Imaging, Inc.
DESIGN FIRM
Tolleson Design
DESIGNERS
Steve Tolleson,
Jean Orlebeke
ART DIRECTOR
Steve Tolleson
PHOTOGRAPHER
Davies + Starr
COPYWRITER
Electronics for Imaging, Inc.
PRINTER
Insync Media

PAPER STOCK
Starwhite Vicksburg Tiara
White Smooth 65# cover
and 80# text, Esblech
Onionskin
PRINTING
book jacket
engraved and embossed;
cover
unprinted;
text
6 over 0 match inks;
dividers
Lee Filter gels
SIZE
7 ½" x 10 ½"
(19 cm x 27 cm),
54 French-fold pages
FONTS
Mono Space, Trade Gothic,
Universal 8
PRINT RUN
50,000
HARDWARE
Macintosh
SOFTWARE
Adobe Illustrator 7.0

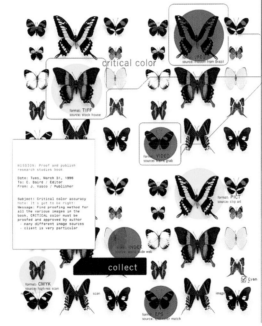

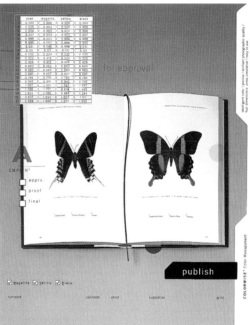

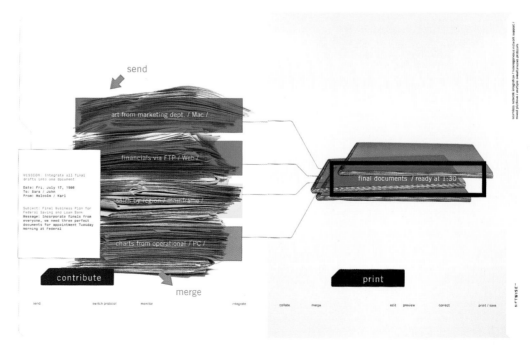

Tree Top Annual Report

TREE TOP'S 1998 ANNUAL REPORT IS AT ONCE SIMPLE, YET RICH, GIMMICK-FREE, YET DIFFERENT, AND UTTERLY CHARMING IN ITS PRESENTATION.

First impressions count, and here Tree Top's annual report excels. We are first struck by the cover stock. The natural kraft feel is in keeping with the orchard theme that is Tree Top, an agricultural cooperative owned by 2,500 apple and pear growers in the northwest United States. The paper gives the report texture, yet it is refined and not as coarse as some other kraft choices.

Understated Elegance
Refined understatement is further realized by four embossed icons illustrated by Denise Weir. Each of the icons is awash in soft color and represents the growing seasons: harvest, prune, fertilize, and protect.

The seasonal theme continues inside the report, which begins with a close-up photograph of lush apples, "full of fire and rounding to fruition" as a reflective quote tells us.

Succeeding pages present panoramic photographic spreads, like picture postcards, of the seasons, following Tree Top's production calendar.

Color Sets the Mood
Color is used strategically throughout to set the mood. Predominant hues in the photographs were chosen as overall color washes for the page, so that winter's cool gray-blue coloring is carried through the copy while the spring spread appears bathed in warm sunlight.

The layout is clean, uncluttered, and unaffected but not predictable. The photograph of the board of directors strays from the typical corporate boardroom scene. Instead, board members are shown standing amid their products—bins of apples.

CLIENT
Tree Top

DESIGN FIRM
Hornall Anderson
Design Works, Inc.

DESIGNERS
Katha Dalton, Jana Nishi

ART DIRECTOR
Katha Dalton

ILLUSTRATORS
Jana Nishi,
Denise Weir (icons)

PHOTOGRAPHERS
Alan Abromowitz, Gary
Holscher, Darrell Gulin

COPYWRITER
Evelyn Rozner

PRINTER
Color Graphics

PAPER STOCK
Gilbert Voice cover,
Strathmore Elements text

PRINTING
5 colors, cover embossed

SIZE
7 ¾" x 11 ½"
(20 cm x 29 cm),
16 pages

FONT
Gill

PRINT RUN
5,000

HARDWARE
Macintosh

SOFTWARE
Quark XPress, Adobe
Illustrator, Macromedia
FreeHand

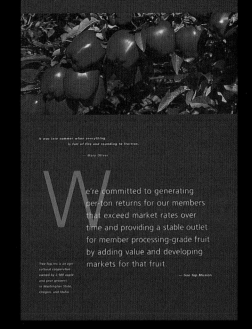

It was late summer when everything,
Is full of fire and rounding to fruition.

— Mary Oliver

We're committed to generating
per-ton returns for our members
that exceed market rates over
time and providing a stable outlet
for member processing-grade fruit
by adding value and developing
markets for that fruit.

— Tree Top Mission

Tree Top, Inc. is an agri-
cultural cooperative
owned by 2,500 apple
and pear growers
in Washington State,
Oregon, and Idaho.

WINTER Dulce Bramel

CHIEF EXECUTIVE OFFICER Frank Eisener

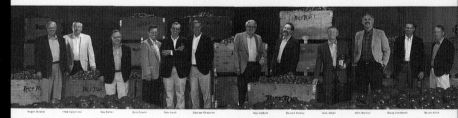

BOARD OF DIRECTORS

COMMITTEES OF THE BOARD 1997-98

Cats Corporation Annual Report

ONE WOULD NOT EXPECT AN ANNUAL REPORT FOR A PEST EXTERMINATING COMPANY TO BE PRETTY, BUT THIS REPORT FOR CATS, INC. PROVES THAT WRONG.

Cats is an environmentally conscious pest exterminating service that takes into account the atmosphere, forests, water, and soil. Simply designed graphic icons representing each of these areas are blind embossed on the cover of the 1998 annual report and repeated on the first page, along with the corresponding Japanese character and English translations.

Illustrations Take Center Stage
This interpretative treatment sets the tone immediately for what is to come—this is not going to be a typical technical or scientific report. Instead, the company objectives and strategy are presented artistically alongside conceptual photography and color-enriched illustrations. These are used less as supporting elements to the copy as the cornerstones for the overall design.

A section introduction begins with a diminutive heading in English, which is the warm-up for the page's main event—a lusciously rich color illustration of an ordinary vegetable rendered extraordinary. The drawings are reminiscent of pricey botanical lithographs.

The resulting layout is clean and fresh. The copy, while heavy, is inviting and accented with green subheads that continue the lush vegetation theme. Pretty green leaves are used for bullets in the charts, adding visual interest even in the financial section.

CLIENT
Cats, Inc.
DESIGN FIRM
Okamoto Issen Graphic
Design Company
DESIGNER/ART DIRECTOR
Issen Okamoto
ILLUSTRATOR
Akira Seto
PRODUCTION
Stock Company Limited
COPYWRITER
Mitsuyuki
PRINTER
Semi-Boud Printing
Corporation Limited

PAPER STOCK
Nonwood pulp paper
PRINTING
4-color process plus
1 PMS, embossed
SIZE
8 ¼" x 11 ¾"
(20.5 cm x 30 cm),
17 pages
FONTS
Japanese characters
MM-A-OKL;
English characters
Template Gothic Regular
PRINT RUN
10,000

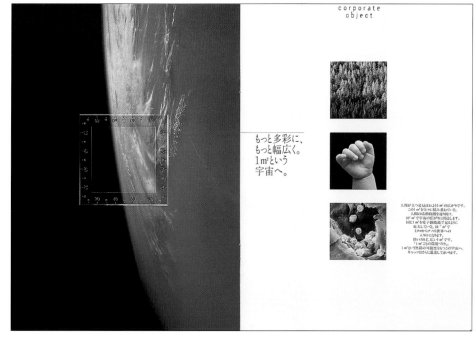

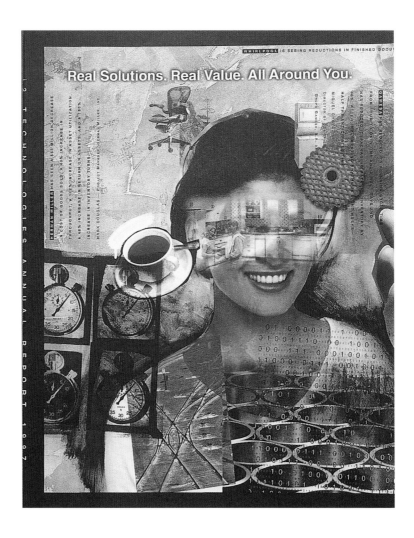

i2 Technologies Annual Report:
"Real Solutions. Real Value. All Around You."

I2 TECHNOLOGIES IS INVOLVED IN MANY TECHNOLOGIES WE ENCOUNTER EVERY DAY. THEY WORK TO IMPROVE INDUSTRY AND, ULTIMATELY, THE CONSUMER. EVIDENCE OF I2 TECHNOLOGIES' WORK IS, AS THE ANNUAL REPORT SAYS, "ALL AROUND YOU," SO THE LOGICAL NEXT STEP WAS TO CREATE AN ANNUAL REPORT THAT WAS QUITE LITERALLY, JUST THAT.

"All Around You"

The point—that i2 Technologies impacts all we do and is all around us—is made dramatically with an accordion fold-out mural, measuring 137½" (348 cm), or nearly 12' long! The mural, created by illustrator Rick Smith, presents a visual roster of i2's customers and the products they make that have an impact on our lives.

"Pages and spreads are like stopping points—visual breaks that I wanted to avoid," said Brian Boyd. "I wanted the examples to be continuous, presented nonstop in one constant stream."

A Graphic Stream of Consciousness

The concept is monumental. Executing it effectively posed challenges of equal magnitude. Boyd retained Smith as the illustrator because of his skill with photographic collages. Smith created the mural as one illustration on as many as five canvases. He measured out the canvases and calculated the points where one would separate into the next. The canvases were then photographed as transparencies, which the printer lined up and color separated. The canvases were printed on sheets and then glued together into one stream of graphic consciousness.

Boyd likes Smith's style because he integrates illustration with photography and uses actual everyday objects rather than interpretations. "The mural is not just photographs; it is more painterly. With computers, a lot of illustrators can claim, 'I do photo collages.' Smith is different. He actually paints into the image for a look that is not so pedestrian," Boyd explained.

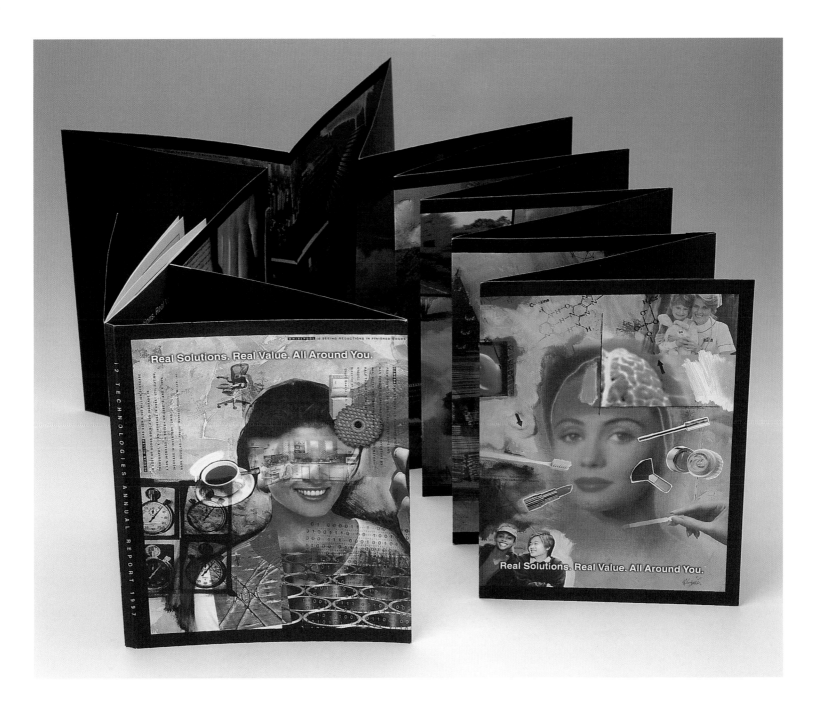

CLIENT
i2 Technologies

DESIGN FIRM
Richards Brock Miller
Mitchell (RBmm)

DESIGNER/ART DIRECTOR
Brian Boyd

ILLUSTRATOR
Rick Smith

COPYWRITER
Scott Price

PRINTER
Williamson Printing
Corporation

PAPER STOCK
80# Cougar Opaque cover
and 100# text

PRINTING
cover
8 over 3 with Hexachrome
orange and gloss varnish;
foldout
8 over 3 with Hexachrome
orange and tint cream;
financials
6 over 6

SIZE
8 ⅞" x 11 ½"
(22 cm x 29 cm),
14-panel foldout,
12-page financial section,
3-panel cover

FONTS
Helvetica, Mrs. Eaves,
Usherwood, ITC Garamond

PRINT RUN
40,000

HARDWARE
Macintosh

SOFTWARE
Quark XPress 3.3, Adobe
Illustrator, Adobe
Photoshop

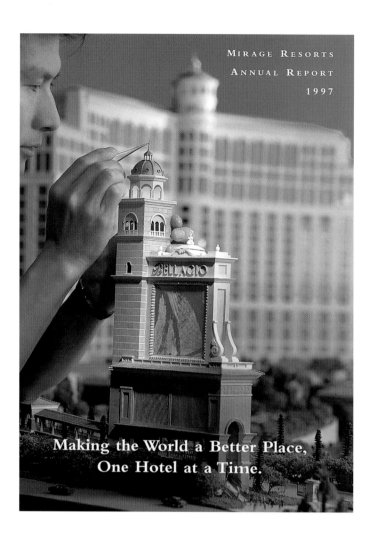

Making the World a Better Place,
One Hotel at a Time.

Mirage Resorts, Inc. Annual Report

CASINOS, LIKE THE PRIMARY HOST CITIES OF LAS VEGAS AND ATLANTIC CITY, NO LONGER OFFER JUST ADULT NIGHTLIFE AND GAMING. TODAY, THEY ARE ELEGANT, UPSCALE RESORTS WHERE THE HOTEL IS AMONG THE MAJOR TOURIST ATTRACTIONS FOR PEOPLE OF ALL AGES.

From The Mirage, Treasure Island, and Monte Carlo hotels/ casinos in Vegas to its two newest enterprises, the Bellagio, also in Las Vegas, and Beau Rivage in Biloxi, Mississippi, Mirage Resorts epitomizes the trend in sophisticated casinos as luxurious getaway resorts.

It is no surprise that the goal of the company's annual report was to "create a book that was upscale and elegant without appearing too flashy," said Joe Rattan.

Built-In Craftsmanship

Casinos have always carried the stigma of being somewhat shoddy. The old joke was that the worst hotel rooms could be found in Las Vegas because owners wanted the guests to spend money in the casinos, not while away the hours in a luxurious suite.

The new casinos take the opposite tact; guests are treated royally and details are attended to in every facet of the hotel. This feeling of craftsmanship and artistry is conveyed aptly on the cover of the Mirage Resort annual report. The painstakingly crafted model of the newest jewel in its resort empire, the Bellagio, is reinforced by the headline, "Making the World a Better Place, One Hotel at a Time."

Finding the Right Image

Inside the report, photographs echo this message, showing the architectural detail of the properties operated by Mirage Resorts and the management teams that support them.

Credit for getting the right photographs can be attributed to what Rattan calls, "a collaborative effort among myself, the photographer, Stewart Cohen, and the client." The client wanted to avoid anything too conceptual, so Rattan and Cohen scouted and photographed a variety of locales; other shots were found in Mirage's library.

"Given the theatrical nature of some of the images, there were instances of numerous shots being composed into a single image in order to capture the correct positions of the actors, the fire, the light, etc. We worked very hard with Williamson Printing Corporation and their color guru, Art Busch," said Rattan, who credits Williamson with helping enhance the look of the photography and encouraging experimentation with different coatings and finishes.

CLIENT
Mirage Resorts, Inc.
DESIGN FIRM
Joe Rattan Design
DESIGNER/ART DIRECTOR
Joe Rattan
PHOTOGRAPHER
Stewart Cohen
COPYWRITER
Mirage Resorts, Inc.
PRINTER
Williamson Printing
Corporation

PAPER STOCK
Vintage Velvet 100# cover
and book, Carnival Soft
White 70# text
PRINTING
cover
4-color process plus 1 PMS
and gloss UV coating over
4-color process, 1 PMS,
and gloss varnish;
text
4-color process plus 1 PMS
and special mix pearl tint
SIZE
8 ½" x 12" (22 cm x 30 cm),
68 pages
FONTS
Bembo, Earth Font One,
Helvetica, Snell, Snell
Roundhouse, Times
PRINT RUN
85,000
HARDWARE
Macintosh
SOFTWARE
Quark XPress 3.3,
Adobe Illustrator, Adobe
Photoshop 4.0

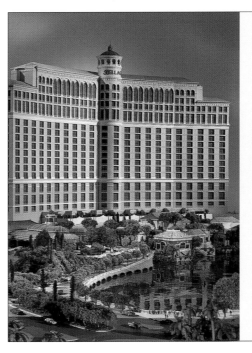

BELLAGIO

LAS VEGAS ~ OPENING OCTOBER 1998

*"There are places in the world so exceptional
they don't require superlatives. They
are best described with the simplest of words.
Bellagio is such a place."*

A picturesque lake filled with over a thousand fountains will run the length of Bellagio's grounds. Fragrant gardens and the red tile roofs of Tuscan villas will line the water's edge.

Stretching across the ceiling of the lobby will be an elaborate sculpture of hand-blown, multicolored glass. Nearby, a botanical conservatory will be home to exotic plants and flowers such as orchids, lilies and hyacinth.

Complementing the beauty of nature will be a gallery featuring works of the masters—original paintings by Vincent van Gogh, Claude Monet, Edouard Manet and Pierre Auguste Renoir, among others.

Nearby will be a collection of shops rivaling Rodeo Drive and Madison Avenue. Bellagio's theater will be a venue unlike any other, with luxurious seating overlooking a stage that rises and falls into one of the world's largest enclosed bodies of water.

Bellagio will be a legend on a large scale. It is not just another Las Vegas casino, or even just another elaborate hotel. Bellagio will redefine the concept of vacationing itself.

TREASURE ISLAND

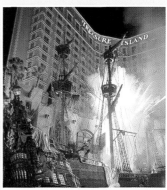

Treasure Island, in its fourth full year of operation, continued to achieve excellent results. Our company's investment in this property is approximately $500 million and it has consistently achieved returns on such investment in excess of 40% per year.

During 1997, we made several significant enhancements to Treasure Island. We built a new hotel lobby overlooking the swimming pool. We then removed the old lobby and replaced it with a new entertainment lounge and a popular new restaurant, "Francesco's," offering Italian cuisine and a lively open display cooking area. We also added a new retail store and redesigned much of the casino floor. The construction caused some disruption to our business, but has prepared the property for the competition ahead.

We also recently completed an employee parking garage behind Treasure Island. This permitted us to sell the previous employee parking lot, north of Spring Mountain Road, to the nearby Fashion Show Mall. The mall plans to use this land for a major expansion, which we believe should prove beneficial to Treasure Island in future years.

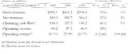

FINANCIAL OVERVIEW

OUR CYCLE OF SUCCESS

We started with one small casino. We provided excellent customer service in that casino and its success enabled us to build a second. That second resort provided career enhancement for our employees, helping us attract, motivate and keep the best employees. In turn, those employees provided excellent service to our guests, who have rewarded us with their preference and loyalty. That customer preference ensured the financial success of that second resort, enabling us to build a third, thereby providing career enhancement for our employees...and so on.

This cycle of success has proven mutually beneficial for our customers, our employees and our investors. We have hosted millions of guests, enhancing their vacations, their honeymoons and their business meetings. Our employees have fulfilling jobs and many opportunities for advancement. Meanwhile, our shareholders have enjoyed compound returns on their investment over the last 25 years averaging 28% per annum.

Fueling this cycle is the fact that our returns on new investments have greatly exceeded our cost of capital. Each of our resorts built over the past 20 years has achieved returns on total investment in excess of 20% per annum.

In recent years, as we have continued to build new resorts, we have reduced our cost of debt capital. We recently retired our 9¼% notes and paid at maturity our zero coupon, 11% accreting notes. Our lowest cost debt is currently our commercial paper, issued at rates generally under 6%. Our highest cost debt carries an interest rate of 7½%. All of our debt is now unsecured, allowing our company a great deal of financial flexibility. During 1997, we also increased the size of our bank line to $1.75 billion and extended our average debt maturities. Our low average cost of debt capital and extended maturities help augment our shareholder returns.

**MIRAGE RESORTS' STOCK PRICE
COMPOUND APPRECIATION RATE**

3-year	50%
5-year	38%
10-year	27%
25-year	28%

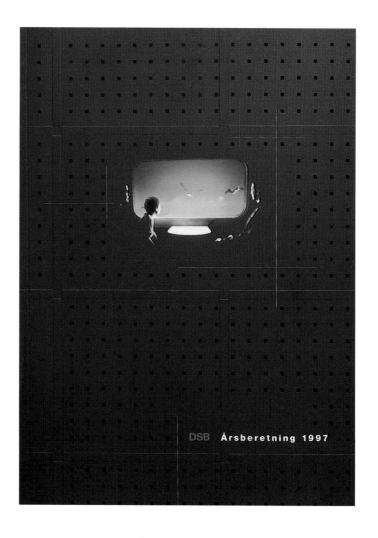

DSB Årsberetning 1997

Danish State Railways Annual Report

DANISH STATE RAILWAYS ENJOYED A HEAVY MEDIA PRESENCE IN 1997 WHEN THE BRIDGE OVER STOREBAELT OPENED, CONNECT-ING TWO MAJOR PARTS OF DENMARK. IN ADDITION TO COMMEMORATING THE OPENING OF THE BRIDGE, DANISH STATE RAILWAYS WANTED TO USE ITS ANNUAL REPORT AS AN OPPORTUNITY TO HIGHLIGHT TRAVEL AND TRAVELERS.

Acknowledging the heavy media exposure Danish State Railways received during the bridge opening—it appeared in the media almost daily—the design group at Hovedkvarteret suggested showing the media focus with pictures taken direct-ly from a TV screen.

Using Polaroids for Their Color
An old Polaroid camera was used for the TV screen shots because it actually enhanced the colors and provided the desired effect.

Other photos came from videos of actual situations, giv-ing the report a documentary feel. When shots of travelers were not available on video but only in static formats, they were scanned and brought up on a computer screen, which was then photographed with a Polaroid camera.

Seismic Color Used Sparingly
The finished product shows that the extra care and inventive-ness of the Polaroid technique paid off.

Throughout, color is used sparingly, but when it appears, it shakes up the report with seismic intensity on an otherwise clean white page with a tight grid layout.

The UV lacquering on the cover enhances the color and together with the embossing—even on selected text pages—gives the overall report a richness and tactile quality that makes one want to linger over it.

CLIENT
Danish State Railways
DESIGN FIRM
Hovedkvarteret Aps.
DESIGNERS
Helle Eliasson,
Klaus Wilhardt
ILLUSTRATOR
Hovedkvarteret
COPYWRITER
Danish State Railways
PRINTER
Datagraf Auning A/S

PAPER STOCK
Satimat Club
Borsch/Winther 250 g
and 135 g
PRINTING
cover
4 over 0 plus partial UV
lacquering and embossing;
text
4 over 4 plus partial UV
lacquering and embossing
SIZE
8 ¼" x 11 ¾"
(20.5 cm x 30 cm),
68 pages
FONT
Helvetica
PRINT RUN
1,000
HARDWARE
Macintosh
SOFTWARE
Quark XPress 3.31,
Adobe Illustrator 6.0

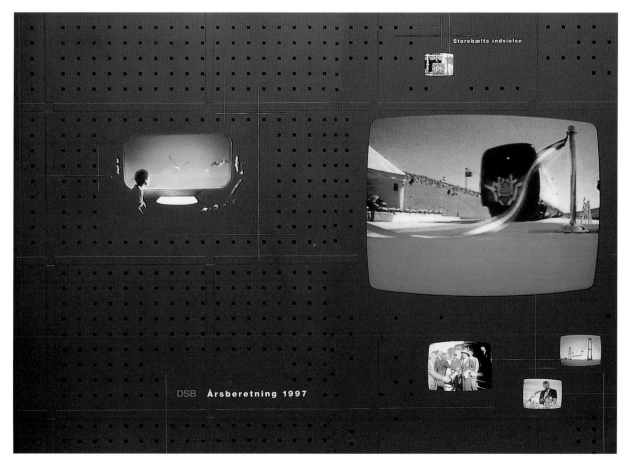

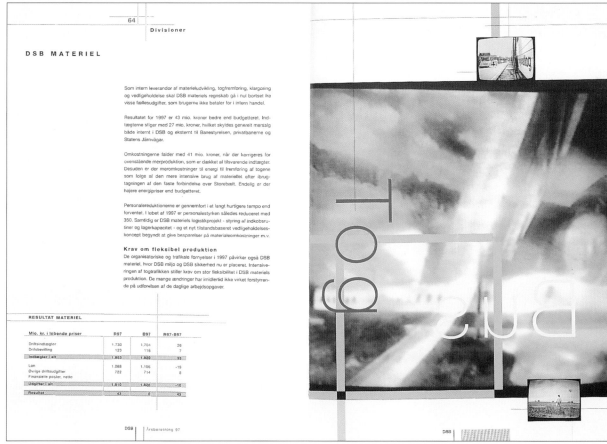

På sporet af årtusindeskiftet

Også 1998 bliver begivenhedsrigt for DSB. Samtidig vil det markere sig som et år, hvor afgørende beslutninger om DSBs fremtidige virksomhed skal træffes.

Årets største enkeltbegivenhed bliver åbningen den 27. september af Øresundsbanen til lufthavnsstationen i Kastrup og dermed gennemførelsen af første etape på vej mod den faste øresundsforbindelse. Der lægges ud med tre tog i timen fra Helsingør til lufthavnsstationen, et tog i timen fra Roskilde med en rute uden om Københavns Hovedbanegård samt daglig en halv snes InterCity tog eller InterCityLyn fra Fyn og Jylland.

Storebæltsforbindelsen indgår allerede i det europæiske jernbanenet, og når den faste øresundsforbindelse åbner i år 2000 vil trafikken fra Oslo og Stockholm til Hamburg ske via et sammenhængende net.

En anden stor trafikal begivenhed bliver åbningen af vejbroen over Storebælt den 14. juni. Trods en forventet nedgang i DSBs passagertal mellem den østlige og vestlige del af landet ventes det, at størsteparten af den fremgang, togtrafikken fik med den faste forbindelse, vil kunne fastholdes.

Perspektiverne for den nære fremtid blev i starten af 1998 klart tegnet op gennem præsentationen af DSBs vision, Gode Tog til Alle, hvis hovedelementer er hyppigere toggang og anskaffelse af mere materiel i de kommende år. Målet er en S-togslignende køreplan overalt i Danmark fra tidlig morgen til sen aften. Samtidig vil der med indsættelse af nyt materiel kunne opnås besparelser i rejsetiderne på ca. 10 pct. på de enkelte strækninger. Realiseres denne vision, vil der især blive tale om en stærkt forbedret betjening af DSBs passagerer.

DANISH STATE RAILWAYS
ANNUAL REPORT

United Pan-Europe Communications Annual Report: "Get Connected!"

PIONEERING NEW TERRAIN—WHETHER PREPARING FOR AN INITIAL PUBLIC OFFERING, USING NEW PRODUCTION TECHNIQUES, OR CREATING A COMPANY MASCOT—IS NEVER EASY, BUT IT CAN BE EXCITING AND, IF WELL EXECUTED, CAN PAY OFF WITH INCREASED AWARENESS.

As recently as 1998, Netherlands-based United Pan-Europe Communications (UPC) toiled quietly as a private company doing business in the fast-growing cable telecommunications industry. But that was about to change; the company was ready to go public. To do so, they needed an annual report that worked hard as a corporate marketing tool to help raise funds to support their ongoing expansion and create awareness with key investors prior to the IPO.

UPC wanted to communicate not just the changes rapidly occurring in the cable and telecommunications sectors but also how these changes were affected by fundamental political changes in Europe. Moreover, UPC wanted to be distinctive; they shunned conventional images of technology and screens.

Creating a Company Mascot

"A compelling business offer needed a compelling visual theme," said Adrian Nunn. "That's where Marius the Mole comes in."

Marius Mole was developed as a company mascot. The story of UPC's fully-integrated broadband distribution network is told "from the point-of-view of the subterranean cartoon character who gradually gains experiences of the benefits of integrating voice, data, and video communications," Nunn explained.

New Production Avenues: Paper and Ink

Beyond the cartoon treatment, which greatly simplified the topic and differentiated the report from the competition, the technical aspects of the report proved both distinctive and innovative.

"It was the first time that the U.S. paper Starwhite Vicksburg Ivory Smooth had been used in the U.K., and it was the first time the Hexachrome process was used on uncoated paper under commercial conditions," said Nunn. (The Hexachrome process yields bright and vibrant colors that are not possible with four-color process.) "The production process saw us push the process and the paper to the limit. We involved Westerham Press at the concept stage and did extensive research and testing prior to going on press."

The report did exactly what UPC hoped. Perhaps its name should be changed from "Get Connected!" to "Get Noticed!"

CLIENT
United Pan-Europe
Communications (UPC)
DESIGN FIRM
Pauffley
DESIGNERS
Brigitte Whitefield,
Smith Joseph
ART DIRECTORS
Adrian Nunn,
Fraser Southeby
ILLUSTRATOR
Nila Aye
COPYWRITER
Alyson Harvey
PRINTER
Westerham Press,
St. Ives plc

PAPER STOCK
Fox River Starwhite
Vicksburg Ivory Smooth 176
gsm and 118 gsm
PRINTING
cover and text
6 Hexachrome colors plus
overall varnish;
financials
2 colors plus varnish
SIZE
8 ¼" x 11 ¾"
(20.5 cm x 30 cm),
48 pages
FONTS
Barmeno, Caflisch Script,
Helvetica
PRINT RUN
10,000
HARDWARE
Macintosh
SOFTWARE
Quark XPress 3.32,
Adobe Illustrator 6.0

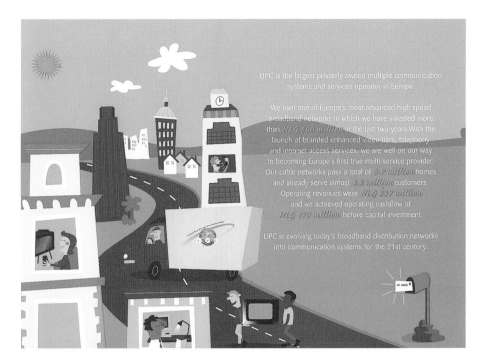

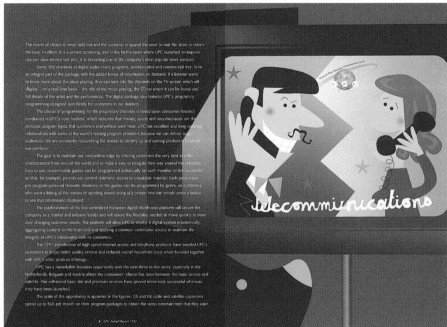

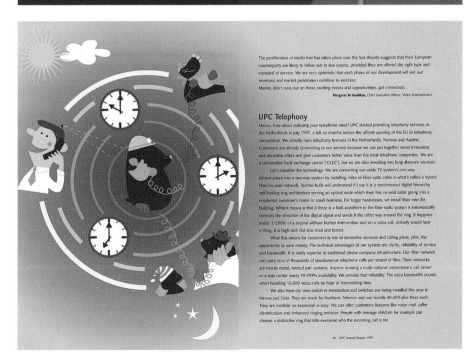

Starbucks Coffee Company Annual Report: "Points of Contact"

STARBUCKS COFFEE COMPANY'S 1998 ANNUAL REPORT SHINES NOT ONLY FOR ITS PERSONALITY, AKIN TO A TRAVELER'S JOURNAL FILLED WITH SNAPSHOTS OF PEOPLE AND PLACES ON A SUMMER VACATION, BUT ALSO FOR ITS PRODUCTION PROFICIENCY.

This annual report has a personality. While many annuals do, not all are so distinctive. Starbucks' 1998 report, entitled "Points of Contact," is casual, familiar, and as intriguing as the many diverse faces staring back at us as they enjoy Starbuck's products.

Getting Personal

This journal is packed with mementos from Starbucks—photos from a sidewalk café and the Lilith Fair along with a scrap of a handwritten order and a scribbled reminder to get coffee. Photographer Nancy LeVine traveled to numerous Starbucks locations to get the shots. The result is a melange of slice-of-life stories, from a young boy sharing Starbucks ice cream with his dog to the architect of the Holocaust Memorial Park.

Getting Technical

This report may look simple to the casual observer, but as many designers know, the projects that epitomize simplicity are often the ones that are the hardest to pull off technically.

The report cover has a label in a debossed frame that presents the cover copy in a clean, sharp block and contrasts nicely with the uncoated coffee-colored paper. The label was hand-applied, adding ten to twelve extra working days to the schedule and necessitating that cover production be underway two weeks before the rest of the annual.

Photos were printed as duotones in a mix of brown and black, yielding images with detail and richness. The designer kept the brown to the shadow/midtone range to warm up the visuals without making them appear too sepia.

CLIENT
Starbucks Coffee Company
DESIGN FIRM
In-house
DESIGNER
Jon Cannel
ART DIRECTOR
Doug Keyes
CREATIVE DIRECTOR
Michael Cory
PRINT PRODUCER
Sheryl Saks
PROJECT MANAGER
Chris Gorley
ELECTRONIC DESIGNER
Lori Record
PHOTOGRAPHER
Nancy LeVine
COPYWRITER
Brian Mekenna
PRINTER
George Rice and Sons

PAPER STOCK
Crown Vantage Tuscan
Printable Pulp Brown 100#
cover, MACtac StarLiner
Matinee 60# cast coated
litho pressure-sensitive
label, Crown Vantage cus-
tom make of Regalia 80#
text, Benefit Mushroom
70# text
PRINTING
cover
3 over 0, 2 hits of black,
spot varnish, and deboss;
label
5 over 0, diecut;
text
5 over 5, 1 over 1
SIZE
7" x 10" (18 cm x 25 cm),
48 pages plus 2-page insert
FONTS
Claredon, Berthold
Garamond, Trade Gothic
PRINT RUN
175,000
HARDWARE
Macintosh
SOFTWARE
Quark XPress 4.04 for
layout and Macromedia
FreeHand 8.01 for sticker

I know people by their drinks. There's the double tall nonfat vanilla latte lady. And they know me by my quirks. I love it.

A welcoming smile. A drink handcrafted personally for you from the finest coffees in the world. A few private moments to sit back and dream, reflect, relate, create, escape, enjoy. Welcome to Starbucks.

Gabe Reed

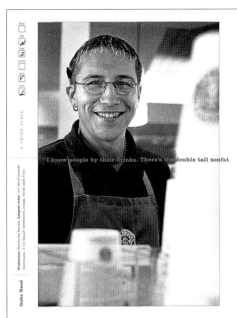

I use details to create human scale. People relate to that.

E-mail. Faxes. Cell phones. Get a call, grab the blueprints, make a change. Push it harder. Is it better? Who would notice? Stop a minute, think it through. Okay, you really like it. Take a break, reward yourself.

George Vellonakis

It wasn't my cone, it was Aunt Nancy's cone. She always talks about sharing and the ice cream was starting to melt anyway.

So here you are, ten years old and thinking about things. Like having friends and sharing and being responsible for someone you love and learning to play by the rules. Now, why is it again that we have to grow up?

David Mishler

Waterlaboratorium Noord Annual Report

ONE WOULDN'T EXPECT TO SEE A HIGH-TECH LABORATORY PRESENT AN ANNUAL REPORT THAT LOOKS LIKE A CHERISHED WRITER'S JOURNAL, COMPLETE WITH HANDMADE PAPERS, DELICATE SCRIPT TYPEFACES, AND STYLIZED PHOTOGRAPHY, BUT THAT IS EXACTLY WHY THIS ONE WORKS.

The Waterlaboratorium Noord is a laboratory serving the water suppliers in the three northern provinces of The Netherlands. Erwin Zinger had designed much of the marketing and identity materials for his client; this report was a natural evolution of the design standard he previously set, including choice of typography, photography, and even the handmade paper.

Capturing the Image of Water

"Water is a substance you can't grab," said Zinger. "It has no form, no color, and no taste. But water moves. Not by itself, but by natural elements like the wind or rain. And its movements take on very different forms."

To capture the image of water, Zinger used a handmade paper that includes pieces of real water flowers, which proved to be the most challenging aspect of the job on press. Because of the flowers, printing had to be carefully monitored throughout the run. While Zinger had experience printing on these papers from other projects, handmade paper can vary from carton to carton, so nothing was taken for granted.

A flowing script that conveys movement accents a stylized photograph of water on the report cover. The script is in marked contrast to the clean, analytical text typeface that is more in keeping with the nature of laboratory work.

Because lab personnel tend to think in terms of measurements, Zinger placed the year of the annual report in a scale, along with the page numbers.

Aesthetic versus Antiseptic

Aside from this report's clean layout, everything else about is more aesthetic than antiseptically scientific. That enhances the report's value for readers accustomed to material communicated in an environment that is literally and visually sterile.

CLIENT
Waterlaboratorium Noord
DESIGN FIRM
Erwin Zinger Graphic Design
DESIGNER/ART DIRECTOR
Erwin Zinger
PHOTOGRAPHER
Marinus Brink
COPYWRITER
Gerrit Veenendaal
PRINTER
Van Denderen BV

PAPER STOCK
Khadi and Village Industries
Commission Only Natural
Algen 190 gsm, Mersen
Paper Butterfly Soft Orange
120 gsm
PRINTING
cover
2 over 1;
text
black for text pages,
full-color for title pages
and graphics
SIZE
8 ¼" x 6 ¼"
(21 cm x 15.5 cm),
24 pages
FONTS
Linotype, Embassy,
Serpentine
PRINT RUN
200
HARDWARE
Macintosh
SOFTWARE
Quark XPress 3.31,
Adobe Illustrator 6.0
with Kai Power Tools,
Adobe Photoshop 4.0

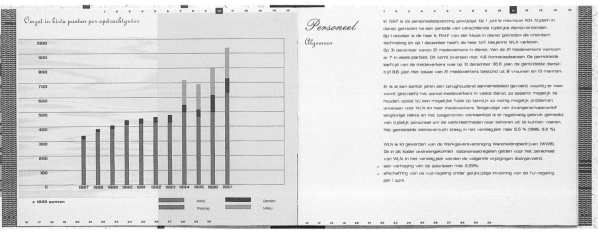

Inktomi Corporation Annual Report

WHAT CAN YOU ACCOMPLISH WHEN BUDGET IS NO OBJECT? INKTOMI'S 1998 ANNUAL REPORT IS AN EXAMPLE OF HOW FAR YOU CAN PUSH THE DESIGN ENVELOPE WITHOUT LOSING THE MESSAGE.

It is rare, but every now and then budget is not the most important issue—impact is. That is exactly the situation 1185 Design faced when preparing the 1998 annual report for Inktomi, an Internet service provider and search engine.

Sometimes, when no limitations are set on design, it can become design purely for design's sake, full of nuances and gimmicks that look great but do nothing to communicate the message.

This is not the case with 1185 Design's work for Inktomi. The report is cleverly assembled and obviously complex to produce, yet workable, practical, and compelling.

A Sum of Its Parts

The report is broken—literally—into three parts for easy navigation. A beautifully printed and embossed jacket folder holds three booklets inserted into die-cut slits in the jacket that hold them remarkably securely. The editorial and the financial booklets are companion pieces, featuring the same embossed cover artwork. The wall calendar is a bonus, with plenty of room to customize with appointments of your own. It is a fun keeper, with a distinctive look.

Making It Fun

Inktomi's objective was an annual report that reflected the fun, energetic personality of a young, startup company. The design makes good use of the definitive color palette of youth: bold primary hues.

The result is everything Inktomi desired—dynamic, energizing, playful, and young.

Inktomi

Scaling
The
Internet

1998
ANNUAL
REPORT

CLIENT
Inktomi Corporation
DESIGN FIRM
1185 Design
DESIGNER
Joan Takenaka
ART DIRECTOR
Peggy Burke
PHOTOGRAPHER
Ann Fischbein
COPYWRITER
Jon Rant
PRINTER
Craftsmen Printing

PAPER STOCK
Starwhite Vicksburg Tiara
White Smooth 110# cover
and 80# text, Utopia One
Dull 80# cover and text
PRINTING
jacket
3 PMS (double-hit 2 PMS)
and dull varnish on 1 side,
multilevel blind emboss,
fold-and-glue 3 pockets,
die-cut slits;
editorial cover
1 PMS double hit, dull
varnish each side;

editorial text
2 over 2, 4-color process,
2 PMS, and dull varnish;
financial cover
1 PMS double hit and dull
varnish on 2 sides, multi-
level blind emboss;
financial text
black and 1 PMS, dull var-
nish on 2 sides;
calendar cover and text
4-color process, 2 PMS
and dull varnish on 2 sides
SIZE
6" x 11 ½" overall
(15 cm x 29 cm),
16-page editorial booklet,
22-page calendar,
40-page financials
FONTS
Sabon, Thesis Sans,
Resbaloso
PRINT RUN
30,000
HARDWARE
Macintosh
SOFTWARE
Quark XPress 3.0,
Adobe Illustrator 8.0,
Adobe Photoshop 5.0

SHOPPING Inktomi's new Shopping Engine enables Internet users to compare and buy products on more than price alone by including commentary, user reviews and other criteria.

Shopping

online

e-commerce

PRODUCTS

MARCH

m1	
t2	
w3	
th4	
f5	
s6	
su7	
m8	
t9	
w10	
th11	
f12	
s13	
su14	
m15	
t16	
w17	St. Patrick's Day
th18	
f19	
s20	Vernal Equinox (First Day of Spring)
su21	
m22	
t23	
w24	
th25	
f26	
s27	
su28	Palm Sunday
m29	
t30	
w31	

OCTOBER 1997
- Announces selection of Inktomi Search by Microsoft's MSN
- Announces strategic alliance with Intel
- Sun-Inktomi conduct first large-scale benchmark test on network caching

DECEMBER 1997
- Ships Traffic Server

FEBRUARY 1998
- Celebrates 2-year anniversary

MARCH 1998
- Opens Europe office

APRIL 1998
- Identifies Traffic Server to AOL
- Signs up players for Traffic Server
- Partners with CompuServe/Digital

MAY 1998
- Steps up its ties with Intel benchmarks
- Signs up Telenor of Norway for Traffic Server
- Teams up with Sumitomo Corporation in Japan for distribution

JUNE 1998
- Going Public Initial Public Offering (NASDAQ:INKT)

JULY 1998
- Yahoo! goes live with Inktomi Search
- With Novell Networks for Traffic Server and Search
- Reports first quarterly results

AUGUST 1998
- Teams up with Sun Microsystems to create world's first cache for streaming media
- Extends Traffic Server to Telecom of Portugal

SEPTEMBER 1998
- Acquires C2B Technologies for online shopping
- Enters into alliance with Netscape Engines
- Traffic Server fully deployed across AOL
- Unveils Traffic Server 2.0
- Opens Asia office
- Signs up channel partners in United States, Europe and Asia
- Orders of Traffic Server up for Inktomi Search
- Reports 3.15 billion search queries served in last three months

1999

inktomi

1999
Calendar

1998
Annual
Report

Scaling
the
Internet

Inktomi®

1998
Financial
Review

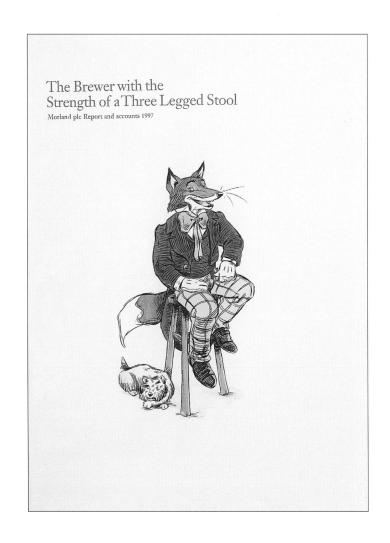

The Brewer with the
Strength of a Three Legged Stool

Morland plc Report and accounts 1997

Morland plc Annual Report:
"The Brewer with the Strength of a Three-Legged Stool"

MORLAND'S ANNUAL REPORT PROVES THAT TRADITION AND MODERN THINKING CAN GO HAND IN HAND. THOUGH IT LOOKS LIKE A FAIRY TALE, THE SUCCESS STORY TOLD INSIDE IS SERIOUS BUSINESS.

Founded in 1711 by the Morland family, Morland plc is a regional brewer in the United Kingdom. It operates a large number of pubs and restaurants in the traditional pub style, but its success comes from its modern approach to doing business.

The Old Speckled Hen

At the heart of the business is Morland's Old Speckled Hen brand, whose advertising materials feature a fox. This fox is the star of the annual report, reinforcing the brand that has accomplished so much to strengthen the overall business.

An illustrated book format was chosen as the perfect vehicle to carry this theme, with the central character rendered in pen-and-ink drawings that are not just traditional but catchy, colorful, and reminiscent of the English pub style that is recognized around the world.

Black-and-white photography is also used throughout to show populated pub scenes and product shots, such as the one where the old fox discovers the Old Speckled Hen.

A Three-Legged Stool

The title, "Three-Legged Stool," comes from the phrase commonly attached to companies that operate in three areas of business. Morland plc is a three-legged stool because it operates in retail, brands and brewing, and tenancy. The title works with the playful storybook format. Incidentally, it also ties in nicely with the traditional stools that are usually filled at Morland's pubs.

This is definitely not a report to be read and tossed. It is a report to be read and kept.

CLIENT
Morland plc
DESIGN FIRM
Radley Yeldar
DESIGNER
Robert Riche
ART DIRECTOR
Andrew Gorman
ILLUSTRATORS
Gary Andrews, Mike Brown
PHOTOGRAPHER
Edward Webb
COPYWRITER
Beryl McAlhone
PRINTER
The Colourhouse

PAPER STOCK
Cyclus Offset 170 gsm
PRINTING
6 colors, bound in boards
SIZE
7 ¼" x 10 ⅛"
(18.5 cm x 25.3 cm),
56 pages
FONT
Janson
PRINT RUN
6,000
HARDWARE
Macintosh
SOFTWARE
Quark XPress 3.3

Financial highlights

Brands and Brewing

Morland is a committed brewer. We demonstrated our confidence in this part of the business by opening a new brewhouse last year at a time when other brewers were taking capacity out. The decision was well timed as our premium ale brand Old Speckled Hen immediately outgrew previous capacity. We believe the future lies with brands. Old Speckled Hen continues to buck market trends with its sparkling performance, growing in the on trade and becoming a market leader in the off trade. Now Morland has built an even sturdier brand platform by buying one of the most famous names in British beer – Ruddles. Morland can move Ruddles ahead in a way the previous owner could not. In particular we can quickly slot Ruddles into our new take-home and export divisions set up for Old Speckled Hen. As the industry consolidates, the outlook for brewing is by no means gloomy. We believe gaps will be created, bringing new opportunities. We intend to be even more of a brand-led brewer. We have the plant needed to add more brands – through acquisitions, licensing agreements or through our own efforts.

Following the purchase of Ruddles, Old Speckled Hen has two new chums The timing is perfect. Old Speckled Hen now justifies an in-house division for take-home sales and exports to 19 countries. Ruddles' two top brands are entirely complementary, and can follow where it leads.

Brands and Brewing continued

This was a good year for us. We can report a strong performance throughout the division. Old Speckled Hen lost none of its impetus and overall volumes again grew, reducing our surplus capacity. The virtues of our vertical structure were made apparent in a year when the retail sector slowed. We were able to secure brewing profits ahead of target. The year's two key events were the acquisition of Ruddles and the setting up of a take-home division. Each is a major step forward, and they lock together particularly well.

The Ruddles deal brought us a famous ale brand for the price of three or four managed houses. Ruddles' products perfectly complement Morlands', and we now have a leading brand in each sector of the cask ale market – Old Speckled Hen (speciality premium ale), Ruddles County (premium ale) and Ruddles Best Bitter (mainstream bitter). The idea of a complementary mix is central to our strategy in brands and brewing, as in retail. We believe Ruddles will thrive with us because we can attack on three fronts. We are known for our strength in marketing niche brands and expect to build volume and market share. Ruddles is capable of growth in the two free markets – take-home and export – where it can take advantage of the infrastructure established for Old Speckled Hen. We streamlined and transferred to Morland head office sales and administration, and cut production costs.

Ruddles entirely fitted our strategy of buying underperforming businesses with growth potential. Old Speckled Hen has proved that a niche brand can grow strongly even when the cask ale market drops. In a year when draught cask ale volumes across the country were down between 12% and 15%, UK Old Speckled Hen draught volumes were marginally up. This is a significant achievement, and we expect to continue the same steady advance against the trend. Performance in the take-home sector was remarkable, up 18%. This year Old Speckled Hen became the number one premium bottled ale in supermarkets – a leadership position which is unique among regional brewers.

Left: Old Speckled Hen is now the number one premium bottled ale brand.

It's not only the fox who is discovering Old Speckled Hen. The brand is now number one for premium bottled ale in supermarkets. Good ideas continue to drive the marketing – including this innovative seven bottle hexagonal pack developed for the Christmas trade.

NONPROFIT

NONPROFITS AND austerity—the two always seem to go together, never more so than in annual report design. The production of annual reports can represent a sizable investment—funds that supporters might rather see spent elsewhere, namely to carry out the organization's mission.

The economics of design and nonprofits will never be too far apart, but there are exceptions. Some nonprofits are wealthier than others and have different priorities, but most organizations readily admit that they do not want their report to look too expensive. They request that no new photography be shot. Above all, they ask that costs be contained on press.

Within these budget constraints, designers' creativity can be sorely tested. In these examples, it looks like budgetary duress can also prompt designers to rise to the challenge, forcing them to find inventive ways to make a budget-challenged report stand out. More importantly, the trend is toward reports that are fiscally responsible without appearing visually lackluster.

Here are examples of annual reports using foil stamping, conceptual and object photography, unusual shapes, die-cuts, and color—all of which lend sparkle and shine without breaking the budget.

"IN THE COMING YEARS, IT IS PROBABLE THAT ANNUAL REPORTS WILL BE POSTED ON THE INTERNET AND WILL SATISFY SEC REGULATIONS REGARDING FULL DISCLOSURE.
"WHAT WILL THIS MEAN TO ANNUAL REPORT PRINTERS AND STOCKHOLDER COMMUNICATIONS EXPERTS? NECESSARILY, THE QUANTITIES OF ANNUAL REPORTS MAY DECLINE, BUT THE BOOK WILL EVOLVE INTO MUCH MORE OF A MARKETING VEHICLE THAN EVER BEFORE. AS THIS METAMORPHOSIS TAKES PLACE, DESIGNERS WILL LOOK FOR ADDITIONAL WAYS TO ENTICE AND EXCITE THE READER. DESIGN, PAPER, FORMAT, ILLUSTRATION, PHOTOGRAPHY, AND PRINTING TECHNIQUES ARE JUST A FEW WAYS THAT WILL BE USED TO DIFFERENTIATE THE COMPANIES AND ILLUMINATE THE NUMBERS.
"IT IS PREDICTABLE THAT PRINT WILL ALSO BE RELEASED FROM ITS TRADITIONAL ROLE OF LISTING AND CATALOGING TO PERFORM A NEW MISSION OF COMMUNICATION THAT MAY BE MUCH MORE INFLUENTIAL."
—GARY DICKSON, PRESIDENT, DICKSON'S, INC.

Poston
ARIZONA

Dear Miss Breed,

Thank you for the iron which yesterday whelmed wi the iron.

all night how I my gratitude.

Do you remember
why you went to Law School?

CHICAGO VOLUNTEER LEGAL SERVICES
1998 ANNUAL REPORT

Chicago Volunteer Legal Services Annual Report: "Do You Remember Why You Went to Law School?"

REMEMBER WHEN YOU WERE FULL OF IDEALISM AND THOUGHT YOU COULD CHANGE THE WORLD? THAT KIND OF POSITIVE THINKING AND CAN-DO ATTITUDE, OFTEN ASSOCIATED WITH YOUTH AND COLLEGE STUDENTS IN PARTICULAR, IS THE FOCUS OF CHICAGO VOLUNTEER LEGAL SERVICES (CVLS) 1998 ANNUAL REPORT.

According to CVLS, the law attracts idealists who want to change the world and do good. But paperwork and desk jobs take their toll on positive mindsets. CVLS wanted to rekindle the positive outlook of youth and help the realists in the law profession understand that "if they can't change the world, they can change some lives."

Back to School

Remember your college textbooks? The collegiate cover, the distinctive typeface, and the thin, light weight pages that looked deceptively like a fast read, easily accomplished on a study break? These are the elements Tim Bruce used to spark long-forgotten memories of college days.

"We wanted to remind the audience of why they became a lawyer in the first place," said Bruce. "Debt and the pressure to get high-paying corporate jobs have clouded their vision. Our goal was to convince them that they could volunteer, take a case, handle it in their spare time, and make a difference."

A Textbook Case

The annual report is designed to resemble a law textbook, complete with inexpensive paper and big, awkward type. The cover looks authentic, too, printed on a leatherlike stock and foil stamped in two-colors—gold and a marbleized burnt red—for a very conservative appearance.

The photography is reproduced as duotones, picking up on the red on the front cover foil stamp and giving the photos a warmth not possible with traditional black-and-white photography.

A Mission and a Point of View

What are the particular challenges of designing an annual report for nonprofits? "They must have a clear mission statement," said Bruce. "CVLS has a point of view, and they are not afraid to put it out there. A mission and a point of view are essential because annual reports are less about the financial documents. As a positioning statement, nothing works better."

CLIENT
Chicago Volunteer
Legal Services
DESIGN FIRM
Lowercase, Inc.
DESIGNER/ART DIRECTOR
Tim Bruce
PHOTOGRAPHERS
Tony Armour, Joshua Dunn
COPYWRITERS
M. Lee Witte,
Margaret C. Benson
PRINTER
H. MacDonald

PAPER STOCK
Holyoke Leatherflex, Fox
River Rubicon 60# text,
50# magazine-grade
coated stock
PRINTING
cover
2-color foil stamp;
text
2 colors, black and
match red
SIZE
7 ½" x 11"
(19 cm x 28 cm),
52 pages plus cover
FONT
New Century Schoolbook
PRINT RUN
5,000
HARDWARE
Macintosh
SOFTWARE
Quark XPress 4.0,
Adobe Illustrator 7.0

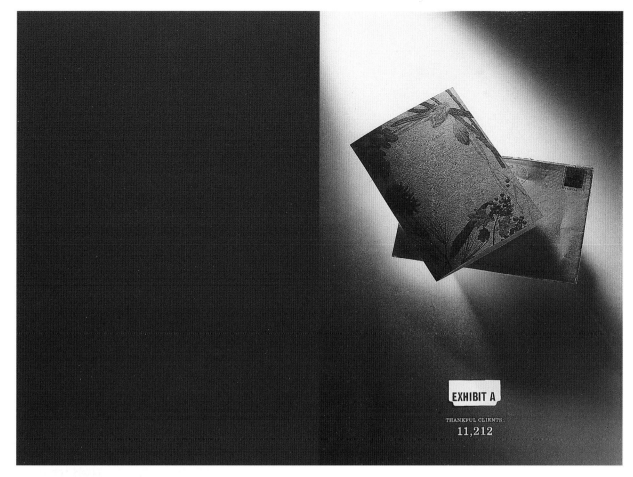

EXHIBIT A

THANKFUL CLIENTS:
11,212

¹St. Procopius Legal Clinic in Pilsen

TO
CONTRIBUTE

Since joining CVLS shortly after our creation in 1964, **Bill Cooney's**[1] seen thin and flush economic times. He's seen bar associations question the ethicality of pro bono and later push for mandatory "volunteerism." Law firms have forbidden pro bono, embraced it, memorialized principles, and then refined those principles into oblivion. Through it all, the only thing that mattered to Bill was that CVLS had clients with problems and he was a lawyer with solutions. While developing his corporate practice at McBride Baker & Coles, Bill volunteered at several CVLS clinics, eventually chairing our **St. Procopius Legal Clinic in Pilsen.**[2] Now he's with our Panel Referral Program as an ERISA specialist, helping CVLS clients like Simmie M. who failed to appeal when his pension was denied 6 years earlier. Bill appealed but wasn't surprised when the trustees rejected it as untimely. And we weren't surprised that the story didn't end there. The law wasn't on Simmie's side, but his lawyer was. Bill negotiated a settlement of $1,500.

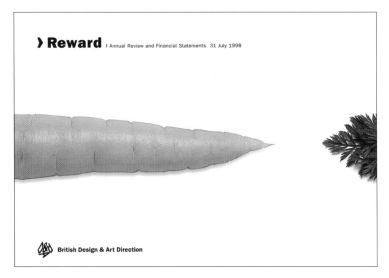
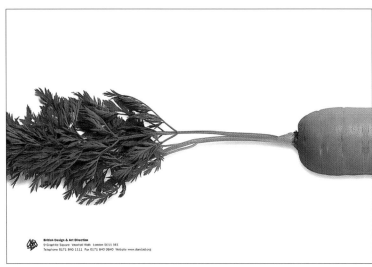

British Design & Art Direction Annual Report

WITH "REWARD" THE THEME OF ITS 1998 ANNUAL REPORT, BRITISH DESIGN & ART DIRECTION (D & AD) DANGLES A CARROT IN FRONT OF ITS RECIPIENTS.

D & AD was founded thirty-five years ago to improve the standards of design in publicity, graphic communication, and advertising materials in Great Britain and abroad. Their mission is to set creative standards, educate and inspire the next generation, and promote good design in the business arena. It stands to reason that taking on this particular annual report could be intimidating as well as a great opportunity to push the creative envelope.

The Circle of Creativity
The Partners rose to the challenge, opting for a simple message built around the cyclical theme of creativity: D & AD rewards creativity > creativity rewards business > business rewards D & AD > D & AD rewards creativity, and so forth.

Chasing the Carrot
The theme is cleanly presented on the cover. The large image of the carrot appears almost three-dimensional against the white background. The leafy top bleeds off the page and runs around the back. The effect works on two levels: the carrot reinforces the circular theme by wrapping around the annual report and it conveys the feeling of a chase.

A wide, top-page band of bold yellow contains a message that travels marqueelike throughout the book. The yellow ties into D & AD's Yellow Pencils annual awards program as well as to eye-catching graphics—from an autograph book to a pencil-shaped tie.

Equally as interesting as the graphics is the information packed into this report. The first eighteen pages tell the stories of thirteen solid, results-driven advertising campaigns, complete with storyboards. The information is presented concisely in three bullets: client, project, and results.

The President's Lectures

Each year D&AD's President invites great creative talents from around the world to share their experiences and insights with D&AD members, students and the industry generally.

The purpose is inspiration, and this year's theme, 'These are a few of my favourite things', provided a fascinating insight into the influences on twelve diverse creative talents. The series included an exploration of the objects in the home of Sir Terence Conran, snapshots from the eclectic lens of Paul Smith's camera, revelations about musical ideas with Michael Nyman, and a journey through the life and surreal mind of Michael Palin.

Over the year 8,000 people attended the lectures, reviews of which are also published in D&AD's house magazine, *Ampersand*, and on our website (www.dandad.org).

Exhibitions

D&AD's Touring Show is a celebration of the best of contemporary British and international design and advertising. Each year all the work that has either won or been nominated for a D&AD 'Yellow Pencil' is displayed in a fully curated exhibition.

This year's show explored the creative trends revealed through the D&AD Awards whilst also highlighting the links between creative excellence and effectiveness. With the help of the British Council, the tour was extended to reach new destinations including Rio de Janeiro and Jordan.

Shown below is the installation that formed part of D&AD's Sight & Sound event in London this year.

Mastercraft Series

This year's addition to the Mastercraft Series was *The Commercials Book* and *Reel*. It joins *The Copy Book* and *The Art Direction Book*, revealing how some of the world's leading creative talents ply their trade.

With combined sales in excess of 20,000 copies, the Mastercraft Series has sought to address the dearth of good titles on the art and craft of advertising. Plans are now underway to expand the series into key design disciplines.

Membership

D&AD is run for and by its members who currently include more than 1,500 leading design and advertising professionals, as well as students and associates. Full membership is an accolade reserved for those creatives whose work has appeared in the D&AD Annual. It is only Full members who are part of the Association's constitution and can vote for, or be elected as, members of the executive.

There are two other categories of membership.

Associate membership is open to those not working in a creative design or advertising function but who are recognised as encouraging and supporting D&AD's aims and ideals.

International membership is available to individuals overseas who wish to keep up with the latest and best in British design and advertising.

6

7

Food & Drink

Client: Batchelors

Title: Clean
Director: Daniel Kleinman
Creatives: Scott Leonard,
Libby Brockhoff, Kirk Palmer,
Mark Waites, Robert Saville
Advertising Agency: Mother

Project

A television commercial which is part of a campaign aimed exclusively at 18-35 year old men, radically repositioning this instant food brand – moving it away from the traditional target of mums.

Results

The campaign resulted in a 72% rise in weekly sales against the six monthly averages. Through retailer analysis, it was proved that the advertising contributed at least 42% to brand performance.

Batchelors Supernoodles:
A switch of emphasis away from targeting mums leads to a 72% sales hike.

Seattle Coffee Company: Unusual packaging design which supports rapid brand outlet development has paved the way for an $85 million acquisition.

Client: Seattle Coffee Company

Title: Seattle Coffee
Design Director: David Beard
Designers: David Beard, Clem Halpin
Design Group: Wickens Tutt Southgate

Project

Brand packaging for the Seattle Coffee Company, fashioning a poetic image based on the company's laid-back, civilised Seattle location.

Results

Founded in 1995 with just six stores, the Seattle Coffee Company has enjoyed spectacular growth, opening nearly 60 outlets. In April 1998 it was acquired for $85 million by US coffee shop giant, Starbucks.

Meat & Livestock Commission:
A campaign promoting red meat eating restores year-on-year market growth.

Client: Meat & Livestock Commission

Title: Anniversary
Director: Trevor Melvin
Copywriter/Art Director: John Webster
Advertising Agency: BMP DDB

Project

A wry and affectionate TV commercial which depicts an old couple's day out in damp out-of-season Clacton, showing how British beef is part of our way of life. Part of a three-year campaign to promote red meat eating.

Results

The campaign ran against a barrage of social, ethical and economic factors, including the BSE health scare. It succeeded in slowing the rate of decline, resulting in additional sales of £739 million on a total media spend of £36.2 million – a return of nearly 18 to 1.

10

11

CLIENT
British Design & Art Direction (D & AD)
DESIGN FIRM
The Partners
DESIGNER
Tracy Avison
ART DIRECTOR
Gillian Thomas
PROJECT MANAGER
Maryanne Murray
PHOTOGRAPHER
Christine Donnier-Valentin
COPYWRITER
Jeremy Myerson
PRINTER
Colourtec Ltd.

PAPER STOCK
Classic Triple Silk
PRINTING
4-color process plus 1 spot color; cover matte laminated
SIZE
12" x 8 ½" (30 cm x 22 cm), 36 pages
FONT
Franklin Gothic
PRINT RUN
3,000
HARDWARE
Macintosh
SOFTWARE
Quark XPress 4.0, Adobe Photoshop 5.0

annual
report
7.01.96
6.30.97

Japanese American National Museum

Japanese American National Museum Annual Report

HOW DO YOU CUT BACK AN ANNUAL REPORT BUDGET WHEN YOU NEED TO PRINT THREE TIMES AS MANY COPIES?

The Japanese American National Museum was about to launch its new Phase II Pavilion. While this angle provided the news hook for the report, it was to be mentioned only in passing because the Pavilion would not open during the fiscal year. Because the museum was in transition, the director requested that the annual report *look* less expensive as well as *be* less expensive than in past years.

A Plain Brown Wrapper
5D Studio designer Jane Kobayshi decided that a simple approach—including a brown wrap cover and inside pages printed only in black—might accomplish both objectives. Black-and-white photographs, pulled primarily from the museum's archives, were used throughout with stylized special

effects to illustrate the exhibits. While the cover is dressed up with three-color printing and thermography, the inside pages are austere, with text and black-and-white photographs offset with quotes reversed out of stark black blocks.

Building on the brown wrapper theme, the designer went for the look of newsprint stock for the copy intensive-back pages of the book.

Transition: Accomplished
Were the objectives accomplished? Yes, according to Kobayshi. "The report was very successful. We hit the budget, delivered twice as many books, and still won first place in the American Museum Awards."

CLIENT
Japanese American
National Museum
DESIGN FIRM
5D Studio
DESIGNER/ART DIRECTOR
Jane Kobayashi
PHOTOGRAPHER
Norman Sugimoto,
museum archives
COPYWRITER
Michelle Bekey
PRINTER
Typecraft

PAPER STOCK
Fox River Confetti
Kaleidoscope 80# cover,
Potlatch McCoy Dull 80#
text, French Speckletone
Natural 70# text
PRINTING
cover
3 colors plus thermography;
text
2 hits of black and dull
aqueous coating
SIZE
8 ¾" x 8 ¾"
(22 cm x 22 cm),
68 pages
FONT
News Gothic
PRINT RUN
14,000
HARDWARE
Macintosh
SOFTWARE
Quark XPress 3.3

The Japanese American National Museum now is building on its past — from virtually every angle. Our major exhibitions have sought to commemorate the distinctive contributions and hardships of first- and second-generation Japanese Americans, and to apply the lessons of those experiences to a world in which divergent ethnicities and cultures increasingly encounter one another. At the same time, the Museum is building on its own past by expanding the exhibitions, programs and activities that have helped us create a unique historical and cultural entity. We're also building on the past by constructing our new Pavilion adjacent to the existing Museum site.

These three frameworks — historical, institutional and architectural — jointly are shaping our efforts. To move forward with anticipation, yet look backward with appreciation, is a challenging task. It is also one eminently appropriate for the world-class institution we seek to become.

Exhibitions: Blending Past and Present
The Museum has become known for its innovative programming, and in 1996 and 1997, we stretched in new directions while maintaining a taut sense of purpose. *Fighting for Tomorrow*, an exhibition chronicling the heroism and humanity of Japanese American soldiers in the nation's wars, closed at our East First Street site. The Museum exhibited *The Kona Coffee Story*, a highly successful collaboration that we hope will become a model for sharing other communities' stories. We hosted or toured several smaller exhibitions, maintained ongoing activities such as our National School Project and continued our energetic schedule of programs and events around the country. The Museum also created its first Web site, among many other efforts. We meanwhile devoted considerable time and energy to Phase II fundraising and constructing the Pavilion itself.

About 20,000 cubic yards of sandy soil were removed from the Pavilion site, which was once a riverbed, and trucked to Long Beach harbor for use as essential landfill.

Among the year's most successful exhibitions: *Finding Family Stories*, the three-year, multi-institutional project we initiated in 1994. *Finding Family Stories* seeks to help Los Angeles' diverse ethnic communities investigate their similarities and differences, learn from and better appreciate one another — while educating visitors about the nation's rich ethnic and cultural milieu.

"I've always taken **Coffee** for granted... I will **appreciate** it more now that I know how **important** it has been throughout **history**."
DEB, Des Moines, Iowa, writing in the Museum's Guest Book

inmates, with different objects in each locale. The Museum meanwhile showcased *Whispered Silences: Japanese American Detention Camps Fifty Years Later*, a striking series of platinum-palladium photographs documenting the ruined sites and their echoes of disrupted lives.

We also closed *Fighting for Tomorrow*, the last in our series of three inaugural exhibitions on Japanese Americans' distinctive history, following a well-attended 14-month run. Just after the July, 1997 fiscal year-end, we opened *Sumo U.S.A.: Wrestling the Grand Tradition*, tracing the sport's evolution and considerable influence among Japanese Americans in Hawai'i and the West. And we devoted attention throughout 1996 and 1997 to developing *From Bentō to Mixed Plate: Japanese Americans in Multicultural Hawai'i*, which opened in the Islands' flagship Bishop Museum in late 1997 and will travel to Los Angeles in March, 1998.

There are 13,500 concrete blocks in the foundation walls, 140,000 pounds of reinforcing steel in the suspended decks and about 1,100 tons of structural steel in the building overall.

Activities and Events: Ongoing Favorites, New Directions
Among our other activities: an effort to broaden our appeal with younger audiences, who are crucial to the Museum's relevance and vibrancy. We sponsored a competition jointly with All Nippon Airways in which entrants were asked to answer the question, "How can Japanese American history, culture and/or art be used to build bridges of understanding between Japan and the United States?" Ten ambassadors between the ages of 25 and 35, none of whom had been to Japan previously, traveled to Tokyo and Hiroshima with organizers Cheryl Kaino and Nancy Araki, then shared their impressions with Museum audiences. We also expanded internships, public programs such as cooking classes, and entertainment targeted at younger adults.

We likewise continued numerous programs that have become the Museum's signature. The 1996 Annual Fall Dinner honored Sony Corporation and its founder, Akio Morita, for leadership in building corporate relations between the U.S. and Japan, as well as for raising nearly $10 million in the Phase II campaign. The National School Project brought together 28 grade-school teachers and administrators from 10 states for its second Multicultural Summer Institute. Directed by Lloyd Kajikawa and funded by a grant from the Japan Foundation Center for Global Partnership, the program helps participants develop course materials that allow students to search for meaning and appreciate uncertainty in diverse learning environments. We also offered a wide-ranging lineup of lectures, book parties, arts and crafts workshops and entertainment in Los Angeles, ranging from a program on Japanese American soldiers in the Vietnam war to lighthearted performances by resident favorite Cold Tofu Improv.

"For the artists, the [Finding Family Stories] project provides an unexpected venue [to] participate in an exhibition with a social agenda... Bringing individual attitudes and aesthetic approaches to their work, the artists tell their stories in distinctive voices."
SUZANNE MUCHNIC, Los Angeles Times, October 27, 1996

Office of the Privacy Commissioner for Personal Data, Hong Kong, Annual Report

A NEWLY ESTABLISHED GOVERNMENT ORGANIZATION WITH LITTLE PUBLIC PRESENCE NEEDED TO PROMOTE PRIVACY WHILE BOOSTING ITS PUBLIC PERSONA IN HONG KONG.

At first glance, this 1997–1998 annual report from Hong Kong's Office of the Privacy Commissioner for Personal Data is striking for the prominent use of its logo as the cover's main visual. Perhaps the color palette draws the eye—the pale, muted green with the vibrant dash of red on white of the logo.

When a Logo Is the Main Visual

The logo itself is composed of the Chinese word meaning *privacy* in the background, with the words on top of the white document reading "Privacy Commissioner." The actual logo, which appears on the bottom of the cover, is enhanced slightly as the dominant cover visual. Here, a page of the document is lifted slightly to reveal the words "annual report." It is a modest approach and, yes, private.

"The revelation is symbolic of the disclosure of data and its proper legal handling, which is the client's mission," said Nicholas Tsui. "The design work was particularly challenging because the existing logo needed to be featured and enhanced without appearing to be manipulated disrespectfully."

Conveying Lots of Information—Twice

Inside the report, the text manages to convey a wealth of information in two languages, English and Chinese, its 120 pages neat and devoid of clutter.

Chapters open with a full-color spread featuring a dominant color that is carried through on the following pages. The minimalist graphics are stylized and uniformly positioned on the lower right-hand page. Within the chapter, pages are streamlined. Graphics and photos appear when needed and the subtle thread of color from the opening spread helps the reader navigate the information.

CLIENT
Office of the Privacy
Commissioner for
Personal Data
DESIGN FIRM
Clic Limited
DESIGNER
Martin So
ART DIRECTOR
Nicholas Tsui
ILLUSTRATOR
Leung Kin Lung
PHOTOGRAPHER
Client
COPYWRITER
Client
PRINTER
Fairmount Printing
Factory Ltd.

PAPER STOCK
Coated Artcard 260 gsm,
matte art paper 128 gsm
PRINTING
cover
4-color process over 1 and
one side matte lamination;
text
4-color process
SIZE
8 ¼" x 11 ½"
(20.5 cm x 29 cm),
120 pages
FONTS
Bodini Bold, Bodini Book
PRINT RUN
1,500
HARDWARE
Macintosh
SOFTWARE
Adobe Pagemaker 6.5,
Adobe Photoshop 4.0 and
5.0, Adobe Illustrator 7.0

The Detroit Zoological Society Annual Report

BY AVOIDING THE OBVIOUS, JACQUÉ CONSULTING & DESIGN CREATED AN ANNUAL REPORT FOR THE DETROIT ZOOLOGICAL SOCIETY THAT NOT ONLY MEETS ITS FINANCIAL RESPONSIBILITIES BUT WARMS THE HEART AND ENCOURAGES DONATIONS.

Traditionally, when we think of wildlife and zoos we conjure up images of lush vegetation, tropical colors, bright blue skies, and children. The Detroit Zoological Society's 1997–1998 annual report takes a decided turn from the traditional approach. Yes, it has exotic animals and inquisitive children, but instead of using obvious color, the designer relied on a subtle palette.

Eliciting a Response

Several objectives were presented to the design team. One was to celebrate the combined mission statements of the two groups that constitute the zoo—The Detroit Zoological Society and The Detroit Zoological Institute. Next, the report needed to be a visual treat for the reader and present the animals as precious and beautiful. If these objectives were met, the overall goal was within reach—namely, to prompt an emotional response in the reader.

Cause and Effect

Everything in this annual report—design, photography, copy—is deliberately chosen to elicit a reaction. To begin with, the report comes in its own envelope, piquing the recipient's curiosity. The report has a belly band with a note from the chairman of the board—a nice first impression. Break the seal to see what's inside.

The vellum overcover obscures a photo of a mother and child. When the overcover is pulled away, the photo conveys emotion and warmth. All the photos are printed as duotones using a warm earth tone, PMS 5626, complemented with a cool blue, PMS 534. Special effects are used extensively to achieve the stylized photography. Edges are softened and fade into the text, blurring the line between story and visual and linking the two. Many of the small images on text pages bleed off the edges, only to be continued on the overleaf, providing continuity between pages.

The design team used the zoo's mission statement to help create the annual's overall structure. Not only is the statement printed at the beginning but portions of it are repeated throughout the text.

Celebrating
& Saving
Wildlife

Dear Friends,

I am pleased to present the Detroit Zoological Society 1997-98 Annual Report. The report expresses our gratitude for your support, documents responsible financial management and gives you a first look at some imaginative projects your Zoo is about to undertake. I hope that in reading it you will share my pride in one of the finest zoos in America.

Ruth R. Glancy
Ruth R. Glancy
Chairman of the Board
Detroit Zoological Society

CLIENT
The Detroit
Zoological Society
DESIGN FIRM
Jacqué Consulting & Design
DESIGNERS
Sharon Marson,
Michael Tripodi
ART DIRECTOR
Sharon Marson
PHOTOGRAPHER
Eric Hausman
COPYWRITER
Barbara Lewis
PRINTER
Colortech Graphics, Inc.

PAPER STOCK
Glamma CPI vellum 40#
cover and 24# cover and
text, Sappi/Warren Lustro
Dull 100# cover and text,
Weyerhaeuser Cougar
Opaque 70# text

PRINTING
vellum overcover
1 color;
inside cover
2 PMS plus black, die-cut
for back envelope flap;
inside text
2 PMS plus black
SIZE
11" x 8 ½"
(28 cm x 22 cm),
44 pages
FONTS
Adobe New Baskerville,
Adobe DIN Mittelschrift
PRINT RUN
2,500
HARDWARE
Macintosh
SOFTWARE
Quark XPress 3.34,
Adobe Photoshop 5.0

Detroiters have rekindled their love affair with their Zoo. In record numbers, they're rediscovering the Detroit Zoo as a wonderful place to experience and a worthy institution to support. We're growing faster than any other zoo in the country. We had almost 1.4 million visitors at the Detroit Zoo and nearly 200,000 visit the Belle Isle Zoo and Aquarium last year.

DEMONSTRATING ORGANIZATIONAL EXCELLENCE

Membership in the Detroit Zoological Society increased from 39,000 households in fiscal 1997 to nearly 48,500 in fiscal 1998. These figures demonstrate just how much our zoos and aquarium mean to the community. We are now one of the five most visited zoos in the country and one of Detroit's most important cultural organizations.

CONSISTENT WITH A COMMITMENT TO OUTSTANDING

Visitors, especially members, return because there's always a new experience at the Zoo. An updated exhibit, a new animal, a lecture or special program – people of all ages find something to enjoy and learn about animals. Our naturalistic exhibits and beautifully landscaped gardens offer a refreshing respite from modern lifestyles. Institute and Society success does not hinge on numbers alone, and a true leader has to do more than entertain. A leader must engage our community in positive ways, and the Detroit Zoo is doing this.

SERVICE AND PROGRESSIVE RESOURCE MANAGEMENT.

Community Treasure

The Wildlife Interpretive Gallery, with its Butterfly and Hummingbird Garden, attracts hundreds of thousands of visitors mesmerized by the beauty and behavior of these fragile animals.

International Copper Association, Ltd.

International Copper Association, Ltd. Annual Report

THE DESIGN PROVIDES THE NATURAL GRAPHIC EQUIVALENT OF COPPER, AND IN THIS ANNUAL REPORT, THE EFFECT IS WELL EXECUTED WITHOUT BEING OVERDONE.

The International Copper Association is the leading organization promoting the use of copper worldwide. Its 1997 annual report debuts the organization's new corporate identity and design programs created by R. Bird & Company.

The annual's design works from two premises: First, copper is global. According to Richard Bird, this message is reinforced subliminally through the use of a panoramic layout—everything from the text blocks and photography is laid out on a horizontal plane—and literally through the use of geographic imagery.

Second, copper is essential to life. The copy communicates this point, as does the imagery of people and natural environments.

As Bright as a New Penny
Setting this report apart from the ordinary is its literal and liberal use of copper throughout. The cover's coppery imagery and, particularly, the copper foil-stamped globe replacing the *O* in the black foil-stamped letters spelling out COPPER establish the theme.

The cover's Potlatch Karma Bright White was duplexed after printing and foil stamping to Fraser's Genesis Copper 80# text, giving the reader an eyeful of copper upon opening up the report. Inside, the copper color theme is subtlety repeated as the backdrop for text blocks.

The book was a collaborative effort of two printers: Atlanta's Dickson's, Inc., experts in specialty processes, produced the cover with its foil stamping, and Williamson Printing Corporation in Dallas lithographed the text pages.

CLIENT
International Copper
Association. Ltd.

DESIGN FIRM
R. Bird & Company

DESIGNERS
Kevin Lenahan, Richard Bird

ART DIRECTOR
Richard Bird

COPYWRITERS
International Copper
Association, various

PRINTERS
Dickson's, Inc., cover
duplexing and foil stamping;
Williamson Printing
Corporation, lithography

PAPER STOCK
cover (duplex after printing)
Potlatch Karma Bright White
65# (outside) and Fraser
Genesis Copper 80# text
(inside); Strathmore
Elements Soft Green Lines
80# text and Potlatch
Karma Bright White
80# text

PRINTING
cover
6 colors, duplexed and foil
stamped;
text
3 over 3 colors and 6 over
6 colors plus spot varnish
on photos

SIZE
11" x 8 ½"
(28 cm x 22 cm),
24 pages

FONTS
Bodoni, Futura, Plantin

PRINT RUN
2,000

HARDWARE
Macintosh

SOFTWARE
Adobe Pagemaker 6.5,
Adobe Photoshop 4.0

Alcoa Foundation Annual Report: "One Day"

LOOKING AT THE ALCOA FOUNDATION'S 1997 ANNUAL REPORT, ONE CAN'T HELP BUT INTERPRET THE TITLE AS "ONE FINE DAY." THE SUNNY ICON AND THE BRIGHT COLORS CONVEY THE IMPRESSION THAT THE ALCOA FOUNDATION IS OPTIMISTIC ABOUT ITS FUTURE.

As the Alcoa Corporation grew—it is now the world's largest aluminum producer with 100,000 employees—so has the Alcoa Foundation. In fact, the foundation's role has become so global that designer Rick Landesberg and copywriter Al Van Dine decided to feature the breath and variety of foundation-supported activities around on the world on a given day.

Multiple Photographers, Multiple Venues
Book publishers have done the same thing—invite photographers worldwide to shoot photos in their environs on a specified day—but for one nonprofit organization to be responsible for coordinating such an effort, let alone foot the bill, is something else entirely.

"Because our budget was limited, it was important to use photographers who were based in the locations we wanted to shoot in," said Landesberg. "We shot in Germany, Brazil, China, and the United States. I told them, 'I want to pay a rate as if you were down the street,'and happily, they obliged."

Maintaining Photographic Consistency
Whenever multiple photographers shoot photos across the globe and the potential for language barriers exists, there can be problems achieving and maintaining consistency. Landesberg appears to have artfully sidestepped this problem, providing, in his words, "a few directives so there would be a common look." All the shots are in black and white, none appear to be posed, and they all look as though shot from one camera.

Each photo is identified with its locale, and the copy makes a twenty-four-hour journey around the globe as the sun icon progresses through the pages until it turns into the moon. The concept is innovative in an annual report, and the treatment is uplifting.

CLIENT
Alcoa Foundation
DESIGN FIRM
Landesberg Design
Associates
DESIGNERS
Rick Landesberg, Karen
Berntzen, Joe Petrina
ART DIRECTOR
Rick Landesberg
PHOTOGRAPHERS
Andrew Yeadon, Germany,
Claudio Edinger/SABA,
Brazil, Robbie McClaren,
US, Adrian Bradshaw/SABA,
China
COPYWRITER
Alan Van Dine
PRINTER
Geyer Printing

PAPER STOCK
cover Gilbert Oxford White
80# text; Appleton Papers
Utopia One Gloss Blue
White 100# text, Utopia
Two Matte Ivory
80# text
PRINTING
cover
black and 5 PMS;
text
black and 5 PMS, 2 PMS
SIZE
7 ¼" x 11 ½"
(18.5 cm x 29 cm),
40 pages
FONTS
Bembo, Univers,
Arrow Dynamic
PRINT RUN
3,500
HARDWARE
Macintosh
SOFTWARE
Quark XPress 4.0

A Letter from the President

As our annual report, this book chronicles the work of Alcoa Foundation for one year. Our activities are so numerous that an annual review necessarily deals in summaries and numbers. But while the totals are plural, the meaning is singular. On a given day, one person with a problem encounters someone who can help—a person, often a volunteer, from one of more than a thousand community organizations supported by Alcoa Foundation in cities, towns, villages, and rural districts around the world. Thus the real meaning of our work—the reason for our existence—comes down to the impact of these activities day in, day out, on individuals trying to learn, to grow, to survive, to feed a family, to overcome handicaps, to emerge from difficulties, to forge a better life. The needs, the opportunities where such a helping hand can do the most good are identified by Alcoans in the local communities involved. As Alcoa expands in various regions of the world, this network is expanding commensurately. Our grantmaking becomes ever more international, multicultural, and complex. The Foundation has initiated training to give our Alcoa representatives in new territories the knowledge and skills they need to be effective in matching the resources we have to the specific needs of their communities. And wherever possible, in various parts of the world, we encourage partnerships with other organizations to enlarge the pool of resources available. For a glimpse of this reality on a day-to-day basis, in the following pages we follow the sun around the world—one working day in the life of Alcoa Foundation.

F. Worth Hobbs

NEUSTADT
9 am

Sunrise
HUNGARY

8 am
SWITZERLAND

9 am
GERMANY

10 am
WALES

noon
BRAZIL

Our day begins in this ancient Hungarian city, once the crowning site
Szekesfehervar
of kings, known in Roman times as Alba Regia. Today, its people are growing their industry, building a future, and grappling with problems known to cities the world over. In several such efforts, Alcoa Foundation was able to help in 1997. With equipment and furniture for eight rooms of the Crisis Management Center (Krízitkezelo Otthon), providing housing, hot meals, financial assistance, medical attention, and social support for the homeless. A minivan for the Frim Jakab Specialized Ability Development Home, to transport children with multiple handicaps. Arthroscopic, ultrasound, and ambulance equipment for the Szent Gyorgy Regional Hospital of Fejer County. Costumes and instruments for the pride of Szekesfehervar, the Alba Regia folkdance group, which performs Hungarian folk music and dance in the city, throughout Europe, and in North Africa and Canada. A copper relief portrait of Coloman Beauclerk, King of Hungary from 1095 to 1116, to become a permanent exhibit at the Saint Istvan Royal Museum. Computer equipment for the Metallurgical and Electrical Engineering departments of the University of Miskolc. Water quality control and wastewater laboratory equipment in the School of Environmental Engineering at the University of Veszprem. Computer equipment for science and engineering students at the Technical University of Budapest, and for Business Economics majors at the Budapest University of Economic Sciences.

Independence. Many people with disabilities prefer to remain independent
Lausanne
and live at home—but often they need special transportation. In 1997, Alcoa Foundation helped an association called Transport Handicap Vaud to add a new van to its fleet of special vehicles serving this purpose. Villagers. Developmentally disabled children
Neustadt
are accepted as "villagers" in 80 Camphill Centers worldwide, one of them in Neustadt, near Ludwigshafen. With the Foundation's help, a third home was added to the center in 1997. The new facilities provide a home for eight more villagers, who are living, working, and studying—gaining self confidence and as much independence as possible—within this family environment. Mind and body. When they're not in
Swansea
school, children from the area near Alcoa's Swansea plant can join in active sports programs in three clubs operated by The Welsh Federation of Boys' and Girls' Clubs and supported by Alcoa Foundation. The clubs serve children from all social backgrounds. One of them is a club for physically disabled kids, who are integrated into the community with able-bodied kids through the common theme of sports. Enabled. It's a
Poços de Caldas
busy time at Associação de Pais e Amigos dos Excepcionais (APAE), an organization that helps people with disabilities throughout Brazil. In 1997, the Municipality of Poços in Minas Gerais donated a building to APAE, and Alcoa Foundation funded a remodeling and expansion project to provide services for an additional 200 people.

P A I

Population Action International

Population Action
International

1120 19th Street, N.W., Suite 550

Washington, D.C. 20036

Telephone: 202-659-1833

Fax: 202-293-1795

Email: pai@popact.org

http://www.populationaction.org

1997

Annual Report

Population Action International Annual Report

SHOW IMPACT. THAT SUMS UP THE GOAL OF THIS ANNUAL REPORT FOR POPULATION ACTION INTERNATIONAL, AN ORGANIZATION DEDICATED TO SLOWING GLOBAL POPULATION GROWTH TO ENHANCE THE QUALITY OF LIFE FOR EVERYONE.

"The client wanted an elegant, clear, and unusual report with strong images and a global feeling," said Annemarie Feld. Developing a report that meets all these criteria was not a small task, but Feld knew it could be accomplished with the right graphics.

Finding the Perfect Image

Once rough copy was ready, Feld began an extensive search for photographs to convey the global spirit the organization wanted while visually carrying the report. She found many compelling shots from around the world, but once she found the cover image, photographed by M. Lueders, the rest of the design fell into place.

"This image influenced my color choice for type and graphics throughout. The cream-color paper enhanced these colors," Feld said.

Building a Design on One Graphic

This annual report was inspired by the cover shot. The green and pink tones in the children's clothing and wristbands are echoed throughout the design, as is the warm, sun-bathed glow.

The color palette continues through the inside pages. The type is elegant, a combination of a bold sans serif and a delicate script. The photos are all intriguing, not only because they show people and places we have only heard about but because Feld customized each for added appeal.

Some photos are silhouetted; others are cropped in unusual shapes. The center spread is no exception. Here, an image of a tree is partially outlined, its branches outstretched, sheltering the people in the foreground and anchoring all the elements on the spread.

CLIENT
Population Action
International
DESIGN FIRM
Feld Design
DESIGNER/ART DIRECTOR
Annemarie Feld
PUBLICATION DIRECTOR
Judith Hinds
PHOTOGRAPHER
M. Lueders (cover), various
PRINTER
Colorcraft of Virginia

PAPER STOCK
Warren Lustro Dull Cream
80# cover and text
PRINTING
4 colors plus varnish
SIZE
8 ½" x 11"
(22 cm x 28 cm),
12 pages
FONTS
Universe Condensed,
Carpenter, Kineses
PRINT RUN
5,000
HARDWARE
Macintosh
SOFTWARE
Quark XPress

PAI IS ABOUT ACTION—IT'S OUR MIDDLE NAME.

don't understand that Egypt, Ethiopia, Sudan and Uganda all need to draw on the same finite Nile waters to feed their growing citizenry and power their economic development.

Over the last five years, PAI has helped to develop and support a network of European advocacy partners that has successfully increased annual European funding for family planning and other basic reproductive health services by nearly $275 million. This year we will extend that network and our financial and technical support to NGOs in sub-Saharan Africa working hard to increase their governments' commitment to reproductive health care.

The soul of our nation is the sum of our individual characters. We cannot let Congress sell us short, sell the world short, sell the future short. In the current national debate about how to allocate resources for the public good, the facts are on our side. PAI's job is to make sure that every player with a vote or a veto knows it. We welcome that role.

Why are we doing this? Because PAI is acutely aware of who we are working for. Above and beyond the hundreds of millions of women and men who still do not enjoy the life saving and fundamentally empowering benefits of basic reproductive health care, we are working for the largest single generation of young people in history. Nearly one billion strong, their access to education, reproductive health services and jobs will make or break our collective future in the 21st century. Their well-being is key to their future prosperity and security—and ours.

The decisions these young people make about childbearing and lifestyle will also help determine the future of our planet, including the survival of uncounted other species. The youth of today are the future rowers of our fragile boat. Ten years from now, it will be too late to make a positive difference in their lives and their choices. The time to act is now.

PAI is about action. It's our middle name. National polls confirm that three-quarters of American adults support our mission. PAI must do more to mobilize their votes in support of U.S. leadership and funding for international family planning and a decent global future. We will do this by expanding and strengthening our working relationships with constituencies that share our goals and by forging a vision of the future that the general public will enthusiastically embrace.

Sincerely

Constance Spahn
National Chairperson

Amy Coen
President

MAJOR MILESTONES
Of the Last Year

Thanks to the generous support of its donors, PAI has been able to sustain and strengthen its capacity for the rapid distribution of timely information and research publications to colleague networks and the media in the U.S. and abroad. These capabilities have helped PAI to serve as a central clearing-house of ideas and strategies to advance both funding and field implementation of the Cairo Programme of Action worldwide. They have enabled PAI and its coalition partners to respond more quickly and surely to both the obstacles and opportunities confronting our mission. We are pleased to report these accomplishments.

■ PAI established a satellite office in Europe to support the work of its advocacy partners there. In recognition of their collective success in generating an additional $275 million per year in support for family planning from European donors since 1990, PAI has doubled its annual financial assistance and technical support to these partners.

■ PAI has helped support the strengthening of advocacy initiatives in Canada, Switzerland, Italy, Spain, Denmark, Mexico, Japan and China. Even our newest partners have already been able to report positive contributions. In Italy, AIDOS helped to promote a

25 percent increase in the 1998 contribution to the U.N. Population Fund. In Japan, JOICFP and "2050" helped to hold the contribution to UNFPA constant in yen, despite warnings that such contributions would be reduced. In Spain, the parliament approved a revolution urging overseas to Spain's population aid.

■ PAI helped to launch the Campaign to Preserve U.S. Global Leadership, a coalition of 250 organizations working to strengthen the domestic constituency for foreign aid. In 1997, the Campaign successfully promoted a $1 billion increase in the international affairs budget.

Farming a terraced hillside in Nepal

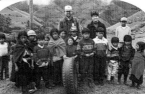

Carolyn Vogel and Rob Engelman of PAI's Population-Environment staff meet with schoolchildren at Gualaceo, a village in the highlands of Ecuador which has been active in a program that integrates natural resource management and reproductive health.

1997								1998				
April	May	June	July	August	September	October	November	January	February	March	April	

complete record of all congressional votes on family planning issues since 1984.

■ PAI stepped up efforts to engage and inform grassroots activists through fact sheets and articles in the newsletters and action alerts of like-minded environmental and humanitarian membership group. The following PAI fact sheets also proved to be effective tools for public and media education in the U.S. and abroad: Why

■ PAI distributed radio public service announcements to 2,000 radio stations nationwide on girls' education in the developing world, on the benefits of family planning to the health and well being of women and children, and on the threat of population growth to scarce freshwater resources. Approximately 10,000 such announcements were aired.

■ PAI's new web site, http://www.populationaction.org, has received favorable mention in the press and several web site awards, as well as about 900 visits per week. PAI's press releases, legislative updates, fact sheets and reports can be accessed on the site, as can a

■ PAI's critique of the World Bank called attention to the current neglect of population issues at the Bank, the inadequacy of its lending in this area, and the loss of expert staff. The much praised report has served as a wake-up call to the Bank's leadership and to donor governments that fund the Bank's activities to pursue the lending goals agreed upon in Cairo. The report has received high level Bank attention, and PAI is working with advocacy colleagues in the United States and abroad, as well as Executive Directors of the Bank, to sustain outside pressure on the Bank to strengthen its support for the Cairo Programme of Action.

■ PAI's Africa report outlined the demographic and reproductive health problems facing Africa, and the strategies needed to address them. It accompanied President and Mrs. Clinton on their 1998 visit to eight African countries, and inspired CBS's 60 Minutes to plan a TV report on how Uganda is confronting the AIDS crisis.

POPULATION
Growth in a Diverse World

The world's population is still increasing by over 80 million people a year, despite the trend worldwide towards smaller families. Moreover, population will continue to grow for at least the next half century and by at least another two billion people. Almost all of this growth will take place in the developing regions: population decline is occurring in only a few industrialized nations, while other developed countries are growing very slowly. In addition, because of past population growth, more young women than ever before are entering their child-bearing years. More funding for family planning is thus needed to enable more couples to have the smaller families they desire. In the long-term, this will contribute to a continued slowdown in population growth rates, as well as to sustainable economic development and individual well-being.

GROWTH WILL CONTINUE…

The population explosion is not over. Some analysts claim 3 population growth is no longer a problem.

based on the trend towards smaller families and very low fertility rates in some countries. But although growth rates are slowing down from their all-time high, human numbers are still increasing. World population is currently growing by about 1.5 percent a year, down from a peak of a little over 2 percent in the late 1960s. But because total population size has been steadily increasing, even at this slower rate of growth about 80 million people will be added in 1998—well above the 72 million people added in 1966 when Paul Ehrlich's book, The Population Bomb, was published.

World population will continue growing. The latest U.N. projections indicate that the world's population could reach between 7.7 billion and 11.2 billion by the mid-21st century under different assumptions about future birth rates. These recently revised projections reflect earlier

2150. These projections, however, are only statistical "guesstimates"—there is no certainty about future population trends, or even that population growth will end during the coming century.

...*AND IS UNPRECEDENTED*

Population growth over the last half century is unparalleled in the history of our planet. Human population growth took hundreds of thousands of years to grow to 2.5 billion in 1950; since then, in less than 50 years, it has more than doubled to

5.9 billion people. Most of this growth has been in developing countries where advances in public health have contributed to lower mortality at all ages. Death rates have fallen faster than birthrates, resulting in higher population growth rate.

Because of this rapid recent growth, between one-third and one-half of the population in most developing countries is under age 15. Over 95 percent of future population growth is also expected to occur in the developing regions.

Many poor countries are already struggling to support their current populations. Rapid population growth is contributing in many countries to increasing degradation of land, water and other natural resources, and making it more difficult for governments to meet the demand for jobs as well as for health care and education.

In sub-Saharan Africa, for example, food production per person has fallen by 16 percent over the past 30 years. In the future, the number of primary school age children is projected to double by 2025, straining education budgets and facilities. As a result of continuing population growth, by the middle of the next century at least two billion people worldwide will

live in countries where water shortages threaten public health and constrain food production and economic development.

FALLING BIRTHRATES, CONTINUING GROWTH

Worldwide, average family size is currently three children, significantly higher than the two-child "replacement level" required for population to eventually stabilize. This global average masks great differences among regions. Most industrialized countries now have an average family size of fewer than two children and are growing relatively slowly. Average family size in developing countries is more diverse, ranging from two children in a few countries to six or seven in many others.

When average family size is even slightly higher than two children, population will continue to grow; where average family size is much larger, population grows very rapidly, doubling in as little as 20 years. But even if average family size worldwide were to go immediately to two children, because of the built-in momentum for future growth created by the young age structure in many countries, world population would still grow by a third, to 8.4 billion in 2050.

THE WORLD'S POPULATION IS STILL INCREASING BY OVER 80 MILLION PEOPLE A YEAR AND WILL CONTINUE TO GROW FOR AT LEAST THE NEXT HALF CENTURY.

IFA Bericht Annual Report

TWO-COLOR ANNUAL REPORTS ARE FEW AND FAR BETWEEN. FOR MANY DESIGNERS, SUCH COLOR RESTRICTIONS ARE CONSIDERED DULL, LACKING THE IMPACT NEEDED TO MAKE THE REPORT STAND OUT.

For other designers, working with a modicum of tools poses an opportunity to exercise their creativity and showcase their talents.

The Challenge in Two-Color Reports

When colors are limited—for creative reasons or, more likely, budget considerations—designers are forced to be resourceful. Because there is no rainbow of color to entice the viewer, the design must be magnetic on its own merit.

Such is the case with this annual report for Germany's Institute for Foreign Cultural Relations. The report is produced in just two colors, yet it makes a distinct impression on the recipient. The budget was limited, so the colors were kept to a minimum to contain print costs while maximizing the number of pages.

The color palette came easily. The colors come from the institute's corporate identity, black and "roof red," as Michael Kimmerle calls it. The photographs were trickier.

Using Posterized Images for Interest

"An annual report shouldn't be a boring part of duty, which nobody reads. It should be editorial and explain the different services of the institution," said Kimmerle. To get the feel he was after, Kimmerle used photographs from a recent exhibition, which were relatively easy to get, but he also wanted to show some of the institution's intangibles as well.

Kimmerle told the photographer to walk around the facility and take photographs from unusual angles, showing the people who work there every day but whose efforts often go unseen.

The resulting photos are rendered as bitmapped, posterized images. They are also large, filling an entire page or running across a spread. Moreover, when an image crosses two pages, the left and the right halves are printed with screens so that one is much lighter than the other, giving the semblance of a faded photo, while others are rendered in their negative form.

The uncoated paper, whose texture resembles construction paper, enhances the grainy effect of the images. Kimmerle experimented with halftone treatments to achieve contrast in the text and in some cases placed the images behind the text for effect without losing readability.

CLIENT
Institut für
Auslandsbeziehungen e.V.
DESIGN FIRM
Michael Kimmerle Art
Direction + Design
DESIGNER/ART DIRECTOR
Michael Kimmerle
PHOTOGRAPHER
Nikolaus Koliusis
COPYWRITER
Susanne Sporrer
PRINTER
Heinrich Fink GmbH & Co.

PAPER STOCK
Trucard 300 gsm, Ricarda
White 120 gsm
PRINTING
2 colors
SIZE
8 ½" x 11 ¾"
(22 cm x 30 cm),
92 pages
FONTS
Thesis, The Sans
PRINT RUN
2,000
HARDWARE
Macintosh
SOFTWARE
Quark XPress

Cancer Care, Inc. Annual Report

"HELPING THOSE WITH NO PLACE TO TURN" IS CANCER CARE'S MISSION AND THE THEME OF ITS 1998 ANNUAL REPORT, WHICH WAS PRODUCED WITH A LIMITED BUDGET AND EXISTING PHOTOGRAPHY.

The primary objective of the annual was to show examples of gratitude received in fan letters and email from people who had nowhere else to turn and who were helped by Cancer Care. "It was important to convey a soft, caring feeling. The client wanted to project accessibility, openness, and modernity," said Anna Lieber.

Like most nonprofit organizations, the budget for this report was limited, allowing only three-color printing and saddle-stitch binding. Cancer Care provided Lieber with existing black-and-white photographs.

Invigorating a Design with Limited Resources

When designers are bound by such common limitations, exactly how can they make a report stand out? Finding innovative treatments for what they have at hand was the answer that worked for Cancer Care.

Lieber enhanced the photos by enlarging them to create a bold presence, silhouetted many of the shots, and created duotones, using unlikely colors of light teal and lavender, for added dimension. The corners of the photos were rounded, as were many of the text blocks, to increase overall interest.

The copy was specified in different typefaces for emphasis. Fan letters were set in a script and OCR was used as the font for electronic feedback so that it would look like the computer-generated document that it was. The financials were delineated in striped rows not only to make it easy to find the information you need but to make the section more visibly interesting.

This report goes far to dispel the myth that audience impact requires a sizable budget. Reports with limited funds can be just as effective as expensive, glitzy annuals; the designer just has to work to figure out how.

CLIENT
Cancer Care, Inc.
DESIGN FIRM
Lieber Brewster Design, Inc.
DESIGNERS
Elisa Carson, Julie Bray
CREATIVE/ART DIRECTOR
Anna Lieber
COPYWRITERS
Lanie Dommu, Ann Navarria
(Cancer Care, Inc.)
PRINTER
Philip Holzer & Associates

PAPER STOCK
Potlatch McCoy Silk 100#
cover, Potlatch McCoy Velvet
80# text
PRINTING
3 colors
SIZE
7 ½" x 10 ¾"
(19 cm x 27 cm),
44 pages
FONTS
Frutiger, Simoncini
Garamond, Linoscript, OCR,
Zaft Dingbats
PRINT RUN
4,000 and 200 inserts
nested inside front cover
HARDWARE
Macintosh
SOFTWARE
Quark XPress 3.32,
Adobe Photoshop 3.0,
Adobe Illustrator 6.0

You have helped me through

one of the most difficult times of my life.
I found your social workers to be a source of
strength, comfort, and guidance.

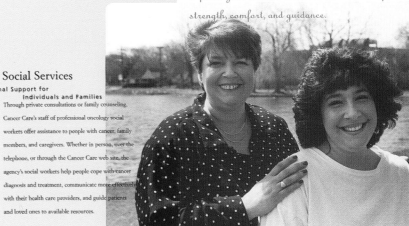

Social Services

**Emotional Support for
Individuals and Families**

Through private consultations or family counseling,
Cancer Care's staff of professional oncology social
workers offer assistance to people with cancer, family
members, and caregivers. Whether in person, over the
telephone, or through the Cancer Care web site, the
agency's social workers help people cope with cancer
diagnosis and treatment, communicate more effectively
with their health care providers, and guide patients
and loved ones to available resources.

Your web site was so helpful.

I found the information
useful and thorough.
The diagnosis of cancer,
treatments, and all that
accompany it can over-
whelm a person as well
as the ones closest to
him or her. Thank you for
making the information so
easily accessible to the
survivors and loved ones
of those diagnosed.

TELECONFERENCE PROGRAMS.
The Cancer Care Teleconference Program, a
simple, innovative use of the telephone, pro-
vides people with cancer, their loved ones, and
caregivers free information on various health
care issues in the comfort of their homes or
offices. Connecting 500 to 800 people nation-
wide in a single workshop, participants follow
along from accompanying written material,
ask questions, and receive additional services.
Cancer Care's teleconferences are also available
via RealAudio by accessing the Cancer Care
web site. Topics include coping with fatigue
and treatment side effects, support for daugh-
ters whose mothers have breast cancer, man-
aged care, understanding clinical trials, and
help for people living with lung cancer. Health
care professionals are invited to participate in
these teleconferences as well as in those
designed specifically for professionals.

THE CANCER CARE WEB SITE
www.cancercare.org
Visitors to the Cancer Care web site have
access to over 500 pages of detailed service
descriptions, informational material, on-line
assistance and support groups, and sections
devoted to specific topics. With over 100,000
hits per week, the web site has proven to be a
one-stop resource for people seeking cancer-
related information. In addition, information
on upcoming events, opportunities to support
the agency, and important links to other helpful

resources are provided. New to the
Cancer Care web site is a section on Health
Care Policy and Advocacy. This important
section reaches ways to advocate on your
own behalf or on behalf of a loved one for
better care and how to advocate on behalf
of policy issues and laws that affect people
with cancer.

ON-LINE AND TELEPHONE SUPPORT
Separated by vast distances, people affected
by cancer are now able to come together on
the Cancer Care web site or over the tele-
phone to provide help, hope, and support for
one another and to address questions and
concerns with Cancer Care's professional
oncology social workers. Groups are com-
prised of individuals from towns and cities
across the country and help people cope with
the impact that cancer has had on their lives.

E-MAIL
info@cancercare.org
The convenience and efficiency of e-mail
can be vital for someone with cancer. E-mail
requests to Cancer Care are answered by the
agency's staff of professional oncology social
workers and often provide people with cancer
and their loved ones a direct line to help they
might not otherwise find. E-mail also provides
the agency with an opportunity to receive
feedback from those who access the Cancer
Care web site.

THE CANCER CARE COUNSELING LINE
1-800-813-HOPE
The Cancer Care Counseling Line at
1-800-813-HOPE (4673) connects callers to
one of the agency's professional oncology social
workers who will answer questions, address
concerns and provide information, referrals,
and practical assistance. The Counseling Line

is available Monday through Thursday,
9am-7pm and Friday, 9am-5pm ET. As the
centerpiece of Cancer Care's national outreach,
the Counseling Line is a gateway to the entire
spectrum of the agency's free professional
services, offering help and hope to the many
who look to us each day.

On behalf of everyone at our school,

I wish to express our appreciation for
the stimulating and highly interesting
workshop. The vitality, commitment,
and vast knowledge that you bring to
these seminars has made each of them
a most worthwhile learning experience.

Community Services

**Cancer Care Reaches Out with
Educational Seminars and Workshops**

Cancer Care's educational seminars and workshops are designed to
provide information to the general public about early detection and
risk reduction. Offered at Cancer Care's offices, in schools, community
organizations, corporations, and institutions, these education and
awareness workshops focus on issues relating to specific types of
cancer as well as on topics such as wellness, nutrition, stress reduction,
and how to communicate with your doctor.

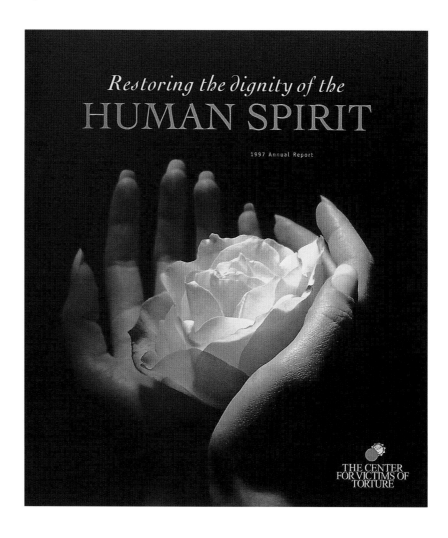

The Center for Victims of Torture Annual Report: "Restoring the Dignity of the Human Spirit"

THE WORD *TORTURE* CONJURES UP GRUESOME IMAGES OF UNIMAGINABLE SUFFERING—NOT EXACTLY THE KIND OF THING YOU WANT IN AN ANNUAL REPORT, EVEN IF IT IS FOR THE CENTER FOR VICTIMS OF TORTURE.

The goal was to present a beautiful first annual report for The Center for Victims of Torture that communicated the seriousness of the subject matter without displaying the details of torture itself.

Pro Bono Contributions Contain Costs
Yamamoto Moss provided all the design and production for this annual pro bono; Litho, Inc., which handled the prepress and printing, also worked for free. Their contributions allayed much of the cost of this report without sacrificing quality.

The report is elegant in its understated presentation and the message is communicated with dignity. One's first impression comes from the report's title *Restoring the Dignity of the Human Spirit*. The color palette and type choices are

simple and soothing and, coupled with the photo of the hands carefully cradling a rose, establishes the theme of life's preciousness.

Torture: An Ugly Word, a Beautiful Report
Torture is such an ugly word, and yet, in this report, the subject matter and message of healing is beautifully conveyed in words and graphics.

The flower theme is carried throughout the report and tied into the center's fund-raising event, the Healing Gardens Tour. "Healing the wounds of government-inflicted torture" is the organization's mission, and the flower metaphor ties in nicely to the message that torture victims can thrive in an atmosphere of caring and acceptance.

CLIENT
The Center for Victims
of Torture

DESIGN FIRM
Yamamoto Moss

DESIGNER
Renita Breitenbucher

PHOTOGRAPHERS
Tim Maas (cover), Cheryl
Walsh Bellville, Beverly Free,
William Clark

COPYWRITER
Paula Beck

PRINTER
Litho, Inc.

PAPER STOCK
Sappi Lustro Dull Cream
100# cover and text

PRINTING
4 spot colors and
aqueous coating

SIZE
8 ¾" x 10 ¼"
(22 cm x 25.5 cm),
24 pages

FONTS
Cochin, Officina Sans

PRINT RUN
3,500

HARDWARE
Macintosh

SOFTWARE
Quark XPress 4.0,
Adobe Photoshop 5.0

LETTER
from Board Chair and Executive Director

Rev. Richard Lundy, Board Chair (right)
Douglas A. Johnson, Executive Director (left)

"Torture survivors have an emotional, mental, physical and spiritual life that needs to be supported and nurtured. We believe survivors can recover from the traumas that have been inflicted on them, are capable of restoring themselves in the context of relations with others and may even go on to thrive as successful, fully contributing members of their communities."

CLIENT CARE:
Healing the Survivors of Torture

Rosa E. Garcia-Peltoniemi, Ph.D., L.P.
Director of Client Services and
Director of Psychological Services

"I have never had a doubt about whether volunteering with the Center was worthwhile. I hope that all volunteers feel about it this way: that it is a worthy effort, that we're doing something important."

VOLUNTEERS

Jean Andrews
CVT Volunteer since 1988

Foellinger Foundation Annual Report:
"Honoring the Past by Investing in the Future"

READING THE FOELLINGER FOUNDATION 1998 ANNUAL REPORT IS LIKE THUMBING THROUGH A LOVINGLY PRESERVED SCRAPBOOK, WITH PHOTOGRAPHS AND MEMENTOS OF DAYS GONE BY.

This annual report can best be described as a tribute that, in keeping with its theme, honors the past and the early days of the Foellinger Foundation in a way that is highly readable.

The people in the vintage photos on the cover may be unknown to us, but we can identify with them. We've seen these photos before—or ones remarkably similar—among our own family albums. A dried rose, a wheat penny, wire-rimmed eyeglasses, a camera, sheet music, a bible, and the snapshots are the stuff of antique dealers, but these vintage pieces are personalized with the story revealed inside.

Making History Interesting
The story of Oscar Foellinger and the foundation that bears his name is told as if by a friend of the family. Through the copy we meet the Foellinger family, get to know them by their first names, and learn of their impact on the people and events in Fort Wayne, Indiana.

Reading this family's history is like reading a diary that, coupled with the photography, doubles as a historical timeline. It is fascinatingly personal for a so-called financial document.

Simplicity and Elegance
The typestyle is classic and, like everything else about this annual report, elegant.

Where Joseph Michael Essex juxtaposes the old photographs with present-day happenings, the design retains its balance and simplicity. If anything, the contrast of the old and the new makes the report poignant, proving that by honoring the past, we invest in the future.

FAMILY CHALLENGES

The loss was even greater for Esther Foellinger and her two daughters, Helene and Loretta. Oscar had married Esther Deuter, also the grandchild of German immigrants, in November 1909. Their first child, Helene, was born in December 1910 and Loretta followed four years later.

Esther, an avid gardener and community volunteer, had supported her husband in his business activities but did not want to run *The News-Sentinel* following his death. However, Helene Foellinger, a top mathematics student and a newspaper editor at South Side High School and the University of Illinois, had always wanted to work in the newspaper business.

So 25-year-old Helene Foellinger, a section editor at *The News-Sentinel*, stepped up to the job. She became the country's youngest publisher in 1936 and served in that role for 44 years before selling the newspaper in 1980.

The first years were the hardest, with Helene spending long hours learning every aspect of the business. During that time her sister, Loretta, worked at Lincoln National Life Insurance Company and volunteered for community organizations, including the American Red Cross and the Civil Air Patrol.

In 1945, the family celebrated Loretta's marriage to Richard S. Teeple, a lawyer and flight instructor in the Civil Aeronautics Authority during World War II.

But five years later, untimely death again struck the Foellinger family when Richard and Loretta Teeple were killed in a plane crash in Wisconsin. The tragedy brought Esther and Helene Foellinger closer and the two women lived together until Esther's death in 1969.

A FOUNDATION FOR THE FUTURE

Esther and Helene traveled the world together, and one of those trips led to the creation of the Foellinger Foundation.

Helene, who said she was "married to [her] job," knew she was the last in her family and worried what would become of her beloved *News-Sentinel* after her death. Before a European trip in 1958, she and her mother created the Foundation, which could run the newspaper and make grants from its profits if anything happened to Helene.

The two women returned from that trip unharmed. But in the following years, their attention increasingly turned to the work of the Foundation and its support of many education, arts and community causes. Esther left the bulk of her estate to the Foundation, increasing its assets to $6 million by 1973.

Meanwhile, the rigors of running *The News-Sentinel* were taking their toll on Helene. Although it was a difficult decision, she chose to sell the newspaper in 1980 to Knight-Ridder.

Helene, a board leader for many nonprofit groups, devoted the last seven years of her life to community affairs. She led the Foundation board's efforts to expand its grantmaking, and was named Indiana's Individual Philanthropist of the Year in 1985.

After Helene Foellinger died in 1987, at age 76, her estate distributed approximately $74 million to the Foellinger Foundation, increasing its assets to nearly $102 million by 1989.

Her last gift guaranteed that her family's commitment to the Allen County community would stay strong and vibrant for generations to come.

CLIENT
Foellinger Foundation
DESIGN FIRM
Essex Two
DESIGNER/ART DIRECTOR
Joseph Michael Essex
PHOTOGRAPHER
Roberts Photography Inc.
COPYWRITERS
Bruce Hetrick, Pam Klien
(Hetrick Communications)
PRINTER
Keefer Printing Company

PAPER STOCK
Strobe Silk 100# cover and text
PRINTING
4-color process plus 1 PMS and varnish
SIZE
8 ½" x 11"
(22 cm x 28 cm),
32 pages
FONT
Weiss
PRINT RUN
2,500
HARDWARE
Macintosh
SOFTWARE
Quark XPress

LESSONS IN A LEGACY

In 1935, as he was preparing to leave on a hunting trip, businessman Oscar G. Foellinger wrote a letter to his wife and two daughters.

He was a successful newspaper publisher, a friend of national politicians and a leader in his Indiana hometown. But Oscar was also a man who recognized that the people he loved most didn't understand why he'd devoted so much of himself to business and civic affairs.

It wasn't to get rich, he told his family, although he'd been lucky enough to make good money through his hard work. He'd had a larger purpose.

"While to me it has been pure fun to make money," Oscar Foellinger wrote, "I have always looked upon it as merely the stamp of approval placed on my earnest efforts in attempting to serve my community."

Ironically, he would die one year later, on a hunting trip in the Canadian Rockies. But his words inspired the three women he left behind to continue his work in community service.

Today, the family's commitment lives on through the Foellinger Foundation, which in 1998 celebrated its 40th year of helping the people of Allen County, Indiana.

A FAMILY TRADITION

The Foellingers' community roots go back to 1836, when 18-year-old Jacob Foellinger arrived in Fort Wayne from Germany. After launching a boot and shoe-making business, Jacob quickly became active in the affairs of his new hometown. He was elected to the Fort Wayne City Council and helped start the city's public schools in 1853. Although it was controversial then, Jacob firmly believed in public support for education – a belief that guided the Foellinger family for generations.

Jacob's son Martin followed in his father's shoe-making footsteps, first working for the family business and then launching his own company. The Foellingers' business acumen and civic involvement was carried forward by Martin's son Oscar, who was born in 1885 and left school at the age of 12.

Oscar Foellinger learned accounting skills at a bank before stepping into what would be his lifelong business love, the newspaper industry.

In 1906, at the age of 21, he became business manager of the Fort Wayne Journal-Gazette. In 1912 he assumed the same role for the rival Fort Wayne Daily News, which in 1918 merged with another daily to become The News-Sentinel. Oscar purchased The News-Sentinel in 1920 and became publisher of the city's largest newspaper.

He also became a strong community activist. Oscar led the fight against tuberculosis and took special interest in a camp for children with TB. Columns in his News-Sentinel advocated better roads, sewers and public health services.

A staunch Republican, Oscar used the newspaper to support conservative fiscal policies and conservative nominees for political office. He also became a close friend of President Herbert Hoover after managing Hoover's campaign in Indiana.

Although he never attended high school, Oscar was a lifelong learner. When he found an interesting subject – in business, politics or the community – he wanted to know all about it. That thirst for knowledge extended to his hobbies, and Oscar was an expert pilot, hunter, fisherman and horseman.

When he died of a heart attack at age 51, Oscar Foellinger was mourned by thousands around the country. In a condolence telegram to Oscar's family, former President Hoover said that "his town, the state and the country lose a real leader of unfailing service."

APPLAUSE FOR THE ARTS

Helene Foellinger and her mother, Esther, loved symphony concerts, theatrical performances and museum openings. In fact, Helene Foellinger's first major philanthropic gesture came in 1947, when she donated $100,000 to build an outdoor theater in Fort Wayne's Franke Park to honor her late father.

It's no surprise, then, that the Foellinger Foundation has a long and proud tradition of serving children, youth and families in Allen County through grants to arts and cultural organizations. It's also no surprise that arts patrons benefited from some of the Foundation's 40th anniversary grants.

To kick off its Milestone Grant program, the Foundation awarded $200,000 to the Fort Wayne Parks and Recreation Department to purchase a new sound system for the Foellinger Outdoor Theatre, the successor to the facility Helene Foellinger helped build more than 50 years ago (the original burned down).

The new system will significantly improve sound quality for concerts, plays and movies at the theater. It also will include an assisted listening system, so hearing-impaired audience members can enjoy films and live performances, too.

The Foundation also recognized the need for local arts organizations to have a broader base of support in the community. So two $100,000 Milestone Grants went to Arts United of Greater Fort Wayne to help arts groups improve their fundraising and reach new audiences.

Arts United is an umbrella organization that represents groups such as Artlink, Fort Wayne Ballet, Fort Wayne Civic Theatre, Fort Wayne Dance Collective, the Fort Wayne Museum of Art and the Fort Wayne Philharmonic.

One of the grants is a three-year grant to match new contributions to Arts United fund drives from 1998 to 2000. The other provides research funding to help Arts United's member organizations better understand the kinds of performances or exhibits that interest the public.

Both of these efforts will develop new audiences and funding, which are vital to the long-term future of arts groups – and music to the ears of an arts-loving community.

STANDING OVATION

Three Milestone Grants were designed to build interest in and support for the arts. Arts United received one grant that will help its member organizations learn more about what audiences want. Another grant will match new contributions to its annual fund drive.

Meanwhile, audiences at the Foellinger Outdoor Theatre will applaud the new sound system funded by a $200,000 grant to the Fort Wayne Parks and Recreation Department. The Theatre, named in honor of music lover Oscar Foellinger, was built in the 1970s through the Foellinger Foundation's grant support.

SOWING THE SEEDS OF LEADERSHIP

What happens if neighbors don't know the best way to lead neighborhood improvement efforts? Or if no one steps forward to help solve a community problem?

The Foellinger Foundation knows that effective grassroots leadership is essential for a strong community. Without it, problems multiply and well-meaning people become discouraged. With it, people get involved in finding solutions.

The Foellinger family understood the value of community involvement. Helene Foellinger served on many nonprofit boards and encouraged *News-Sentinel* employees to contribute their time and talent to civic organizations. Helene's sister, Loretta, regularly volunteered with groups ranging from the Red Cross to the Civil Air Patrol.

To honor the family's community service commitment, the Foundation awarded a $100,000 Milestone Grant to Leadership Fort Wayne.

This organization teaches individuals how to make things happen by taking a leading role in their community. Each year, 30 to 35 people participate in a nine-month training program to learn about community assets and issues and develop leadership skills.

Members of the 1998 Leadership Fort Wayne class used $40,000 of the Milestone Grant to provide leadership training to citizens involved in a broad variety of nonprofit organizations.

The remaining $60,000 was used to support worthy projects in Fort Wayne neighborhoods and outlying Allen County townships. Class members approved grants to install new playground equipment, paint community buildings, establish day care programs, plant flower gardens, publish newsletters and buy neighborhood signs.

None of the projects cost much – some were as little as $500, others cost up to $4,000 – but each had a big impact in its own way. Proving, once again, that the community with grassroots leadership is the community that thrives.

NEIGHBORS HELPING NEIGHBORS

Foellinger family members often volunteered for community projects. Part of this year's Milestone Grant to Leadership Fort Wayne encouraged today's volunteer leaders to do the same through a regranting program for neighborhood projects.

On behalf of Lake Township, Trustee Dan Linnemeier received funds to buy materials to fix up a lakeside dock and playground. Local Girl Scouts and neighborhood volunteers, including those pictured here, provided the sweat equity. And Leadership Fort Wayne class members learned how to make fair and effective grantmaking choices.

A FISH TALE

"Give a man a fish and you feed him for a day," says the old Chinese proverb. "Teach a man to fish and you feed him for a lifetime."

Oscar Foellinger believed in the value of self-reliance, even in leisure activities. That's why he taught his daughters how to fend for themselves during the family's many camping and fishing trips in the wilderness.

The Foellinger Foundation also follows that family philosophy in its grantmaking. We look for nonprofit organizations that are strong, focused on their mission and supported by many segments of the community.

We believe that when organizations know how to manage themselves well, they do a better job of helping the people they serve. So as part of our 40th anniversary celebration, the Foundation developed and funded a series of training programs to help grant recipients learn how to remain financially stable and effective in their community work.

Because it's becoming more difficult for nonprofits to raise all the money they need, we brought in two nationally known experts from the Indiana University Center on Philanthropy. Dr. Eugene Tempel and Dr. Timothy Seiler met with executive directors, development directors and board members of local nonprofits to discuss how they could better raise funds for their organizations.

Because so many funders want to determine the effectiveness of charitable programs and the impact of their donations, we asked Dr. Michael Quinn Patton, an expert on program evaluation, to conduct a workshop on measuring results.

And we brought in a futurist, Geneva B. Johnson, the retired president of Family Service America and a board member of the Drucker Foundation for Nonprofit Management, to help board and staff leaders understand and plan for the changing world in which they operate. In these challenging times for nonprofit management, we think helping organizations learn to be more efficient and effective is vital to continuing the good work they do in our community.

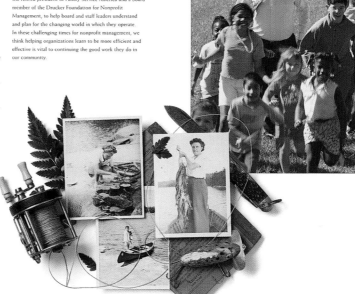

AN INDEPENDENT SPIRIT

The Foellingers believed in developing self-reliance, from childhood on up. That's why they would have appreciated the Foellinger Foundation's efforts to help its grantees better manage their programs and operations. The Foundation sponsored a series of workshops to help agency leaders learn about fundraising, results measurement and planning for the future.

Agency board and staff members, including East Allen County Schools Superintendent Jeff Abbott, pictured with students at Village Woods Elementary School, participated in the program.

Hauptverband Deutscher Filmtheater e.V. Annual Report

HAUPTVERBAND DEUTSCHER FILMTHEATER E.V., OTHERWISE KNOWN AS THE GERMAN ASSOCIATION OF CINEMA OWNERS, GRABS AUDIENCE ATTENTION WITH ITS ANNUAL REPORT. IT DESERVES AN OVATION FOR ITS CLEVER APPROACH.

Movies, cinema, film—by whatever name you choose—the celluloid images that flicker in dark theaters have made the entertainment industry what it is today. We go to the movies to be entertained, so it makes perfect sense that the German Association of Cinema Owners would want to entertain with its annual report.

"The challenge was to find a combination between the client and the material—film, movies, cinema," said Michael Rasch, co-art director on the project.

It's in the Can
In searching for the perfect link between theater owners and their product, the Fantastic New Designment team came upon the perfect metaphor: a can of film.

From there, translating the image to paper on ink was relatively easy. The outside of the film can became the report's round 8 ¼"-diameter (20.5-cm) cover, while the inside pages were printed with a screened image of a spool of film unreeling as the year's story is told.

"The spool of film gives the background to this annual report and underlines the importance of the medium—film—for the association and its members," Rasch added.

Black and White with Technicolor
The bulk of the story is told in black and white, as the majority of text pages are printed simply in one color. But just as Dorothy stepped out of a black-and-white Kansas into a Technicolor Munchkinland, sudden splashes of vivid color on four-color process pages are intermingled with the black and white.

The photos of theater concession stands are especially noteworthy, as are the scenes of the big moneymaker for cinema owners in 1998—*Titanic*, complete with the Coeur de la Mer (Heart of the Ocean) blue diamond.

"The movie itself is the real report ... with good results for the German cinemas," said Rasch.

In short, German theater owners enjoyed a happy ending in 1998.

CLIENT
Hauptverband Deutscher
Filmtheater e.V.
DESIGN FIRM
Fantastic New
Designment GmbH
ART DIRECTORS
Thomas Lass,
Michael Rasch
COPYWRITER
Hauptverband Deutscher
Filmtheater e.V.
PRINTER
Druckerei Schwalm

PAPER
Praxi Edelmatt Arjo Wiggens,
250 g cover and 135 g text
PRINTING
cover and 6 pages
4-color process;
text
1 color
SIZE
8 ¼" diameter
(20.5 cm diameter),
116 pages
FONT
Helvetica Condensed
PRINT RUN
1,500
HARDWARE
Macintosh
SOFTWARE
Quark XPress, Adobe
Photoshop, Macromedia
FreeHand

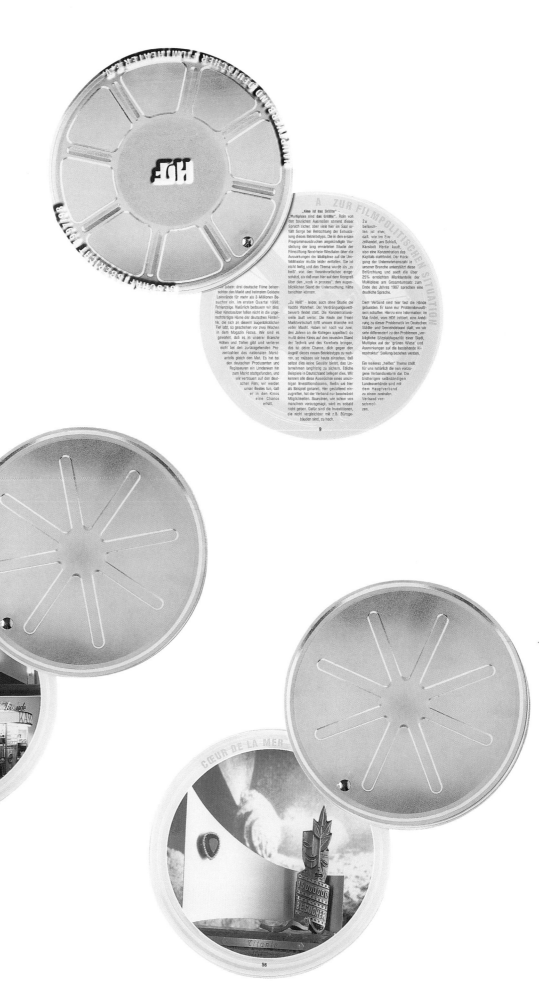

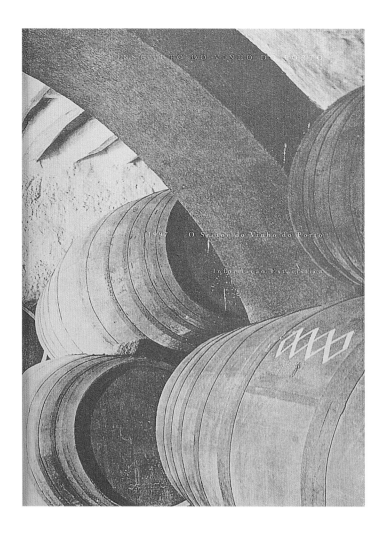

Instituto do Vinho do Porto Annual Report

DUE TO THE INVESTMENT ANNUAL REPORTS REQUIRE, THEY ARE INCREASINGLY DESIGNED FOR MAXIMUM USE AS PROMOTIONAL TOOLS THAT COINCIDENTALLY MEET THE REQUIREMENTS OF FINANCIAL DISCLOSURE.

The Instituto do Vinho do Porto (Port Wine Institute) wanted to maximize its exposure and promotional impact during the International Expo '98, one of the biggest events of the year, which just happened to coincide with the publication of its annual report.

Maximizing the Report's Exposure

To achieve the desired visibility, the Instituto do Vinho do Porto decided to produce two other brochures simultaneously with its annual report to publicize its activities during the Expo.

The result is an impressive portfolio. Though printed in just one color, the portfolio cover's image of wine barrels gives the appearance of an aged, vintage photo, the result of the combination of textured paper stock and the photo treatment itself.

The warm tones of the image carry through the inside of the portfolio, where two pockets reveal three port-colored books—the editorial, an overview of the port wine region's history, and the financials—all subtly blind embossed.

Few Budget Restrictions

Like a fine wine, this is a report to be savored. Because of the importance of the Expo, few budgetary restrictions were placed on the project, and it shows. The full-color photography is magnificent. The aerial shots of the region look as if they belong in a travelogue, not a financial document. Equally intriguing are the photos of the products.

This annual report achieves what it set out to do: boost visibility for the institute.

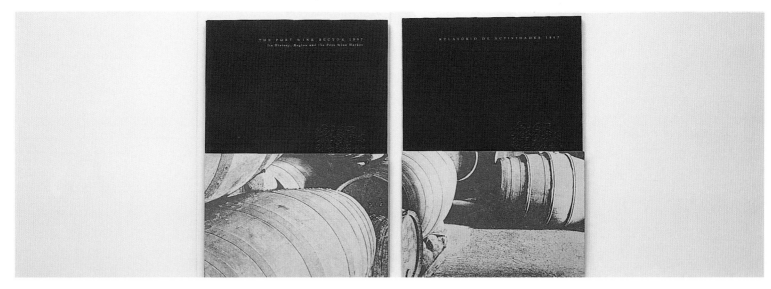

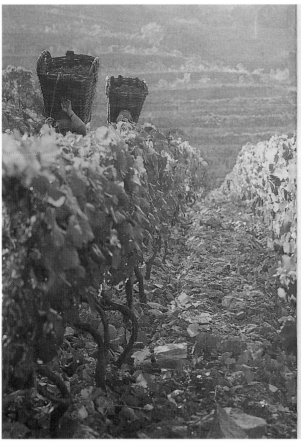

CLIENT
Instituto do Vinho do Porto
DESIGN FIRM
João Machado Design, Lda.
DESIGNER/ART DIRECTOR
João Machado
ILLUSTRATOR
João Machado
COPYWRITER
Instituto do Vinho do Porto
PRINTER
Rocha Artes Gráficas, Lda

PAPER STOCK
Keaycoulour 300 g,
Marcata 140 g
PRINTING
cover
1 color;
text
4 over 4

SIZE
8 ½" x 12"
(22 cm x 30 cm),
48 pages (report),
20 pages (financials),
48 pages
(history and market)
FONT
Garamond
PRINT RUN
2,500
HARDWARE
Macintosh
SOFTWARE
Quark XPress, Macromedia
FreeHand

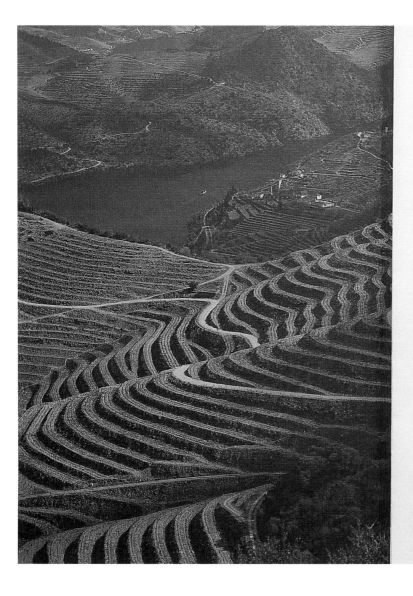

Índice

INSTITUTO DO VINHO DO PORTO
ANNUAL REPORT

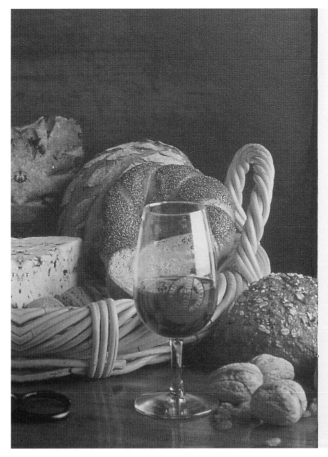

Each kind of Port Wine possesses quite distinct features. Thus, when buying a bottle, one should carefully read the label and take into account the moment of consumption.

Ports present different aromas, according to the type and length of its maturation. The youngest, with a fruity aroma, adapt in a natural manner to many diverse occasions, whilst old tawnies, 20 years old or more, as well as the Colheita or the Vintage, with more complex aromas, require situations of more solemnity and ritual.

When does Port Wine reach its ideal point? For how long should it be kept at home? Ruby should not remain in the bottle for very long as it risks losing the vivacity which characterises them. By the same token, there are also no advantages in keeping a young Tawny. On the other hand, aged Tawnies and Colheitas, while they can perfectly be kept in private cellars for some time, should, however, be drunk in the first few years after bottling.

Vintage, on the other hand, can calmly mature inside the bottle thanks to its high degree of tannins. In fact, these wines reach their full potential 10, 20 or more years after the harvest date. Once it is stored, one should avoid handling it because any sudden movement might unsettle the lees which have formed, leaving particles in suspension. One hour before drinking, Vintage must be decanted, a procedure which is indispensable in order to allow these wines to breathe and become clear at the moment of its consumption.

When very old Vintage are consumed, the corks break easily due to the actions of time and the sugar of the wine itself, which causes the cork to stick to the bottle. In order to obtain a clear wine, the following method may be used to extract the cork: First, one places, for some seconds, a pair of tongs previously heated until they are red-hot around the bottle neck, a slightly below the cork; next, one has to place other cold pair of tongs, ice or a

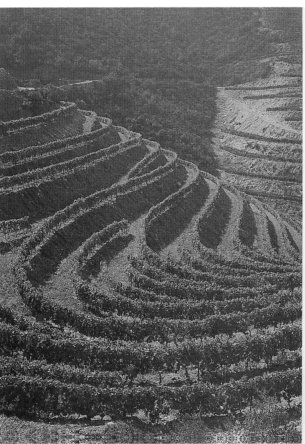

5 • Modernização e Simplificação Administrativa

Prosseguindo o esforço de modernização e descentralização dos Serviços, no sentido de oferecer aos operadores do sector uma melhor qualidade de atendimento e uma maior eficácia na prestação de serviços, entraram em funcionamento, em 1997, as novas instalações dos Serviços de Fiscalização em Vila Nova de Gaia.

Para além de uma melhoria de condições de trabalho, verifica-se igualmente um acréscimo de eficiência dos Serviços, dado passarem a dispor de uma ligação informática ao sistema central, o que permite disponibilizar aos utentes praticamente todos os serviços administrativos inerentes à certificação da Denominação de Origem, recepcionar e tratar as amostras destinadas à apreciação dos vinhos pelos Serviços Técnicos do IVP e ainda permitir a aquisição de selos e cápsulas.

No sentido de dotar os serviços de maior capacidade para exercerem as suas funções, foi dada também continuidade ao trabalho de desenvolvimento e aperfeiçoamento do Sistema de Informação.

Assim, nos últimos anos, tem constituído prioridade a informatização básica dos serviços acompanhada pela reorganização dos procedimentos internos associados. Este processo de modernização tem como objectivo primordial melhorar a operacionalidade do IVP, reduzindo a intervenção humana em tarefas de carácter repetitivo. Considerando-se em fase de conclusão a informatização a nível operacional, a modernização do IVP poderá seguir novos passos dando início ao desenvolvimento de projectos vocacionados para áreas complementares não incluídas na fase inicial.

O desenvolvimento de uma rede interna de computadores pessoais, integrada com o sistema principal AS/400, criou meios para a troca interna de dados e a partilha de equipamentos informáticos. Com o desenvolvimento deste projecto, foi possível acelerar o fluxo de informação entre os diversos serviços da instituição e melhorar a gestão dos seus recursos informáticos.

Unternehmen
in Entwicklung

Unser Unternehmensverständnis

Enterprise
and Development

Our Enterprise Principles

gtz

Deutsche Gesellschaft für
Technische Zusammenarbeit (GTZ) GmbH

Deutsche Gesellschaft für Technische Zusammenarbeit GmbH Annual Report

THIS ANNUAL REPORT COVER IS SURPRISINGLY UNASSUMING, PROVIDING ONLY A HINT OF WHAT'S INSIDE.

Judging from its cover, one wouldn't expect this annual report for the Deutsche Gesellschaft für Technische Zusammenarbeit (GTZ), a nonprofit technical development aid company owned by the Federal Republic of Germany, to be anything out of the ordinary. It is well executed and clean. The typestyle is practical. The photos are definitely intriguing, but they give little intimation of what follows.

Using Impressionistic Collages to Illustrate the Intangible

The GTZ commissioned painter and sculptor Achim Frederic Kiel to create six works of art representing the company's missions. Kiel chose natural materials for collages to reflect the major resources and illustrate the situation of Third World countries.

The resulting collages are altogether fascinating and unsettling. For example, the collage entitled *Our Assignment* depicts the economic divide between rich and poor nations by contrasting a marble plate with a rotting door frame, peeling paint, and a rusty iron plate.

Kiel used "materials often seen as humble building materials in slums all over the world. But a start has been made in building a bridge, hopefully helping to overcome the wide gap one day," said copywriter Delia Partridge.

Integrating Copy with Art

How best to integrate the copy into a design that revolved around the artwork? The solution brought about an innovative layout.

The objective was to avoid the look of an art catalog where artwork is separated with white space from its caption, typically found in the margin, while respecting the character of the original art. The solution was to integrate copy into the pictures by following the composition of the collage's natural forms. Consequently, text is angled to go with the grain in a stone slab, placed within the borders of a door frame, and flows in the direction of rushing water.

CLIENT
Deutsche Gesellschaft für
Technische Zusammenarbeit
GmbH
DESIGN FIRM
Pencil Corporate Art
**DESIGNER/ART
DIRECTOR/ILLUSTRATOR**
Achim Federic Kiel
PHOTOGRAPHER
Lutz Pape
COPYWRITERS
Client staff members (German),
Delia Partridge (English)
PRINTER
Druckerei Ruth

PAPER STOCK
Zanders Chlorine-free
Bleached Recycled Papers
280 g and 130 g
PRINTING
special NovaSpace 4-color
offset scale and printing
colors, transparent varnish,
extreme deep black (not
common Euroscale)
SIZE
8 ⅜" x 12"
(21 cm x 29.7 cm),
16 pages
FONTS
Adobe Garamond,
Helvetica Neue
PRINT RUN
6,000
HARDWARE
Macintosh
SOFTWARE
Quark XPress 3.22

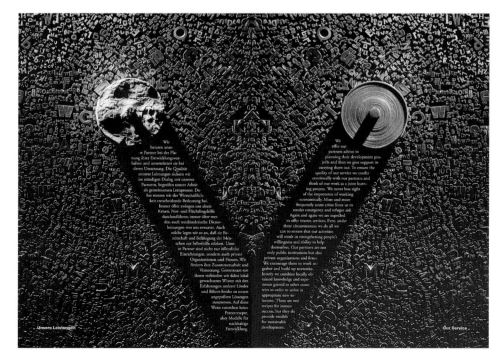

NONFINANCIAL

SOME ANNUAL reports don't go by the numbers. These are reports produced annually that are not required by the Securities and Exchange Commission. Such nonfinancial reports fall into a netherworld; they are not capabilities brochures, nor are they, technically, annual reports.

Despite the absence of financial data, these annuals face the same challenge as traditional reports: to distinguish themselves while also presenting a new face every year.

Nonfinancial annual reports take all forms—fun and funky, conservative and stylish; some even dabble in a virtual reality all their own. One might even say they are trendy in that they may actually be a harbinger of designs to come.

They all have a unique voice, and here they can be heard.

"IN ANNUAL REPORT DESIGN, PAPER CONTINUES TO PLAY AN IMPORTANT ROLE IN COMMUNICATING THE PERSONALITY OF A COMPANY AND THE SUCCESS OF ITS FISCAL YEAR.
"A COUPLE OF YEARS AGO, RECYCLED CONTENT WAS A PRIMARY REQUIREMENT IN CHOOSING A SHEET FOR A COMPANY'S ANNUAL. IN MY EXPERIENCE IN THE CHICAGO MARKET, RECYCLED CONTENT HAS TAKEN A BACK SEAT TO OTHER CHARACTERISTICS. I'M SEEING AN INCREASE IN SOFT FINISHES BEING CHOSEN FOR ANNUAL REPORTS, INCLUDING SILK, VELVET, DULL, AND VELOUR. DESIGNERS AND CLIENTS SEEM TO BE FAVORING THE NONGLARE, EASY READABILITY, AND TACTILE FEATURES THAT THE SOFT-FINISH SHEETS HAVE TO OFFER.
"IN TERMS OF SHADE, ULTRA-BRIGHT, BLUE-WHITE SHEETS ARE STILL IN FAVOR WITH DESIGNERS. I DO SEE SOME OFF-WHITES BEING SPECIFIED, BUT NOT NEARLY AS OFTEN AS THE ULTRA BLUE-WHITE SHEET."
—MOLLY FORSHAY, SPECIFICATIONS SALES, POTLATCH CORPORATION

Discovery Networks' Annual Sales Kit

HUGE, FUN, FUNKY, CURIOUS, HANDS-ON, AND INTERACTIVE. THESE ADJECTIVES AND MORE DESCRIBE THE DISCOVERY NETWORKS' 1998 ANNUAL SALES KIT AS DESIGNED BY TURKEL SCHWARTZ & PARTNERS.

Quite simply, the design objective was to elicit a "wow" response from the cynical advertising community, which is barraged with gimmicks, freebies, trips, and corporate gifts elaborate enough to make anyone else swoon. But this audience is not easily impressed. To break through the clutter, something truly remarkable is needed.

What Is the Brain Dart?

Turkel Schwartz & Partners had previously produced a sales kit for the Discovery Channel. In 1998, the kit was expanded to include all the Discovery networks, including Discovery Kids, People and Arts, and Animal Planet.

"We wanted people to read the report and get a sense of what the Discovery Channel and all of its networks are about—discovery," says Bruce Turkel. "As a design firm, we're always looking for what I call the brain dart—the thing that can penetrate the audience's consciousness."

Production Hurdles

Surprisingly, for a book with this unique approach and of this magnitude, neither selling the concept to the client nor printing the piece proved problematic. Aside from tweaking the photography on the large spreads for greater contrast, so that the images would really pop when viewed with enclosed 3-D glasses, the project progressed smoothly on press.

By far the biggest challenge lay in getting the project and all its gadgetry sourced and produced on time and within budget. The tabs of the book are etched metal cutouts of various objects ranging from a dinosaur to an elephant. A toy is attached by Velcro® so that it can be removed for play. Two sheets of magnetic words in "Dog Talk" provide recipients with another desktop diversion, as does the pair of 3-D glasses, pages in assorted-sized, and booklets.

The eye-catching design and gimmicks are the vehicles to motivate the advertising community to read the essential message, the hard-core data—viewership figures, programming updates, and audience demographics that executives need to make a sound media buy. This information changes quarterly. To make updates easy, the data is laser-printed, making customizing the kit fast and easy and guaranteeing that the information is never out of date.

A Goose-Bump Moment

"Too many annual reports exist because they have to be done, not because they want to communicate," says Turkel. "Because annual reports contain financial information, some people think it must be serious. Nonsense! You can show your audience that the business is doing well and you're making money without being overly corporate."

"Designers and their clients need to say, 'Here's who we are. This is what we stand for. This is what our people are like.' When you think in these terms, you'll get the brain dart. You won't look like everyone else. When you get it, you'll know it. It's a GBM—a goose-bump moment."

CLIENT
Discovery Networks
DESIGN FIRM
Turkel Schwartz & Partners
DESIGNERS/ART DIRECTORS
JoJo Milano,
Janice Davidson
COPYWRITER
Chris Breen
PRINTER
Haff-Daugherty Graphics

PAPER STOCK
special chip board and
black paper stamped
together, Carolina 100#
gloss coated and Cougar
80# text
PRINTING
4-color process plus
varnish, paper and
metal die-cutting, and
3-dimensional film
SIZE
outside
10 ½" x 20"
(27 cm x 51 cm);
circle pages
10" (25 cm) each half;
text
8" x 9 ¾"
(20 cm x 25 cm),
125-150 pages depending
on media input
FONT
Gill Sans
PRINT RUN
1,500
HARDWARE
Macintosh
SOFTWARE
Quark XPress 3.32,
Adobe Illustrator 6.0

DISCOVERY NETWORKS' ANNUAL
SALES KIT

AT&T Jens Corporation Annual Brochure: "Evolution"

COMPANY BROCHURES THAT ARE UPDATED AND PRODUCED ANNUALLY CAN POSE THE SAME DESIGN AND PRODUCTION CHALLENGES AS ANNUAL REPORTS—WITHOUT THE FINANCIAL DATA.

AT&T Jens was the first Internet service provider in Japan. As such, they issue an updated brochure on the company's service capabilities annually and requested this one evoke a soft, warm image versus a digital one.

Rapidly Changing Communication

The title, "Evolution," plays on the theme of the ever-changing Internet and telecommunications capabilities AT&T Jens offers that necessitate the annual update.

The cover introduces a checkerboard motif with an eclectic color palette that is carried throughout the piece; in fact,

the back cover presents a literal translation of this design. Inside, the grid layout provides the template for presenting the message and visuals in an organized, straightforward manner.

Capsule summaries of AT&T Jens services are accented with innovative die-cuts for visual interest. The die-cuts proved problematic on press, with no margin for error.

In total, the piece is well laid out, well executed, and amazingly uncluttered, given the amount of information conveyed and the mix of two languages.

CLIENT
AT&T Jens Corporation
DESIGN FIRM
Kenzo Izutani Office
Corporation
DESIGNERS
Kenzo Izutani, Aki Hirai
ART DIRECTOR
Kenzo Izutani
PHOTOGRAPHER
Yasuyuki Amazutsumi
COPYWRITERS
Goro Aoyama, Kenji Koyama
PRINTER
Nissyo Printing

PAPER
Vent Nouveau V 180 kg
PRINTING
4-color process plus silver
SIZE
8 ¼" x 11 ¾"
(20.5 cm x 30 cm),
8 pages
FONTS
Japanese characters
Gothic MB101-b, Gothic
MB101-H;
English characters
Franklin Gothic
PRINT RUN
5,000 Japanese,
1,000 English
HARDWARE
Macintosh
SOFTWARE
Adobe Illustrator 7.0J,
Adobe Photoshop 4.0J

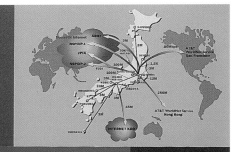

世界のインターネットのエンジニアのトップの多くは、AT&T Jensにいると私たちは考えています。理由は簡単です。まず、AT&T Jensでは国を超えた大きなプロジェクトが組まれていることがあげられます。それぞれの国で生まれた新しい技術は絶えず共通のテーブルにのせられ全体の技術のレベルアップにつなげられています。また、巨額の資金を投入して行われているシリコンバレーAT&T研究所の技術の最前線にいつでも触れられるということもあげられます。私たちが、他社に先がけて、インターネット電話サービスを発表できたのは、AT&T Jensのエンジニアの力を証明するものです。
エンジニアは技術の部門だけではありません。ネットワークエンジニア、プロダクトエンジニア、オペレーションエンジニア、カスタマーサポートエンジニア、セールスサポートエンジニア。AT&T Jensでは、ハードを扱うエンジニアもソフトを扱うエンジニアもひとつの力になって、お客様のご要望にお応えしているのです。

AT&T Jens
Internet Backbone

AT&T Jens
あすの世界標

AT&T Jensは、A
私たちの進む道は、
Jensは、日本で初め
になったのです。以
ネット接続サービス
ネット／エクストラ
構築、VPNなど、の
そして、現在注目を集
のバックグラウンド
があります。そして私
経験があります。高

AT&T Jensは、は

AT&T @phone
エイティアンドティ・アットフォン

インターネットを使った低価格・高品質の電話サービスです。しかも、パソコンやモデムなどの専用機器、加入料、基本料などは一切必要ありません。サービスエリアはすでに世界130ヶ国以上、国内でも大都市圏の通話が可能。エリアはどんどん拡大します。
音声データをパケットに変換して伝送するシステムを採用することにより、AT&Tが持つ大容量のインターネットバックボーン回線を有効に利用することが可能となりました。これが、従来の国際電話サービスに比べ、大幅なコスト削減を実現した一番の理由です。
このインターネット電話を、より手軽にご利用頂けるように、日本で初めてのプリペイドカードも用意しました。街角やご家庭の使いなれた電話から、おトクな国際国内通話が可能です。

●24時間均一の低価格&料金設定です。
●企業やご家庭の一般加入電話はもちろん、公衆電話、携帯電話、PHSでもご利用になれます。
●確かなバックボーンにより、信頼性の高いクリアな品質をお届けします。

*ダイヤラーをインストールしてAT&T @phoneをご利用する場合は別途ダイヤラーレンタル料がかかります。

FLEX LINK SERVICE

付加価値パケット通信を中心として高い導入実績を誇ってきたフレックスリンクサービスが、このたび新しく生まれ変わりました。従来のアクセスサービス（X.28／X.25）に加えて、インターネット（IP）にも対応したのです。IBM（SNA）や富士通（FNA）、日立（HNA）など、各種メインフレームの通信プロトコルを、安定性と信頼性に優れたAT&Tのインターネットバックボーン上でエミュレーションすることにより、ホスト業務とイントラネット／エクストラネット環境とのフレキシブルな統合を実現します。
これまで、異なる通信プロトコルが共存するネットワークを拡張するためには、投資コストの増大やメンテナンス工程の増加といった問題が避けられませんでした。フレックスリンクサービスは、こうした利用環境におけるさまざまな要望に即座に応え、複数のメインフレームとパソコン間（スタンドアロンPC／LAN上のPC）の自由でリアルタイムなアクセスを可能とし、きわめて低コストに、より高度で強力なネットワークへと進化させます。

AT&T WorldNet™ Service

個人むけのインターネット接続サービスです。
インターネットの先進国アメリカで、市民権を得たクオリティが売りものです。快適な接続環境を実現します。

●アナログ公衆回線やINSユーザーホームページサービスのネット64でwwwブラウジング、FTP、E-Mail、NetNews、がご利用になれます。
●接続速度　公衆回線：K56flex、INSネット64：64Kbps(同期)。
●アクセスポイント　札幌（011）、仙台（022）、千葉（043）、横浜（045）、名古屋（052）、大阪（06）、神戸（078）、広島（082）、福岡（092）、沖縄（098）
全国共通アクセスポイント：インターアクセス0098（日本テレコム市外局番電話サービス）により、1分間10円で全国どこからでもアクセスできます。

きっと人類は新しくなる。
国境を越えて協力し、
作品をつくっているこどもたちがいます。
AT&T バーチャルクラスルーム

バーチャルクラスルームとは、「地球上の離れた場所にある教室同士を結んで共同学習を行う環境」のことです。小・中・高校生、世界中のこどもたちが協力して、ウエブ上に作品をつくっています。97年度は、マルチメディア新聞、リレー小説、ファッションショー、環境問題についての協同リサーチ、英文化比較など作品テーマとしてえらばれています。作品の審査は、小学部門、中・高校部門別に行われ、1.コンテンツ（世界にアピールしようとする内容のおもしろさ）2.プレゼンテーション（ウエブによる情報の表現力）3.コラボレーション（生徒達の参加と協力の度合）、以上の3つのカテゴリから評価されています。

AT&T
Virtual
Clas$ro˚m

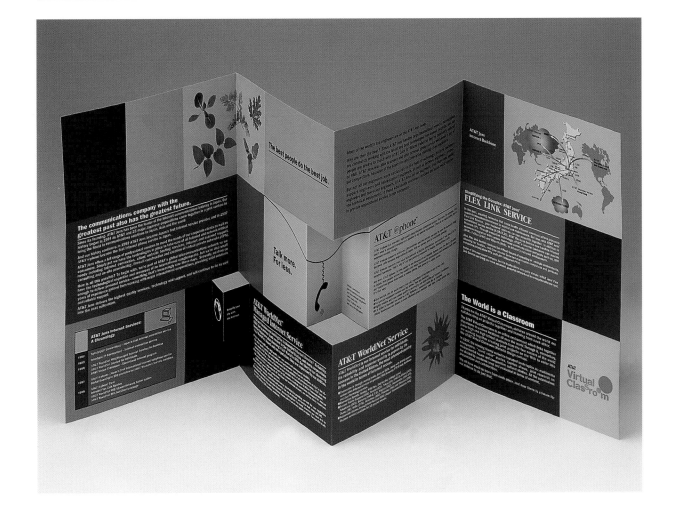

Virtual Telemetrix, Inc. Annual Report

BY AND LARGE, DESIGNERS LOVE SELF-PROMOTIONS. WHY? THERE ARE NO RULES, AND THEY ARE LIMITED ONLY BY THEIR IMAGINATION. IN THE REALM OF SELF-PROMOTION THE DESIGNER REIGNS SUPREME.

The norm in self-promotions, if you can call it that, is the wildly creative. While all are usually wonderfully unique in appearance and copy, they do tend to come in the same packages—capabilities brochures, giveaways, seasonal greeting cards, and the like. Less common is a self-promotion packaged as an annual report.

Virtual Fact or Fiction?

While, technically, annual reports are self-promotions, few design firms showcase their talents under the guise of an annual report and under a pseudonym that sounds like a high-tech corporation.

That alone makes the *Virtual Telemetrix, Inc. Annual Report* standout. It is the brainchild of John Bielenberg, who founded this fictitious company in 1991 when he began a continuing series of self-initiated creative projects that look at the business of graphic design and the role of image making in today's culture. The series includes a book, a 1993 annual report, a poster, a product direct-mail catalog, T-shirt, a Web site, with the latest installment in the 1997 annual report.

Parody of the Annual Report

Its theme is "A Brand New Year," and the report is "designed to take a satirical look at corporate branding, and brand extension,

as well as to parody the annual report as a communications vehicle," Bielenberg said. "As corporations have moved to replace the church or the state in shaping our culture and behavior, the Virtual Telemetrix (VT) report hopes to illustrate this phenomenon."

Of course, no annual report would be complete without the shareholders' letter. This report is no exception—except this letter comes via email. What else would one expect of a virtual company?

VT is its own brand, and according to the report, this brand has saturated every category in the marketplace. The name shows up on everything from VT drugs and spirits and V-mail to VTV television. Did you know the VT Scouts of America exist to carry the brand into our culture and spread it among young people with receptive minds, vulnerable to advertising messages?

As for the financial information, there is none. "No captions, descriptions, notes, or numbers necessary. All you need to know is growth and brand extension!" said Bielenberg.

Four of Bielenberg's VT projects have been acquired as part of the permanent collection of design and architecture at the San Francisco Museum of Modern Art, and an exhibition of all the VT projects is planned.

CLIENT
Virtual Telemetrix, Inc.
DESIGN FIRM
Bielenberg Design
DESIGNERS
John Bielenberg,
Chuck Denison
ART DIRECTOR
John Bielenberg
PHOTOGRAPHER
Victor John Penner
COPYWRITER
Chris Williams
PRINTER
H. MacDonald

PAPER STOCK
Appleton Papers Utopia
One, Blue White Gloss
100# text
PRINTING
4-color process plus
spot dull varnish
SIZE
11" x 17" (28 cm x 43 cm),
20 pages
FONT
Helvetica Inseriat
PRINT RUN
2,500
HARDWARE
Macintosh
SOFTWARE
Quark XPress

MEDIALOGUE

日本の現代写真'98

Photography in Contemporary Japanese Art '98

Tokyo Metropolitan Museum of Photography: "Medialogue: Photography in Contemporary Japanese Art '98"

MEDIALOGUE, A NAME COINED FROM THE WORDS MEDIA AND DIALOGUE, IS A COLLECTION OF CONTEMPORARY JAPANESE ART THAT TRANSCENDS BOTH JAPANESE AND ENGLISH AND SPEAKS VISUALLY TO READERS OF ALL LANGUAGES.

"Photography brings the arts into a closer relationship with the media, a dialog with the media that is accelerating as it develops," reads the preface to "Medialogue," an exhibition at the Tokyo Metropolitan Museum of Photography that epitomizes the role of photography in art.

"One World"

In a 200-page book, where every written word is presented in two languages, a designer runs the risk of visual overload, a problem sidestepped, in this case, with a tight layout. Early in the book the copy introduces the theme of "One World." This concept parallels the presentation that avoids treating the two

languages and the graphics as three separate entities; instead, they are treated as a whole. Japanese copy blocks are found on the verso pages, and English text is mirrored on the recto.

The copy poetically tells the stories of the photographs that follow. The photography ranges from a sea of plastic recyclable bottles and second-hand clothing to images of two men standing proud and stone-faced, reminiscent of the painting *American Gothic*, asking the seemingly unanswerable question, "What am I?"

CLIENT
Tokyo Metropolitan
Museum of Photography
DESIGN FIRM
It Is Design
DESIGNER/ART DIRECTOR
Tomohiro Itami
PHOTOGRAPHER
Hikomaru Mòri
(CD-ROM/Music)
COPYWRITERS
Atsushi Sugita, Naomi
Enami, Kim Seoung-Kon,
Michael L. Sand, Hiromi
Nakamura, Vilnis Auzins,
Angela Magalhaes, Nadja
Fonseca Peregrino, Adreas
Muller-Phole, Kanta
Sanoyama
PRINTER
Tosho-insatu Co., Ltd.

PAPER STOCK
Mitubishi Co. Ltd.
Diapake 110 kg
PRINTING
4-color process
SIZE
6 ½" x 8 ¾"
(17 cm x 22 cm),
200 pages
FONTS
Japanese
A101, BBB1, Ryumin M;
English
Trade Gothic, Stone Serif,
Letter Gothic, Din
Mittelschrift Alternate
PRINT RUN
5,000
HARDWARE
Macintosh
SOFTWARE
Quark XPress, Adobe
Illustrator, Adobe
Photoshop

What am I ?

私が何者であるのかは
私を取り囲む社会的な仕組みによって決まります
私たちはそういった仕組みに
当然のように属しています
組織や職業
人種、性別
日本という国
そしてそれらの概念を支える
身近で基本的なもの
家、血縁、家族

様々な人の集まりを支える根拠は何でしょう
当然だと思っているその骨組みは
そんなに確かなものでしょうか

日本という国に暮らす
私、山田　亘とロブ・キング
「当然」を持たない二人
それぞれの目的を持って対等の立場で
共に何かを感じたり考えたり創ったり
プロジェクトとしての家族
コラボレーティブ・ファミリー
そういうものが「家族」の、ある一つの確かな姿ではないでしょうか

What I am
would depend on
the surrounding various structures
We belong to those structures
without even thinking about them
Organizations, Occupations
Races, Genders
The country of Japan
And the familiar and fundamental structures
that support those concepts,
Home, Blood, Family

What would be the basis to support various groups of people coming together?
Are these given structures what we think they are,
so undoubted and definite?

I, Ko Yamada, and Robb King
living in Japan
Two of us with no "givens"
feel and think and create things together
with each other's independent purpose and position
Family as a project,
A Collaborative Family
Couldn't this be considered a certain state of "family"

40

41

54

55

Contributors

Addison
79 Fifth Avenue, 6th floor
New York, NY 10003
Email: Lsegal@addison.com

Bielenberg Design
245 Fifth Street, #201
San Francisco, CA 94103
Email: John@bielenberg.com

R. Bird & Company
150 E. 52nd Street, 14th Floor
New York, NY 10022
Email: Mail@rbird.com

The Bonsey Design Partnership
179 River Valley Road
Level 5, Unit 1
Singapore 179033
Email: Postmaster@bonsey.com.sg

Cahan & Associates
818 Brannan Street, Suite 300
San Francisco, CA 94103
Email: Courtneyb@cahanassociates.com

Clic Limited
Kornhill Metro Tower
1 Kornhill Road, Suite 801-802
Hong Kong
China
Email: Clic@clic.com.hk

EAI
887 West Marietta Street, NW
Suite J-101
Atlanta, GA 30318
Email: D_gahan@eai-atl.com

Erwin Zinger Graphic Design
Bunnemaheerd 68
Groningen 9737RE
The Netherlands
Email: Erwin_zinger@hotmail.com

Essex Two
2210 West North Avenue
Chicago, IL 60647
Email: Email@sx2.com

Falk Harrison Creative
4425 West Pine Boulevard
St. Louis, MO 63108
Email: Msteinau@falkharrison.com

Fantastic New Designment GmbH
Reinstrasse 77
Wiesbaden D-65185
Germany
Email: Mail@fantastic-net.de

Feld Design
4900 Leesburg Pike
Suite 413
Alexandria, VA 22302
Email: Afeld@erols.com

5D Studio
20651 Seaboard Road
Malibu, CA 90265
Email: Jane5d@aol.com

Foster Design Group
585 Boylston Street
Boston, MA 02116
http://www.fosterdesign.com

Grafik Communications, Ltd.
1199 North Fairfax Street
Suite 700
Alexandria, VA 22314
Email: Lynn@grafik.com

HGB Hamburger Geschäftsberichte
 GmbH & Co.
Rentzelstrasse 10a
20146 Hamburg
Germany
Email: Info@hgb.de

Hornall Anderson Design Works, Inc.
1008 Western Avenue, Suite 600
Seattle, WA 98104
Email: C_arbini@hadw.com

Hovedkvarteret ApS.
Vestergade 10A
Copenhagen 1456K
Denmark
Email: Erik@hovedkvarteret.dk

It Is Design
204 3-15-22 Jingumae
Shibuya-ku
Tokyo 150-0001
Japan
Email: itis@qaz.so-net.ne.jp

Jacqué Consulting & Design
19353 Carlysle
Dearborn, MI 48126
Email: Jmcclure@jcidesign.com
João Machado Design, Lda.
Rua Padre Xavier Coutinho, 125
4150-751 Porto
Portugal
Email: jmachado@mail.telepac.pt

Joseph Rattan Design
5924 Pebblestone Lane
Plano, TX 75093
Email: Rattan@cyberramp.net
Kenzo Izutani Office Corporation
1-24-19 Fukasawa
Setagaya-ku
Tokyo 158-0081
Japan
Email: Izutanix@tka.att.ne.jp

Kim Baer Design Associates
620 Hampton Drive
Venice, CA 90291
Email: Stephanie@kbda.com

Landesberg Design Associates
1100 Bingham Street
Pittsburgh, PA 15203
Email: Rick@designlande.com

Leimer Cross Design
 Corporation
140 Lakeside Avenue, Suite 10
Seattle, WA 98122
Email: Kerry@leimercross.com

The Leonhardt Group
1218 Third Avenue
Suite 620
Seattle, WA 98101
Email: Jenniferc@tlg.com

Lieber Brewster Design, Inc.
19 West 34th Street
Suite 618
New York, NY 10001
Email: Lieber@interport.net

Little & Company
1201 Marquette Avenue
Suite 200
Minneapolis, MN 55403
Email: Lisaj@littleco.com

Louey/Rubino Design
 Group, Inc.
2525 Main Street, Suite 204
Santa Monica, CA 90405
Email: Lrdgla@aol.com

Lowercase, Inc.
4727 North Paulina, 2N
Chicago, IL 60640
Email: Timbruce@lowercaseinc.com

Martin Design Associates
1960 East Grand Avenue
Suite 610
El Segundo, CA 92045

McKown Design
50 University Avenue, #20
Los Gatos, CA 95030
Email: Amckown@ix.netcom.com

Michael Kimmerle
 Art Direction + Design
Ostendstrasse 106
Stuttgart 770788
Germany
Email: Mi@kimmerle.de

Michael Patrick Partners
532 Emerson Street
Palo Alto, CA 94301
Email: Mpp@mppinc.com

Newman Foley Ltd.
5307 East Mockingbird Lane
Dallas, TX 75206
Email: Jfoley@newmanfoley.com

Oh Boy, A Design Company
49 Geary Street, Suite 530
San Francisco, CA 94108
Email: Cgroutt@ohboyco.com

Okamoto Issen Graphic Design Co.
1307 Tatsumura Aoyama
 Mansion 4-35
Miami-Aoyama Minato-Ku, Tokyo
Japan 107-0062
Email: Nessi@sepia.ocn.ne.jp

1185 Design
119 University Avenue
Palo Alto, CA 94301
Email: KathyG@1185design.com

Pangborn Design, Ltd.
275 Iron Street
Detroit, MI 48207
Email: Pangborn@teleweb.net

Parallel
1040 7th Avenue S.W., Suite 600
Calgary, Alberta T2P 3G9
Canada
Email: Nam.dang@parallel.ca

The Partners
Albion Courtyard, Greenhill Rents,
 Smithfield
London EC1M 6PQ
United Kingdom
Email: Mktg@partnersdesign.co.uk

Pattee Design, Inc.
138 Fifth Street
West Des Moines, IA 50265
Email: Pattee@pattee.com

Pauffley
29 Ludgate Hill
London EC4M 7NH
United Kingdom
Email: adrian_nunn@pauffley.com

Pencil Corporate Art
Boecklerstrasse 219
38102 Braunschweig
Germany

Petrick Design
828 North Wolcott Avenue
Chicago, IL 60622
Email: Petrick@petrickdesign.com

Policy Management Systems
 Corporation
One PMSC Center
Corporate Communications
Blythewood, SC 29016
Email: Barrytownsend@pmsc.com

Radley Yeldar
326 City Road
London EC1V 2SP
United Kingdom
Email: r.riche@radley-yeldar.co.uk

RKD, Inc.
853 Alma Street
Palo Alto, CA 94301
Email: Rick@rkdinc.com

RTS Rieger Team
Bunsenstrasse 7-9
Leinfelden-Echterdingen 70771
Germany
Email: Hp@rts-riegerteam.de

Richards Brock Miller Mitchell
 (RBmm)
7007 Twin Hills, Suite 200
Dallas, TX 75231
Email: Rbmm@rbmm.com

Rigsby Design
2309 University Boulevard
Houston, TX 77005
Email: lrigsby@rigsbydesign.com

Saco Design Graphique
10 Rue Des Jeunevrs 75002
Paris, France

SamataMason
101 South First Street
Dundee, IL 60118
Email: Susan@samatamason.com
(cont.)

Sibley Peteet Design—Dallas
3232 McKinney Avenue
Suite 1200
Dallas, TX 75204

Starbucks Coffee Company
2401 Utah Avenue South
8th Floor
Seattle, WA 98134
Email: BBLIXT@Starbucks.com

Thirst
132 West Station
Barrington, IL 60010
Email: Thirstrv@aol.com

Tolleson Design
220 Jackson Street, #310
San Francisco, CA 94111

Tudhope Associates, Inc.
284 King Street East
Toronto, Ontario M5A 1K4
Canada
Email: Ideas@tudhope.com

Turkel Schwartz & Partners
2871 Oak Avenue
Coconut Grove, FL 33133
Email: Bturkel@tspmiami.com

Vrontikis Design Office
2021 Pontius Avenue
Los Angeles, CA 90025
Email: Pv@35k.com

Weymouth Design
332 Congress Street
Boston, MA 02210
Email: Robert@weymouthdesign.com

WPA Pinfold
Ex Libris, Nineveh Road
Holbeck, Leeds LS11 9QG
United Kingdom
Email: Design@wpa-pinfold.co.uk

Yamamoto Moss
252 First Avenue N.
Minneapolis, MN 55401
Email: Smoon@yamamoto-moss.com

Index

About the Author

Cheryl Dangel Cullen is a writer and marketing consultant with an extensive background in the graphic arts industry. She is the author of *Graphic Idea Resource: Photography*, published by Rockport Publishers in 1999. She writes frequently on the subjects of graphic design, paper, and printing, and has contributed articles to *HOW* magazine, *Step-by-Step Graphics*, *Graphic Arts Monthly*, *American Printer*, *Printing Impressions*, and *Package Printing & Converting*, among others. In addition, she gives presentations and seminars on innovative ways to push the creative edge in design using a variety of substrates.

Cullen writes from her home near Ann Arbor, Michigan, where she oversees operations for Cullen Communications, a public-relations firm she founded in 1993. Cullen specializes in orchestrating public-relations campaigns and advertising programs, including writing and design projects, for a national base of business-to-business and consumer clients.

SCHEID VINEYARDS ANNUAL REPORT